THE CERAMICS BOOK

Third Edition • Edited by Bonnie Kemske

EDITOR Bonnie Kemske
MANAGING EDITOR & DESIGNER Kimberley Chandler
PUBLICATION ASSISTANT Hayley Loft
ADDITIONAL SUPPORT The *Ceramic Review* Team

ACKNOWLEDGMENTS
With special thanks to all the ceramic artists who provided the material to make this possible, the photographers who have supplied images, and Ben Eldridge for his help.

IMAGE CREDITS
FRONT COVER Carina Ciscato (Photo: Robert Teed)
INSIDE FRONT COVER Derek Wilson (Photo: Christopher Martin)
P3 Sarah Walton (Photo: Jacqui Hurst) **P4** Bridget Drakeford (Photo: Chris Smart)
P6 Louisa Taylor (Photo: Matthew Booth) **P7** Dylan Bowen (Photo: Ben Ramos)
P8 David Roberts (Photo: Jerry Hardman-Jones) **PP282-3** Wendy Hoare (Photo: Tracey Sherwood) **PP338-9** Margaret Gardiner (Photo: Frauke Abel) **P340 & P343** Contemporary Ceramics Centre (Photo: Sylvain Deleu) **P341** Jim Malone (Photo: Jay Goldmark)
INSIDE BACK COVER Matthew Chambers (Photo: Steve Thearle)

FIRST EDITION 2006 **SECOND EDITION** 2008 **THIRD EDITION** 2012
PREVIOUSLY PUBLISHED AS *POTTERS* **IN TWELVE EDITIONS** 1972-2000

PRINTED AND BOUND BY ASHFORD COLOUR PRESS LTD, GOSPORT, HANTS PO13 0FW

ISBN 978-0-9557732-1-1
PUBLISHED BY CERAMIC REVIEW PUBLISHING LTD
63 GREAT RUSSELL STREET, LONDON WC1B 3BF
© CERAMIC REVIEW PUBLISHING LTD

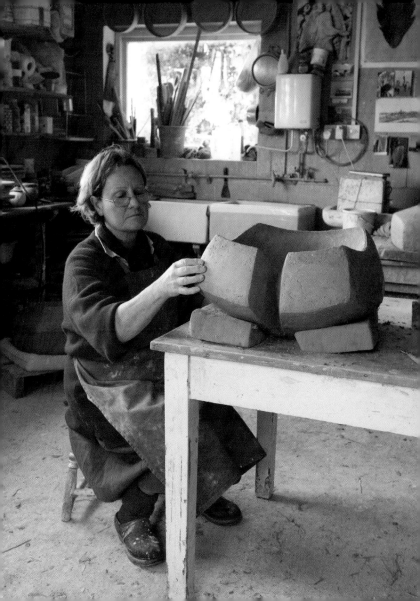

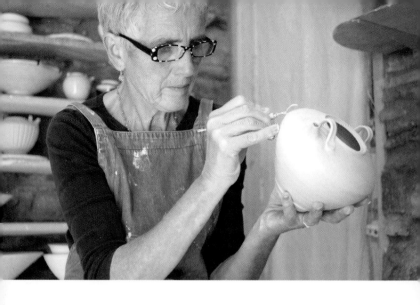

CONTENTS

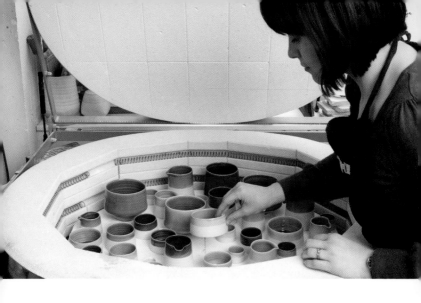

INTRODUCTION

In this, the Third Edition of *The Ceramics Book*, we have created a directory of some of the finest studio potters and ceramists working in the UK today. Each entry gives an image of current work, a short written profile of the artist and his or her work, the potter's mark, and current contact details and website address.

This is an invaluable resource for those who love ceramics, whether users, collectors, students, makers, enthusiasts, or more generally, those interested in what is happening in current studio ceramics. It comprises a wide range of work from tableware to sculpture. In this compilation you can read about the driving forces and inspirations behind the creation of these fine ceramic works, and learn about the technical skills and material knowledge that underpin each piece.

Those listed in this directory are all selected as Members or Fellows of the Craft Potters Association (CPA), a national professional organisation that promotes the work of leading potters and ceramists in the UK. At the back of the book is a listing by region, so if you are out and about and would like to visit a studio, it will be possible to see which potters are within specific areas.

Bonnie Kemske, Editor

DIRECTORY OF MAKERS

BILLY ADAMS Fellow

4 Allensbank Road, Heath, Cardiff CF14 3RB
TEL 07876 451 887 EMAIL theadamsfamily.cardiff@btinternet.com
Visitors welcome by appointment

Billy Adams explores and experiments with aspects of landscape. He works within the vessel format, combining textures and colours to give the viewer an intimate insight into his private view of ceramics, where structures and forms combine and interact with man-made elements to provoke the onlooker into questioning the value of a vessel as sculpture. Rims, handles, lips, and balance are commonplace within traditional ceramics, yet he uses them in a unique integrated structure that elevates them beyond their identifiable function. The conclusive forms are recognised as jugs, bowls, and vessels; however, these represent profound arguments about individual perception and memory of an ever-changing landscape.

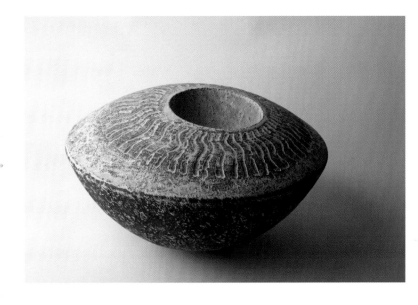

DAVID ALLNATT

Mayfield, Edenwall, Coalway, Coleford, Gloucestershire GL16 7HP
TEL 01594 833 041 EMAIL davidallnatt@btinternet.com WEB www.allnattceramics.com
Visitors welcome by appointment

I produce a series of limited editions that share a common design concept. My ceramics have evolved and changed over the years, but they are still inspired by observing the landscape and organic forms in nature. The idea of positive and negative space intrigues me; the relationship between the inner and outer form is always challenging. All of my work is handbuilt using coiling and press-moulding techniques, using both earthenware and stoneware clays, and decorated with coloured slips and glazes, which I have developed to produce the highly coloured matt surfaces I prefer. I have exhibited widely both in the UK and abroad, and my work is held in both public and private collections.

Allnatt

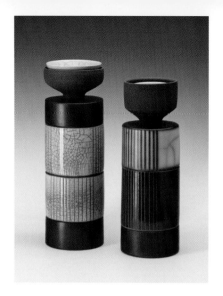

TIM ANDREWS Fellow

Woodbury Studio/Gallery, Greenway, Woodbury, Exeter EX5 1LW
TEL 01395 233 475 EMAIL timandrews@eclipse.co.uk WEB www.timandrewsceramics.co.uk
Visitors welcome by appointment

Well known for his raku ceramics, Tim Andrews trained with David
Leach and at Dartington. He lectures and exhibits in the UK and
abroad and is represented in public and private collections around the
world. He is the author of *Raku* (A&C Black). 'After thirty years my
work continues a conversation between the technical sophistication
of processes, serendipity, and timeless human qualities. The
transformation of mud to art is a fascinating journey of transition.
The simplicity and apparent effortlessness aimed for stems from
a demanding making technique and a dramatic firing process.
Ultimately, for me, each piece has to justify its existence with a
quiet, yet powerful, presence.'

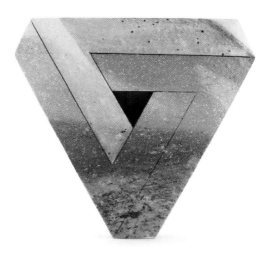

BEN ARNUP

The Cottage, Love Lane, The Mount, York YO24 1FE
TEL 01904 633 433 EMAIL ben@benarnup.com WEB www.benarnup.com
Visitors welcome by appointment

These stoneware objects are influenced by the *trompe l'oeil* of late medieval art. Currently, the use of marbled clays complements the geometric forms – just for fun.

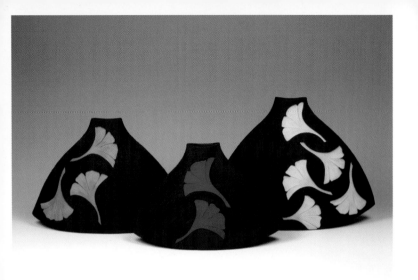

JACQUI ATKIN

White Cottage, 3 Glyn Morlas, St Martins, Oswestry, Shropshire SY11 3EE
TEL 01691 773 670 EMAIL j.p.atkin@btopenworld.com WEB www.jacquiatkin.com
Visitors welcome by appointment; please call in advance for directions

I have been potting for twenty years now and during that time the main focuses of my work have encompassed low-firing techniques, especially resist raku. However, in an attempt to move away from this extreme firing process, recent work has been exploring new surface treatments where texture forms the background for stylised botanical imagery. Using underglaze for dramatic colour variations, my aim is to replicate, to some extent, the look of raku-fired clay.

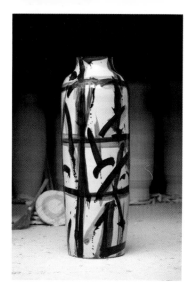

FELICITY AYLIEFF Fellow

1&2 Dafford Street, Larkhall, Bath BA1 6SW
TEL 01225 334 136 / 07714 212 124 EMAIL aylieff@btinternet.com / felicity.aylieff@rca.ac.uk
Visitors welcome by appointment

Felicity Aylieff works both in the UK and China, with studios in Bath and Jingdezhen respectively. China allows her to make pieces that are monumental in scale, often two to three metres high. Their surface decoration is a contemporary translation of her research into the traditional Chinese techniques of Fencai enamel painting and 'blue and white ware'. Smaller works are exploratory in their mark making with energetic brushwork. She is currently senior tutor at the Royal College of Art, London. She has work in numerous public and private collections including the V&A, York Museum, and Birmingham Museums and Art Gallery, and the Devonshire Collection.

F. Aylieff.

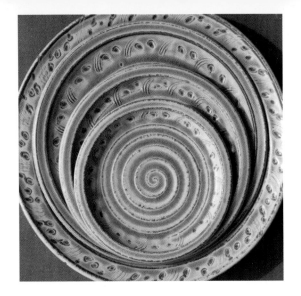

ELIZABETH AYLMER

Buzón 911, 11690 Olvera, Cádiz, Spain
TEL 0034 0956 234 060 EMAIL lizyjen@terra.es WEB www.artesaniadelprado.es
Visitors welcome by appointment

In 2004 I moved from Devon to Andalucía – not to retire but to live and work in the sun. I assumed that my ware would be ´too quiet´ for southern Spain but it has been much admired, so my planned change of direction has so far not happened! I predominantly make hand-thrown functional stoneware pottery with a wood-ash glaze. The incised decoration is influenced by my Zimbabwean roots. It has always been a pleasure to make pottery that will be lived with and used daily. However, I have found time to experiment with porcelain and other techniques, so the future for my third age looks very exciting!

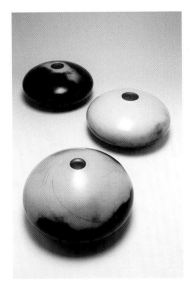

DUNCAN AYSCOUGH Fellow

Farmers, Bethlehem, Carmarthenshire SA19 9DW
TEL 01550 777 460 EMAIL duncan@ayscoughceramics.co.uk
WEB www.ayscoughceramics.co.uk • Visitors welcome by appointment

I am intrigued by the movement of form and structure when throwing on the potter's wheel; the fluidity of this process combined with terra sigillata finishes and firing the pots in sawdust provide a unique form of surface patina. I aspire to use these processes as a means of recording the physical and sensual act of making. My works demonstrate my continual concern with oppositional elements: light and dark, night and day, fragile and strong, fluid and rigid. I divide my time between lecturing on the ceramics programmes at Cardiff School of Art and Design and working from my studio in Bethlehem, West Wales.

DA

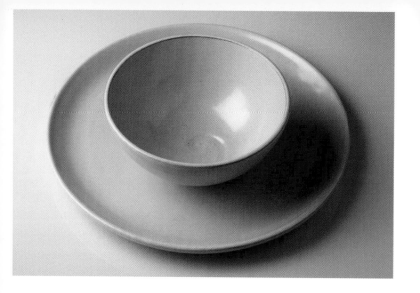

SYLPH BAIER

3 Florence Road, Brighton, East Sussex BN1 6DL
TEL 01273 540 552 **EMAIL** ceramics@sylphbaier.co.uk **WEB** www.sylphbaier.co.uk
Visitors welcome by appointment

Sylph Baier's interest in producing functional tableware originated in Germany while working in advertising, mainly displaying ceramics. After serving a traditional apprenticeship and three highly successful years studying ceramics in Wales, Sylph joined an artists' co-operative in Brighton where she started to produce her *Storm in a Teacup* range. Her current *Lift* range is mainly form-based. By taking the material to its limits and constantly exploring functionality and purpose, Sylph is able to produce tableware that emanates a timeless beauty, and is both accessible and sensuous to the touch.

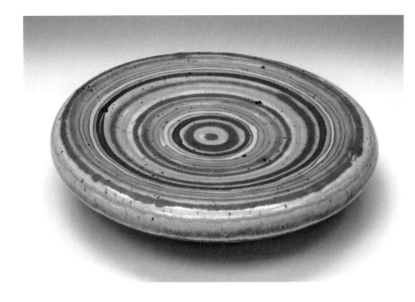

CHRIS BARNES

The Knott, Ainstable, Carlisle, Cumbria CA4 9RW
TEL 01768 896 421 EMAIL tempest2000@hotmail.co.uk WEB www.morvernpottery.co.uk
Visitors welcome by appointment

Thrown stoneware pots, ranging from functional mugs and bowls to more sculptural work, the work has rich glazes with bright colour reactions from reduction firing. I tend to explore volume, scale, form, and surface decoration, and I get excited about using clay, glaze, form, and colour together. You can use the pots too. I studied sculpture at St Martin's School of Art, London (1979-81). Then I made pots at The Chocolate Factory N16 in London (1995-2006) before setting up Morvern Pottery in Argyll in 2007. In 2010 I set up a new pottery near Ainstable in Cumbria.

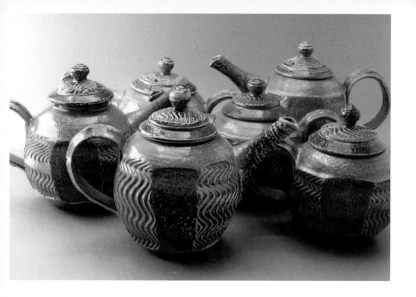

DEBORAH BAYNES

Nether Hall, Shotley, Ipswich, Suffolk IP9 1PW
TEL 01473 788 300 EMAIL deb@deborahbaynes.co.uk WEB www.potterycourses.net
Visitors welcome by appointment

Probably best known for my residential summer workshops, held since 1971 at White Roding, Essex, and since 1993 from Nether Hall, between courses I produce a great many pots, my constant preoccupation being throwing and manipulating wet clay both on and off the wheel, combined with the alchemy of fire. Since 1986 I have mostly salt-glazed except for periods making raku for the sheer fun of it. My work is available through various exhibitions and from my workshop. I am a founder member and former chair of the East Anglian Potters Association, and a Member of the Suffolk Craft Society.

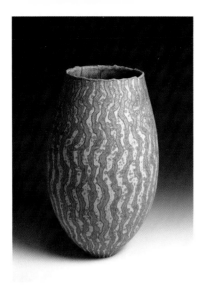

PETER BEARD Fellow

Tanners Cottage, Welsh Road, Cubbington, Leamington Spa, Warwickshire CV32 7UB
TEL 01926 428 481 EMAIL peter@peterbeard.co.uk WEB www.peterbeard.co.uk
Visitors welcome by appointment

Thrown and handbuilt individual pieces in stoneware. Vessel and
non-vessel based – strong, simple shapes decorated with complex glaze
surfaces. Matt and semi-matt glazes are built up in layers, creating
textural surfaces during the firing, and wax resist is used between
layers to create pattern. Exhibits widely in the UK and abroad, with
work represented in many publications and collections. Regular
lectures and demonstrations in Europe, with workshop tours of South
Africa, India, Australia, and New Zealand. Artist in Residence in
Kecskemét (2010). Author of *Resist and Masking Techniques* (A&C Black).
Winner of Inax Design Prize and Silver Medal, Vallauris Biennale.
Member of the International Academy of Ceramics.

BEV BELL-HUGHES Fellow

Fron Dirion, Conwy Road, Llandudno Junction, Conwy LL31 9AY
TEL 01492 572 575 EMAIL bevandterry@googlemail.com
Visitors welcome by appointment

Having done a Foundation course at Sutton School of Art (1965-67),
I then did the Harrow Studio Pottery Diploma under Victor Margrie
and Michael Casson (1967-69). After moving to Wales in 1978 my
work has developed more, relating to the environment in which I live,
which is near the river estuary of Conwy, the sea, and the mountains
of Snowdonia, all of which inspire my work – particularly the sea and
the tidal system, the marks left in the sand, erosion, shells, rocks,
driftwood, and bones. The work is press-moulded and then pinched,
using other additions of clay and sand to change the surface texture.
I do not set out to imitate nature, but aspire to echo the process.

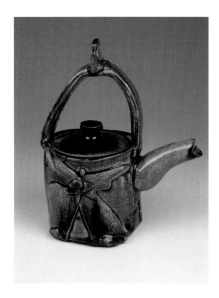

TERRY BELL-HUGHES Fellow

Fron Dirion, Conwy Road, Llandudno Junction, Conwy LL31 9AY
TEL 01492 572 575 EMAIL bevandterry@googlemail.com
Visitors welcome by appointment

I am primarily interested in high-fired domestic pots, which are thrown in series and reflect influences from Oriental and British country pots. I trained at Harrow School of Art under Victor Margrie and Michael Casson. I have exhibited in solo and shared exhibitions in Britain and abroad and have work included in several public and private collections.

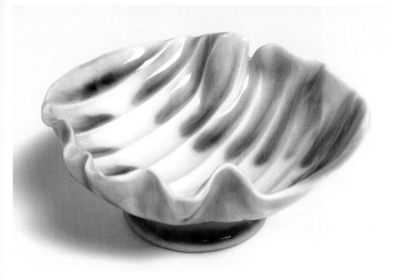

KOCHEVET BENDAVID Fellow

147 Overhill Road, East Dulwich, London SE22 0PT
TEL 020 8516 1241 **EMAIL** kookiebendavid@hotmail.co.uk **WEB** www.kochevetceramics.com
Visitors welcome by appointment

With a bold interpretation of function my work reflects a deep interest in the relationship between ceramics, food, and people. The luxurious dishes are designed to offer exciting possibilities for presenting food, while creating an ambience of sumptuous elegance and celebrating the joy of food sharing. Using my fingers for texturing, and manipulating very wet Limoges porcelain to form soft folds, I create flowing, sculptural forms. Fluid, colourful glazes fuse in the firing, pool in the folds of clay, drip off feet and edges, accentuating the sense of overflowing plenty.

K Bendavid

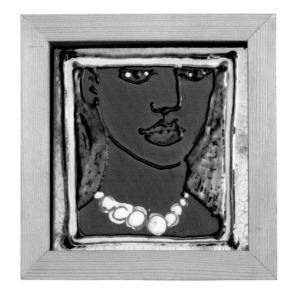

MAGGIE ANGUS BERKOWITZ Honorary Fellow

21/23 Park Road, Milnthorpe, Cumbria LA7 7AD
TEL 01539 563 970 EMAIL maggie@maggieberkowitz.co.uk
WEB www.maggieberkowitz.co.uk • Visitors welcome by appointment

An enthusiasm for earthenware, a passion for pictures on pottery, plus being aware of the history of tiles in the international history of ceramics, have kept me working for more than sixty years. In past years working with tiles has allowed me to work large, which I liked, in cramped circumstances. Now I am happy to enjoy exploring ideas and glazes in a single tile, as life's other limitations take effect. I still enjoy working to commission though, and with no limit on size!

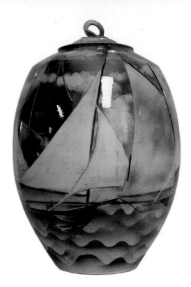

ROB BIBBY

Woodnewton Pottery, 43 Main Street, Woodnewton, Oundle PE8 5EB
TEL 01780 470 866 EMAIL robbibby@btinternet.com WEB www.robbibbyceramics.co.uk
Visitors welcome by appointment

I make thrown earthenware pottery that is mainly functional, as well
as larger and commemorative pieces. My work is usually glazed and
sometimes burnished, with colours and images included. I work in
a converted chapel, and visitors can see work in progress as well as
visiting the showroom. I run regular classes and occasional weekend
courses specialising in earthenware glazing and decoration.

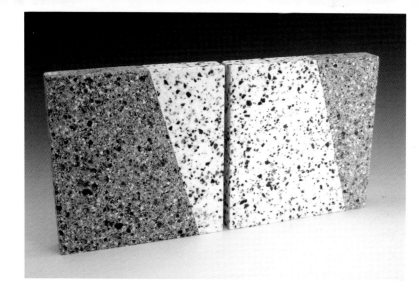

DAVID BINNS Fellow

34 Park Street, Denbigh, Denbighshire, North Wales LL16 3DB
TEL 07946 795 896 EMAIL dsbinns@hotmail.com WEB www.davidbinnsceramics.co.uk
Visitors welcome by appointment

I divide my time between my studio in North Wales and lecturing
at the University of Central Lancashire, Preston, UK. My work
draws inspiration from disparate sources, including engineering,
architecture, and the natural landscape, aiming for a visual richness
and a sense of quiet simplicity. I am interested in pushing boundaries,
researching new techniques and alternative uses of materials.
Currently, I am exploring recycled waste glass and mineral aggregates
within a unique kiln casting process. Work is finished through a
process of grinding and polishing. I exhibit my work throughout the
UK and internationally. Work is featured in numerous books, journals,
and collections. Member of the International Academy of Ceramics
and the Crafts Council Index of Selected Makers.

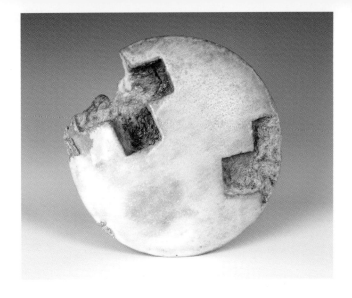

MATTHEW BLAKELY Fellow

9 Abbey Lane, Lode, Cambridge CB25 9EP
TEL 01223 811 959 EMAIL smashingpots@uk2.net WEB www.matthewblakely.co.uk
Visitors welcome by appointment

Of all the arts pottery is the most connected to and dependent on the physical nature of the planet we inhabit and the life that grows on it. My aim is to establish the link between ceramics and geology and place, making pieces that rely entirely on geological samples collected in specific sites that illustrate the qualities inherent in these materials.

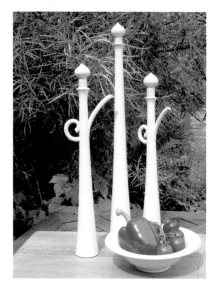

RICHARD BOSWELL

66 Wallington Shore Road, Fareham, Hampshire PO16 8SJ
TEL 01329 511 497 EMAIL richatwallington@yahoo.co.uk
Visitors welcome by appointment

I create hand-thrown earthenware flasks, bottles, and bowls. The tactile quality of the work is of great importance to me, and this satin white glaze, fired to 1117°C, is very satisfying to handle. Some pieces are very finely decorated with coloured clay inlay.

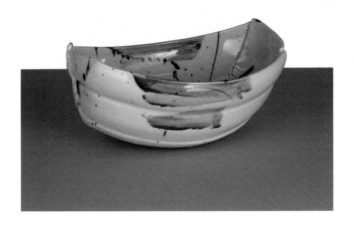

JOY BOSWORTH Fellow

Springbrook Lodge, Forge Lane, Blakedown, Worcestershire DY10 3JF
TEL 07779 221 678 **EMAIL** info@joybosworthceramics.com
WEB www.joybosworthceramics.com • Visitors welcome by appointment

The forms have developed from an investigation into vessels made
in different materials found in boatyards, industrial scrap yards, and
also baskets and other containers like fast food packaging. The pieces
are made from clay ribbons, extruded from self-cut die plates, which
are cut, then assembled with textured clay sheets, sometimes within
moulds. Slips and underglaze marks and splashes add surface interest.
They are glazed with a transparent glaze and fired to 1100°C. Joy has
written two books published by A&C Black, *Ceramics with Mixed Media*
(2006) and *Ceramic Jewellery* (2010).

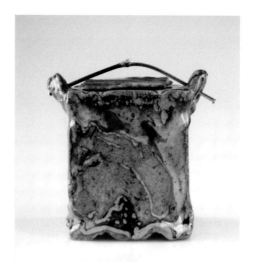

LIZ BOWE

5 Chapel Court, 20 Briggate, Knaresborough, North Yorkshire HG5 8PF
TEL 01423 863 493 EMAIL lizbowe@gmail.com
Visitors welcome by appointment

I produce stoneware intended for everyday use. The focus is on function, form, mark making, and surface. My work is particularly informed from several years spent under the mentorship of Vincent Potier. It is my intention to link traditional to contemporary practice, and while acknowledging the influence of ceramic history, I believe my work illustrates new growth based on solid foundations. Pieces combine throwing and handbuilding with several shino glazes used in combination to build several layers, achieving a variety of subtle variations in depth, tone, and surface quality. The work is fired to cone 9/10 through a reduction atmosphere.

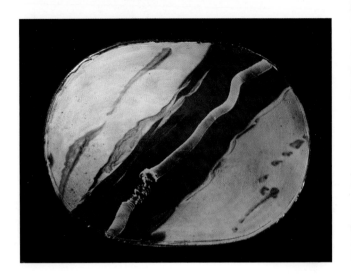

CLIVE BOWEN Fellow

Shebbear Pottery, Shebbear, Devon EX21 5QZ
TEL 01409 281 271 EMAIL rosiebowen@talktalk.net
Visitors welcome by appointment

Clive Bowen has been making wood-fired slipware at Shebbear since
1971. He started his own pottery after a four-year apprenticeship with
Michael Leach, and a year working as a production thrower at CH
Brannam Ltd. He originally studied painting at Cardiff. His work
ranges from small domestic pots to large individual pieces. He has
exhibited widely in the UK and around the world. His work is held in
numerous public collections.

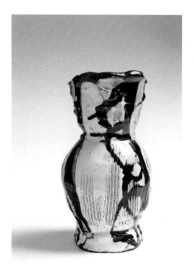

DYLAN BOWEN

The Old Smithy, 12 The Green, Tackley, Oxfordshire OX5 3AF
TEL 01869 331 278 EMAIL jdbowen@talktalk.net WEB www.dylanbowen.co.uk
Visitors welcome by appointment

Dylan Bowen trained at Shebbear Pottery with Clive Bowen and at
Camberwell School of Art, graduating in 1992. Dylan makes slip-
decorated earthenware using traditional materials. The work is
thrown, altered on the wheel, handbuilt, or carved. Slips are then
poured, trailed, and brushed on.

Dylan Bowen

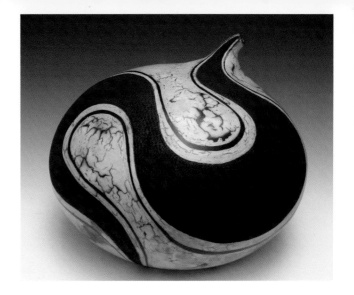

SHEILA BOYCE

Oak Villa, Lower Brynamman, Ammanford, Wales SA18 1SN
TEL 01269 826 942 EMAIL oncefired@aol.com WEB www.oncefired.co.uk
Visitors welcome by appointment

Deciding at forty-eight on a complete career change, I studied ceramics
and glass at university. Since then I have been producing quite large
burnished and smoke-fired sculptural forms from my home studio.
My imagination is triggered primarily by nature's spontaneous
designs, textures, and forms found around the beaches of the British
Isles, and from the invigorating feeling that I get wandering the
beaches in winter and spring. My work is shown regularly at selected
galleries and events nationally, and I have provided work for collections
in the US and Switzerland, as well as commissioned pieces for the
Arcadia Cruise Ship.

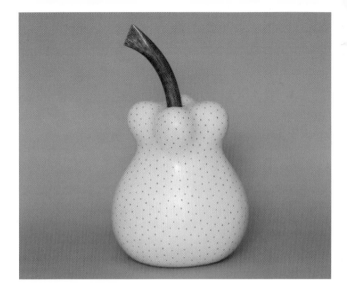

LORETTA BRAGANZA Fellow

The Coach House, 198 Mount Vale, York YO24 1DL
TEL 01904 630 454 EMAIL loretta@braganzas.freeserve.co.uk
WEB www.braganzaceramics.com • Visitors welcome by appointment

Trained in graphics with a fine art background, Loretta makes
handbuilt sculptural forms that exist in the natural and imagined
world. Images from the past are recreated in the present – exploring
the vibrancy of tropical colour, meditative quiet forms, and
surreal abstractions. Each handbuilt piece uses varied methods
of construction. Shapes are linked by deceptively simple surface
patterning using coloured slip and underglaze colours. Loretta has
work in public, corporate, and private collections in Britain and
abroad. These include Bupa, Baker & McKenzie, Aviva, Coopers &
Lybrand, Oldham Art Gallery, Cartwright Hall, and the Duke of
Devonshire's collection at Chatsworth House.

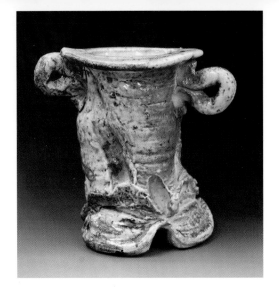

BEN BRIERLEY

25 Turner Avenue, Loughborough, Leicestershire LE11 2DA
TEL 01509 828 349 EMAIL benedict@supanet.com
WEB www.ben-brierley-woodfired-ceramics.co.uk • Visitors welcome by appointment

My ceramics are concerned with the malleability of material through making and firing. I endeavour to capture the softness of clay in the finished objects. Work revolves around concepts of functionality and is informed (among other things), by early animated films, such as *The Sorcerer's Apprentice*, where domestic utilitarian objects are anthropomorphised, taking on human gestures and interactions. All pieces are fired in wood-fired anagama kilns for three to five days, using the pyroplasticity, fly ash, and flame flashing of the firing to accentuate the softness and movement of the forms.

Benedict Brierley

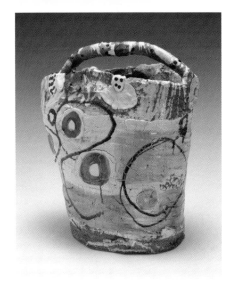

SANDY BROWN Fellow

3 Marine Parade, Appledore, Bideford, Devon EX39 1PJ
TEL 01237 478 219 EMAIL sandy@sandybrownarts.com WEB www.sandybrownarts.com
Visitors welcome by appointment

Trained in Daisei Pottery, Mashiko, Japan. Exhibits worldwide with
work in numerous public collections nationally and internationally.
Is a doodler. Likes working big, using colour, digging up mud and
messing about. Visual jazz. With squiggles splashes splats swishes
swooshes and squidges. Regularly invited to ceramic events worldwide
to lecture and demonstrate. Runs occasional courses around the world
called *Creativity is Play*. Does performance piece *Jump Touch Yellow* with
dancer Sue Way.

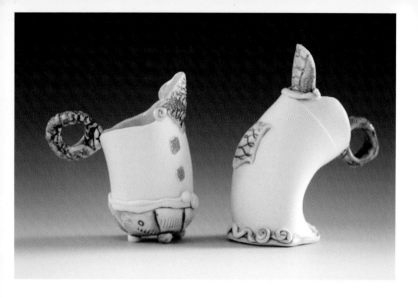

SUSAN BRUCE

4 Pinewood, Woodbridge, Suffolk IP12 4DS
TEL 01394 384 865 EMAIL susie.bruce1@btinternet.com
Visitors welcome by appointment

Having trained at Cheltenham and Lowestoft Colleges, then taught in London, Cambridge, and Colchester, I now live in Woodbridge, Suffolk. In 2000 Crowood Press published my first book, *The Art of Handbuilt Ceramics*. I retired in 2006 and since then have been making handbuilt porcelain. The work has areas of texture and applied clay. I use slabs or thrown clay, which are cut and re-assembled, then various slips and coloured glazes are applied. My inspiration comes from a fascination with armour and the way pieces are fitted together with studs. I love textiles and use scraps of fabric to texture the clay. Member of the Suffolk Craft Society.

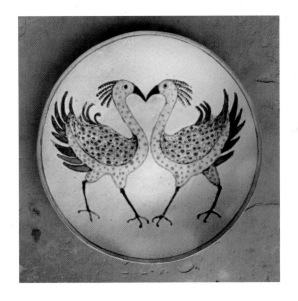

KIRSTI BÜHLER FATTORINI

5 Broadway Hale, Altrincham, Cheshire WA15 0PF
TEL 0161 980 4504 **EMAIL** kfattorini@hotmail.com **WEB** www.kirstifattorini.com
Visitors welcome by appointment

Educated in Switzerland, I studied painting and ceramics in Rome
and ceramics at Manchester College of Art. Married and in England,
I changed from earthenware to stoneware. I make plates and bowls
to use. Every item is different. I use coloured stoneware glazes, often
mixing them for special effects. My designs are drawn from nature,
animals, birds, fish, and flowers. I feel that pots are not just for
decorations, but should be used! The work is dishwasher and
oven friendly.

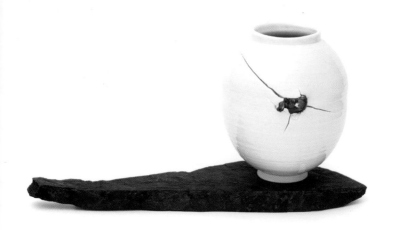

ADAM BUICK

The Studio, Llanferran, St Davids, Pembrokeshire SA62 6PN
TEL 07772 935 367 EMAIL adam@adambuick.com WEB www.adambuick.com
Visitors welcome by appointment

My work explores the human experience of landscape through a single jar form. By incorporating stone and locally dug clay into the jars I want to create a narrative that conveys a unique sense of place. The unpredictable nature of each jar comes from the inclusions, both in off-centering the throwing and the dramatic metamorphosis during firing. This individuality and tension between materials speaks of the human condition and how the landscape shapes our perception of the world around us.

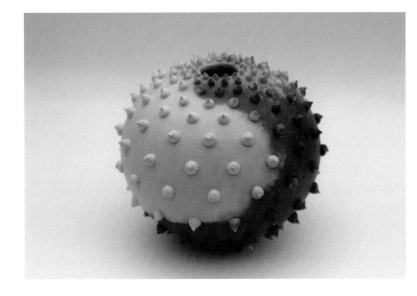

VANESSA BULLICK

The Barn, Torr Forret, Cupar, Fife KY15 4PY
EMAIL vanessabullick@yahoo.co.uk WEB www.vanessabullick.co.uk
Visitors welcome by appointment

Vanessa Bullick makes sawdust-fired, burnished, textured, and patterned pots. Influences are from natural form and pattern. Vanessa has been working as a potter since 1995, during which time she studied for a degree in sculpture at Edinburgh College of Art. She works from her studio in North East Fife.

V

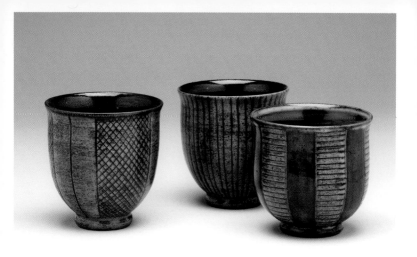

KAREN BUNTING Fellow

53 Beck Road, London E8 4RE
TEL 020 7249 3016 **EMAIL** bunting.all@btinternet.com **WEB** www.studiopottery.co.uk
Visitors welcome by appointment

I am drawn to that particular quality of stillness and sobriety that pots can have and aim to make pieces that are quiet and contemplative, revealing their qualities to the viewer over time and through use and handling. I make functional ceramics in reduced stoneware. Each piece is initially thrown, then individually worked and decorated. Stripes, spots, and cross-hatching help map out the surface and reveal aspects of the form. The reduction firing produces muted colours, which are often marked out with darker lines of patterning. The resulting pot is unique, but shares a family resemblance with its fellows.

 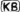

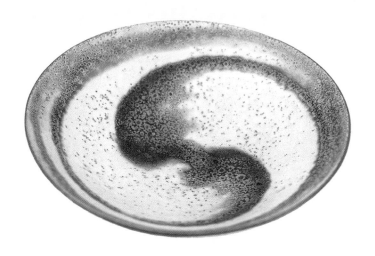

DEIRDRE BURNETT Fellow

48 Gipsy Hill, London SE19 1NL
TEL 020 8670 6565 EMAIL deirdreburnett@btinternet.com
Visitors welcome by appointment

Deirdre studied sculpture at St Martins School of Art, then ceramics at Camberwell School of Art, London. She makes individual vessel forms in oxidised stoneware and porcelain, which are mostly wheel-thrown, turned, and altered, although large floor-standing pieces are handbuilt. Volcanic, reactive, or colour surface qualities come from oxides and materials thrown or laminated in the body, or from slips and glazes that react to each other. All the glaze effects are controlled accidents, chemical reactions held fossilised by heat control. Work is in many private and public collections, including MoMA, New York; V&A, London; Museum Boymans-van Beuningen, Rotterdam; National Gallery of Victoria, Australia; The Sainsbury Collection, Norwich. On the Crafts Council Selected Makers Index.

DB

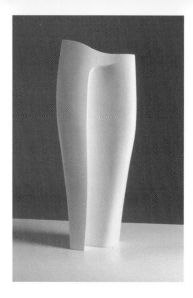

IAN BYERS Fellow

16 Stroud Road, London SE25 5DR
TEL 020 8654 0225 EMAIL ian.byers3@btinternet.com
Visitors welcome by appointment

My work has evolved from a figurative mode to a purely visual one.
The main focus of my work in the last ten years has been sculptural,
working with forms that can be read differently from several
viewpoints in space. Images have developed from the early figurative
concerns through to a preoccupation with underlying compositions.
In particular, I have been dealing with light and shadow, positive
and negative, as much as building forms. I feel that I have been
deconstructing and reconstructing pure form, allowing relationships
of structure and light to gather in new ways.

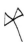

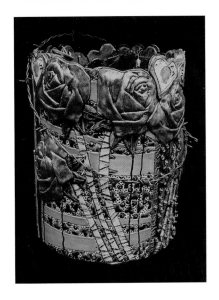

JAN BYRNE

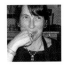

19 Rosslyn Rd, Bath BA1 3LQ
TEL 07789 200 735 EMAIL jan.byrne1@btinternet.com WEB www.janbyrne.net
Visitors welcome by appointment

My work is handbuilt with many layers of decoration. The pieces are becoming increasingly fine art in nature and represent my thoughts, feelings, or ideas, which often mirror events either personal to me or ones that are part of our collective experience.

Jan Byrne

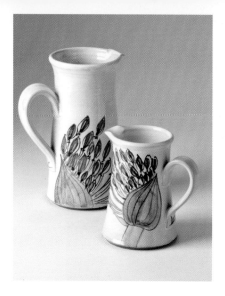

DAPHNE CARNEGY Fellow

Unit 30, Kingsgate Workshops, 110-116 Kingsgate Road, London NW6 2JG
TEL 020 8442 0337 **EMAIL** d.carnegy@tiscali.co.uk **WEB** www.daphnecarnegy.com
Visitors welcome by appointment

The attraction of maiolica for me lies in its unique qualities – a softness, depth, and luminosity of glaze and colour, the transformation of the pigments in the firing, and the variations of intensity and texture of the pigments. I make a range of thrown and painted tin-glazed earthenware, combining an awareness of historical precedents with my passion for plants. I use a broad colour palette, but also enjoy working with a more limited palette – often just shades of blue or black. My new book, *Maiolica*, has recently been published by A&C Black.

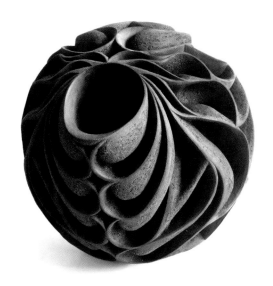

HALIMA CASSELL *Fellow*

155 Lammack Road, Blackburn, Lancashire BB1 8LA
TEL 07817 053 308 **EMAIL** info@halimacassell.com **WEB** www.halimacassell.com
Visitors welcome by appointment

Combining geometric elements with strong, recurrent patterns and architectural principles, my work utilises definite lines and dramatic angles in an attempt to manifest the universal language of number and create an unsettling sense of movement. This particular approach is the culmination of influences drawn from my passions for the recurrent use of pattern in African art and the architecture and spirituality associated with Islamic art. I hand carve my pieces in heavily grogged clay using relatively thick surfaces to carve to my desired depth. The form remains simple in order to maximise the impact of its complex surface pattern, combined with strongly contrasting contours.

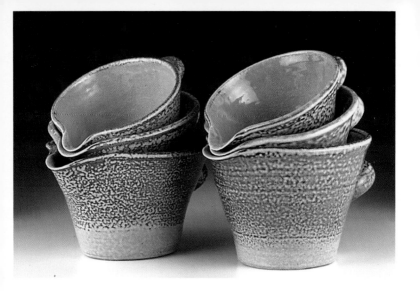

SHEILA CASSON Honorary Fellow

Wobage Farm, Upton Bishop, Ross-on-Wye, Herefordshire HR9 7QP
TEL 01989 780 233
Showroom open Mar-Dec, Sat & Sun, 10am-5pm; at all other times please phone first

I was born in 1930. I make thrown, salt-glazed, domestic stoneware, and intend to continue with the salt-glaze, alongside handbuilt vessel forms, which are fired to 1000°C prior to smoking in a sawdust kiln. I find the handbuilding very satisfactory because of the slower method of working, which allows me to concentrate on form. My inspiration for both the thrown and handbuilt pots comes from early Mediterranean wares.

MATTHEW CHAMBERS

43 Downsview Gardens, Wootten Bridge, Ryde, Isle of Wight PO33 4LS
TEL 07715 181 269 **EMAIL** info@matthewchambers.co.uk **WEB** matthewchambers.co.uk
Visitors welcome by appointment

My sculpture is born from the potter's wheel. Each piece is constructed of many sections that create a sculpture of complex, individual beauty with rhythm and symmetry. I am interested in the progression of the pattern and how it can evoke a different feeling and quality depending on the position of the flow. An early training in production ceramics gave me a passion for the making process and is still the driving force behind the creation of my sculpture. Then through my education, practice, and persistence I have developed a unique method that utilises the versatility of clay to its potential.

M. Chamb

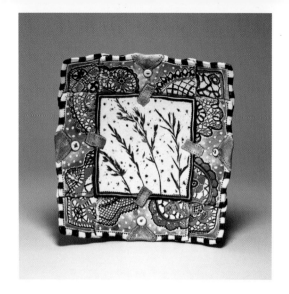

LINDA CHEW Fellow

42 Cheriton Road, Winchester, Hampshire SO22 5AY
TEL 01962 867 218 EMAIL chewceramics@yahoo.com
Visitors welcome by appointment

Linda lives and works in Winchester. She studied sculpture at
Cheltenham College of Art where she became fascinated with the tactile
properties of clay, enabling her to express her love of pattern and texture
in and around three-dimensional forms. Vintage textiles and her own
knitted and embroidered pieces, plus vegetation from the garden and
countryside, are used to impress delicate silhouettes into soft slabs of
porcelain and stoneware clays, which are then assembled to create dishes
and vases. The rich surface textures add to the impact on the senses,
reaching out and demanding to be touched and investigated.

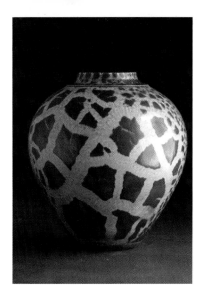

BRUCE CHIVERS

The School House, Dunsford, Exeter, Devon EX6 7DD
TEL 01647 252 099 EMAIL bruce.chivers@southdevon.ac.uk
WEB www.studiopotteryandsculpture.co.uk • Visitors welcome by appointment

Born and trained in Australia, Bruce Chivers moved to Devon in 1985. He produces individual, thrown pots in porcelain, utilising both high-fired and raku techniques. He divides his time between lecturing on the 3D design degree at South Devon College and working from his studio. His work is represented in public and private collections, and he exhibits throughout the UK, Europe, US, and Japan.

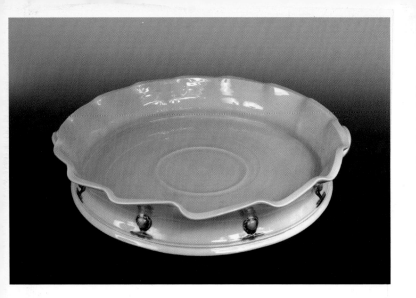

KEVIN DE CHOISY Fellow

50 Bove Town, Glastonbury, Somerset BA6 8JE
TEL 01458 835 055 EMAIL glazed&confused@talktalk.net
Visitors welcome by appointment

Born in 1954, Kevin attended Harrow during the 'Golden Years' of the early 1970s before travelling extensively. He lived and worked in the US as a production thrower and designer for industry for many years. He now lives in Somerset and makes a range of functional pots in polychrome earthenware and porcelain with Song celadon glazes.

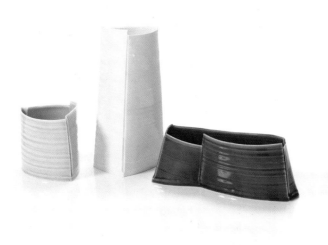

CARINA CISCATO Fellow

Unit 7c Vanguard Court, 36-38 Peckham Road, London SE5 8QT
TEL 020 7701 2940 **EMAIL** studio@carinaciscato.co.uk **WEB** www.carinaciscato.co.uk
Visitors welcome by appointment

Space, volume, and architecture...
It's partly sensorial and partly an ideal aesthetics.
It's relative, irregular, and fragile.
This new work is about a search for an unconventional balance,
reconstructing forms and creating objects with a quality that solicits the
expansion of sensorial information, becoming tactile and unpredictable.
Each pot is totally unique with its own personality, which cannot be
reproduced. However, it does belong to a family of pots that share
similar characteristics. They are content to be perfectly imperfect.

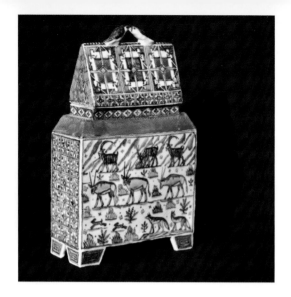

RUSSELL COATES Fellow

The Haven, Gare Hill Road, nr Witham Friary, Frome, Somerset BA11 5EX
TEL 07745 477 135 EMAIL russell.coates@yahoo.co.uk WEB www.russellcoates.co.uk
Visitors are welcome at the showroom; please phone first

I make underglaze blue enamelled porcelain in the style of Kutani ware, which I studied in Japan under the direction of master potter Prof Fujio Kitade. I start the decoration with a charcoal pattern transfer to get any geometric design onto the biscuit pot, then draw out the birds, animals, and sea creatures freehand. These are painted in underglaze blue. The pot is clear glazed and fired to 1270°C. The enamels are added into the spaces, after which there is a third firing to 840°C. I was commissioned to make ceramic wall pieces for the P&O liner Aurora Medina restaurant, and the Spode factory have reproduced some of my designs.

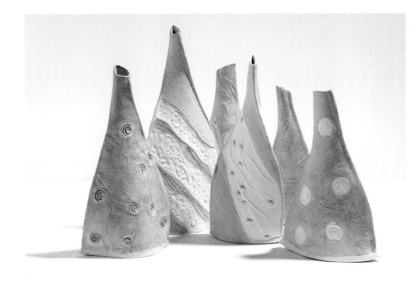

ROSEMARY COCHRANE

76 Mill Street, Usk, Monmouthshire NP15 1AW
TEL 01291 671 567 EMAIL rc@rosemarycochrane.co.uk WEB www.rosemarycochrane.co.uk
Visitors welcome by appointment

After a lifetime making salt-glazed functional ware, I have moved from stoneware clay and salt firings to explore the malleable and delicate qualities of paperclay and electric kiln earthenware firings. During an inspirational collaboration with an embroiderer, I found forms that combine a liberation from function with a delight in translating the textures of embroidered textiles into ceramics. Landscapes and the natural world continue to inspire me and no doubt functional pieces will return alongside the more abstract work. Author of *Salt-Glaze Ceramics*, published in 2002 by The Crowood Press and available from the author.

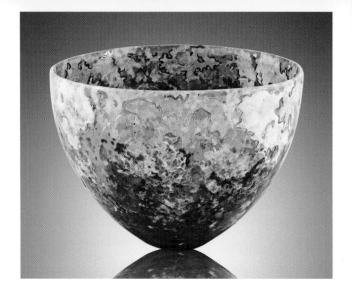

ROGER COCKRAM Fellow

Chittlehampton Pottery and Gallery, Chittlehampton, North Devon EX37 9PX
TEL 01769 540 420 EMAIL roger@rogercockram-ceramics.co.uk
WEB www.rogercockram-ceramics.co.uk • Visitors welcome by appointment

Roger Cockram studied at Harrow in the 1970s. For the first ten years he made wood-fired domestic ware. The work is now based on ideas derived from observations of natural water (movement, rhythms, colours, etc) and the life found in it. It is thrown, then altered, modelled, glazed, etc. There is also a small range of domestic stoneware. All the work is once-fired to cone 11. Roger sells through his own showroom, and at galleries and fairs in the UK and mainland Europe, and through exhibitions, commissions, and his website.

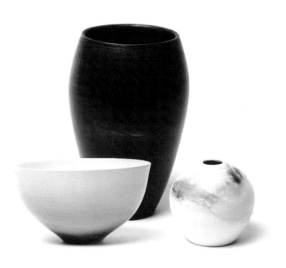

ELAINE COLES

73a High Street, Chobham, Surrey GU24 8AF
TEL 01276 856 769 EMAIL elaine@elainecoles.co.uk WEB www.elainecoles.co.uk
Visitors welcome by appointment

My current work is smoke-fired, porcelain, thrown on a wheel, then burnished. Layers of terra sigillata are applied and polished in between each layer, which gives the pot a high sheen. I fire in saggars and a raku kiln, leaving the smoke and flames to dance over the surface, creating unique marks. I find the combination of the smoke and clay fascinating as it gives my pots a sophistication through the use of what is a fundamental and primitive approach. Continuing my love of colour I also make traditional, glazed raku pieces, using a raku clay. I sometimes incorporate precious metal clay and gem stones.

Elaine Coles

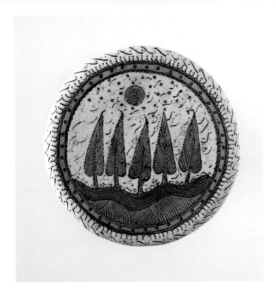

JENNIFER COLQUITT

Field Ceramics, c/o 14 Dibdale Road, Dudley, West Midlands DY1 2RU
TEL 01384 258 522 EMAIL jen@jen-and-petercolquitt.com
WEB www.jen-and-petercolquitt.com • Visitors welcome by appointment

My current work has evolved through combining texture with fine detail. I have always worked on a fine scale, using fine quality porcelain to make wall panels, dishes, brooches, and extruded forms. Subtle colour is achieved by using oxides and metallic lustres. Porcelain is a fascinating material to use because it combines fragility with great strength, as it must withstand high firing temperatures. The themes used have evolved over several years. The intensity in the work of Samuel Palmer has had a lifelong influence on me, as has observing and abstracting leaves and flowers.

Jennifer Colquitt
x

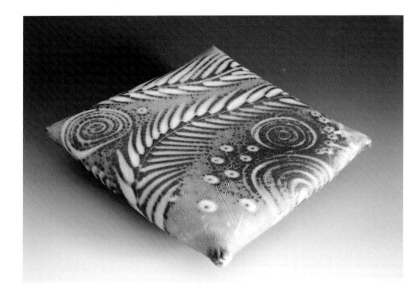

JO CONNELL

2 Harcourt Spinney, Market Bosworth, Nuneaton CV13 0LH
TEL 01455 292 678 EMAIL jo@jjconnell.co.uk WEB www.jjconnell.co.uk
Visitors welcome by appointment

I work experimentally with coloured clays that I layer, marble, and manipulate to make sculptural vessels and wall panels, sometimes combining mixed media. The clay surface is often highly textured, sometimes stretched and stressed, almost in the same way as geological forces affect the earth's crust. My inspiration comes from the natural world – land and seascape, rock strata, plant growth, patterns made by water, vibrant colour – and from an enjoyment in the working properties of clay itself. Author of *The Potter's Guide to Ceramic Surfaces* (Apple Press, 2002) and *Colouring Clay* (A&C Black, 2007).

JC

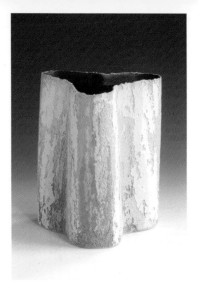

CLARE CONRAD Fellow

44 Watkin Terrace, Northampton, Northamptonshire NN1 3ER
TEL 01604 628 125 EMAIL clareconrad@hotmail.com WEB www.clareconradceramics.co.uk
Visitors welcome by appointment

I produce individual stoneware pots, distinctive for the painterly
exploration of colour and texture. The forms are wheel-thrown,
sometimes altered, in a high quality, coarse clay mix. My technique
of layering vitreous slips onto the exterior surface provides a rugged,
but refined texture to contrast with the satin-matt glaze inside.
Artistic inspiration comes from the effects of light and weathering on
architecture and artefacts, together with dramatic land and seascapes.
I began my experiments with vitreous slips while at Bristol (UWE), and
since graduating in 1987, I have exhibited widely throughout the UK
and abroad. The medium continues to fascinate and challenge.

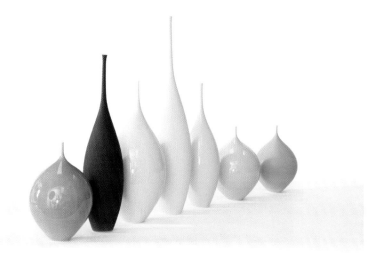

SOPHIE COOK

4 Dunstans Road, East Dulwich, London SE22 0HQ
TEL 07880 524 514 EMAIL sophie@sophiecook.com WEB www.sophiecook.com
Visitors welcome by appointment

Sophie Cook's porcelain pod, teardrop, and bottle vessels are supremely elegant. With the focus entirely on colour and form, they make a striking statement either on their own, or with different shapes mixed together. Her work can be seen in permanent collections worldwide, from the Geffrye Museum, London, to the Indianapolis Museum of Art, US. 'Sophie's work is a collector's dream. The more you own, the better it looks.' (Olivier Dupon, *The New Artisans*, 2011)

S C

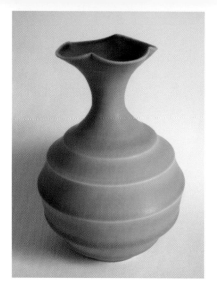

DELAN COOKSON Fellow

3 King George Memorial Walk, Phillack, Hayle, Cornwall TR27 5AA
TEL 01736 755 254 EMAIL delancookson@hotmail.com
Visitors welcome by appointment

Throwing has always appealed to me, and I enjoy the exploration of pure form. I work in porcelain because of its fine white structure – a canvas for delicacy and colour. I make bowls, bottles, and vases, each piece designed to stand alone or in a group. My main outlet is The New Craftsman Gallery, St Ives, Cornwall.

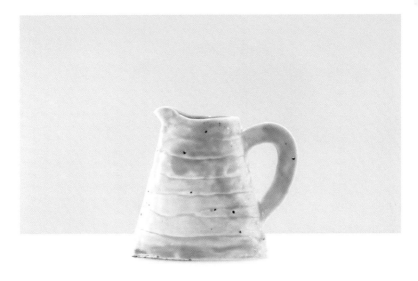

EMMANUEL COOPER Honorary Fellow

Fonthill Pottery, 38 Chalcot Road, London NW1 8LP
TEL 020 7722 9090

Individual pots, mostly in porcelain, including bowls and jug forms.
Glazes tend to be bright and rich and include turquoise blues and
greens, nickel pinks and blues, uranium yellow. All are fired to 1260°C
in an electric kiln. He has been making pots since 1965, and is the
former Editor of *Ceramic Review*. Recent exhibitions include Beaux
Arts, Bath; Millennium Gallery, Sheffield; and gallerytop, Derbyshire.
Author of *Ten Thousand Years of Pottery* (British Museum Press) and
Bernard Leach: Life and Work (Yale University Press). Emmanuel
Cooper's biography of Lucie Rie is due to be published in Spring 2012.

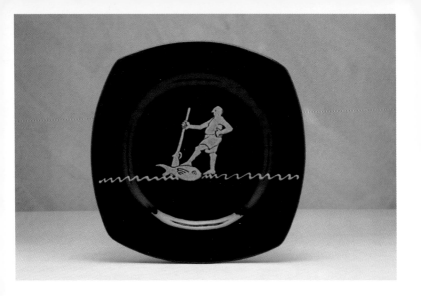

PRUE COOPER

Studio A208, Riverside Business Centre, Haldane Place, Wandsworth SW18 4UQ
TEL 020 8870 2680 **EMAIL** info@pruecooper.com **WEB** www.pruecooper.com
Visitors welcome by appointment

Prue Cooper trained as a painter in the 1960s, and spent twenty years
dealing in drawings before deciding to return to making things.
She makes press-moulded earthenware dishes, decorated with slips;
some are inscribed, the overall design of the dish echoing the sense of
the words. Slipware is an approachable medium, and a dish for food
implies sociability. They are meant to be used; they are glazed with
a food-safe glaze, and are dishwasher-proof and gently ovenproof.

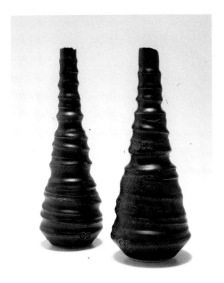

GILLES LE CORRE Fellow

19 Howard Street, Oxford OX4 3AY
TEL 01865 245 289 EMAIL elaine@lecorre5.wanadoo.co.uk WEB www.photostore.org.uk
Visitors welcome by appointment

I trained at Camberwell School of Art and Crafts, London. I am
fascinated by experimenting with high-fired glazes. My latest thrown
pieces and thin black bottles are the beginning of a totally new idea,
purposely textured and ribbed with the addition of a deep black
glaze obtained in a reduction atmosphere. Each bottle is part of a
larger group, which reflects on a forest of vessels. They bridge the gap
between sculpture and function, and give a sense of energy and poetry,
thus aiming to exploit the hypnotic potential of making repetitive and
playful forms.

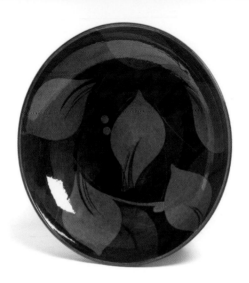

JANE COX Fellow

85 Wickham Road, Brockley, London SE4 1NH
TEL 020 8692 6742 **EMAIL** jane@janecoxceramics.com **WEB** www.janecoxceramics.com
Visitors welcome by appointment

Jane trained at Camberwell School of Art and the Royal College of Art,
London, and now pots from her studio in Brockley, South London.
She makes earthenware tableware and large statement dishes and
platters that combine bold elegant forms with energetic, striking
surface patterns. She uses slip decoration and sgraffito to painterly
effect through the use of coloured transparent glazes. Her work is
represented by Contemporary Applied Arts, Contemporary Ceramics,
Yorkshire Sculpture Park, and by a number of other Crafts Council
selected galleries. She has also exhibited in France, the Netherlands,
US, and Japan.

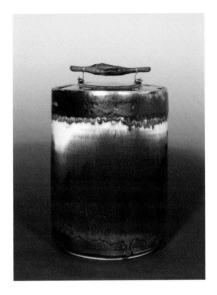

EDDIE CURTIS Fellow

Middle Rigg, Wearhead, Co Durham DL13 1HS
TEL 01388 537 379 EMAIL eddie@eddiecurtis.com WEB www.eddiecurtis.com
Visitors welcome by appointment

I work predominantly with celadons and copper reds – visual extremes of calm coolness and deeply visceral heat. Because I like to allow the firing to exert a certain unpredictability, I load my glazes thickly onto my works. I actively encourage natural glaze runs, streaks, variations of texture and colour.

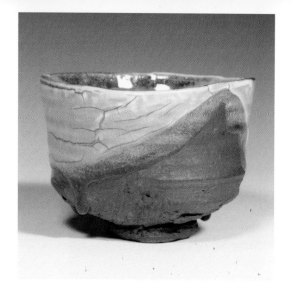

MARGARET CURTIS Fellow

Middle Rigg, Wearhead, Co Durham DL13 1HS
TEL 07816 865 043 EMAIL margaret@margaretcurtis.com WEB www.margaretcurtis.com
Visitors welcome by appointment

Currently, I like to take a very energetic approach to making my work, while venturing to instil a natural calmness into each piece. I endeavour to create a harmony between extreme materials, employing rough, dark, gritty clay combined with smooth, creamy porcelain slip. In February 2011 I was invited to become a Fellow of the CPA.

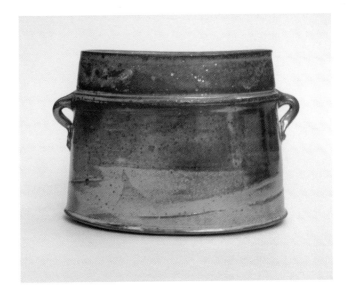

SYLVIA DALES

75/77 Melford Road, Sudbury, Suffolk CO10 1JT
TEL 01787 374 581 / 07773 182 138 EMAIL sylviadales@hotmail.co.uk
Visitors welcome by appointment

I trained at Harrow School of Art, London, and make functional pots for everyday use. I am influenced by classical forms from different cultures. The pots are thrown and sometimes altered. Recently, I've been experimenting with oval forms. I work with French stoneware clay, and exclusively with shino, ash, and celadon glazes, and explore and exploit carbon trapping and lustre. The work is fired in a reduction kiln to 1300°C.

Sylvia Dales

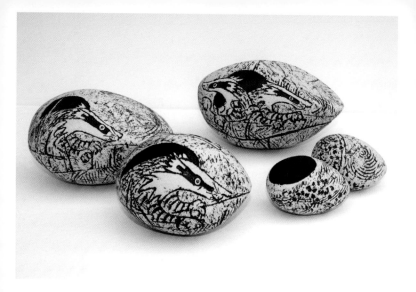

LOUISE DARBY

Clay Barn, Redhill, Alcester, Warwickshire B49 6NQ
TEL 01789 765 214 EMAIL louisedarby@louisedarby.co.uk WEB www.louisedarby.co.uk
Visitors welcome by appointment

A professional potter since 1978, Louise initially worked with the late Reg Moon at Torquil Pottery, Henley-in-Arden; since, at her own workshop near Stratford-upon-Avon. She is known for her finely thrown stoneware and porcelain, making the techniques of incising and carving very much her own. Cutting freehand or creating textures in leatherhard clay, she inlays with her satin-finish glazes after biscuit firing. In pleasing contrast to these animated pieces, there are those that are simply glazed. Craftsmanship, attention to detail, surprise and humour, and a sensitive balance between clay and glaze surfaces, make Louise's work pleasing to the hand and eye.

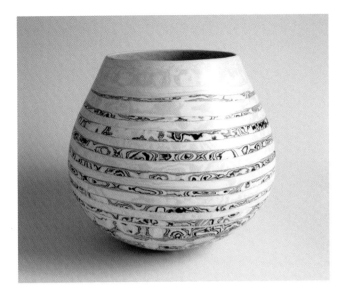

BEN DAVIES

17 Cecilia Road, London E8 2EP
TEL 020 7249 6519 **EMAIL** ben@bendaviesceramics.co.uk
WEB www.bendaviesceramics.co.uk • Visitors welcome by appointment

Inspired by my pottery teacher at school, I studied art at Foundation Level. I then took a degree in geography and geology before training as a professional cellist at the Royal Academy of Music. I returned to ceramics in my late 30s. Working from home and not having a kiln, I started making unglazed coiled pots using coloured and textured clays, employing burnishing techniques, and occasionally smoke-firing. My current work explores textures and patterns inspired by geology and landscape. I use a variety of handbuilding techniques to produce vessels, which I then sand and polish to achieve smooth tactile surfaces.

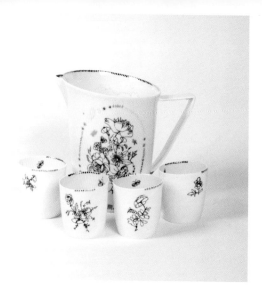

LOWRI DAVIES

Fireworks Clay Studios, 24 Tudor Lane, Riverside, Cardiff CF11 6AZ
TEL 07973 623 005 EMAIL lowri_davies@yahoo.com WEB www.lowridavies.com
Visitors welcome by appointment

Lowri Davies works in bone china to create vessels that are characterised by slanted coloured openings or soft burred edges. These works reference china displays and household accumulations that allude to a sense of place through a re-stimulation of iconography and symbolism that has a deep relationship with her own roots. Lowri graduated with a degree in ceramics from Cardiff School of Art in 2001 and a post-graduate degree in ceramic design from Staffordshire University in 2009. She was awarded the Gold Medal in Craft and Design at the National Eisteddfod of Wales in 2009, and is a current Creative Wales Award recipient (awarded by the Arts Council of Wales).

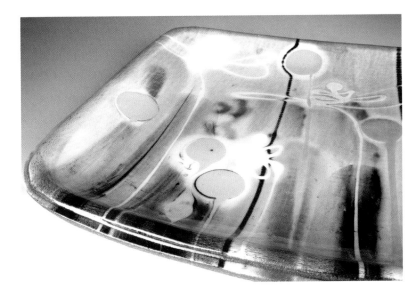

PATIA DAVIS

Wobage Farm Craft Workshops, Upton Bishop, Ross-on-Wye, Herefordshire HR9 7QP
TEL 01989 780 495 WEB www.workshops-at-wobage.co.uk
Open Thurs-Sun, 10am-5pm; at all other times please phone first. Closed Jan & Feb

There are two ranges of work: ash-glazed porcelain and slip-decorated earthenware. The porcelain's beauty accentuates the soft gentle forms I make; when throwing, I look for a 'sense of quiet'. My earthenware pieces often begin with the clay as the canvas – working slip wet into wet, layer upon layer of pours, drips, trails, feathering, and brush marks with intensity and speed. Yet it is carefully considered in response to the moment of process, new ideas, or to previous experience. After firing these plates, beakers, and dishes are transformed into three-dimensional paintings. I aim for a contemporary edge to a range of pots, with a deep respect for past tradition.

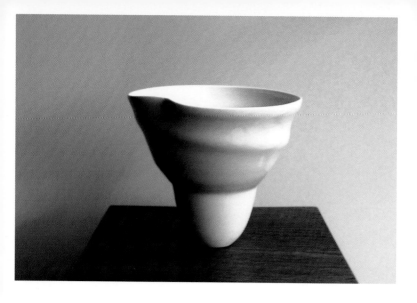

JOHN DAWSON

47 Heathwood Gardens, Charlton, London SE7 8ES
TEL 020 8316 1919 EMAIL john16749@btinternet.com WEB www.btinternet.com/~john16749
Visitors welcome by appointment

I trained initially as a musician at Trinity College of Music, London, studying the organ and harpsichord, and was drawn to the music of the Baroque period. Later I attended the very last ceramics course at Goldsmiths College (1992-1993), specialising in thrown porcelain. I make functional but decorative pieces, using either a black satin matt glaze or a simple celadon crackle glaze. My work has strong parallels with my music; a simple form is embellished or decorated to enhance the simplicity and the sense of movement within the form.

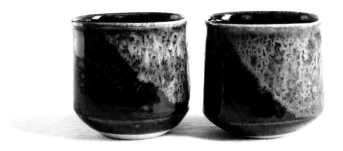

ISABEL K-J DENYER

Wighill House, Wighill, nr Tadcaster, North Yorkshire LS24 8BG
TEL 01937 835 632 EMAIL isapot@isabeldenyer.co.uk WEB www.studiopottery.co.uk
Visitors welcome by appointment

I love to know that my pots are being used and enjoyed on a daily basis as well as for special occasions. The sense of continuity and 'centredness' that I feel when throwing is a favourite part of the process of making my stoneware reduction fired pots. Decorative influences come from the stonemason's chisel marks on Yorkshire barns, the movement of water, and the 'Cintamani' three dot motif. I trained at Farnham School of Art and then on the Harrow Studio Pottery course in the 1960s, and have made pots ever since, both abroad, and from the 1980s, in North Yorkshire.

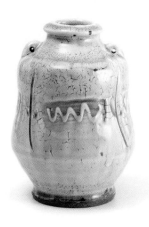

MIKE DODD Fellow

The Pottery, Dove Workshops, Barton Road, Butleigh, Glastonbury, Somerset BA6 8TL
TEL 01458 850 385 **EMAIL** mike@mikedoddpottery.com
Visitors welcome by appointment

I love the process of discovery, of letting go, of allowing one's aliveness its own unique play – it's fascinating to watch and to be absorbed by this relationship between disciplined technique and the free play of the heart. Reduction glazes, oil-fired – mostly unrefined natural glaze materials, e.g. granites, hornfels, basalt, ochre, various wood ashes, and local clays.

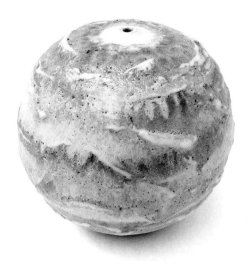

ROSALIE DODDS

14 Rugby Road, Brighton BN1 6EB
TEL 01273 501 743 **EMAIL** rosaliedodds14@hotmail.com **WEB** www.firewaysartists.com
Visitors welcome by appointment

My inspiration and ideas come from landscape, rocks, and stones.
I use various ways of making, sometimes combining thrown work and
handbuilding, then altering the form by squeezing and beating. I am
interested in surface texture, and use silicon carbide slips and oxides.
Glazes used mainly are a feldspathic white and a dry white, fired to
1240°C in an electric kiln.

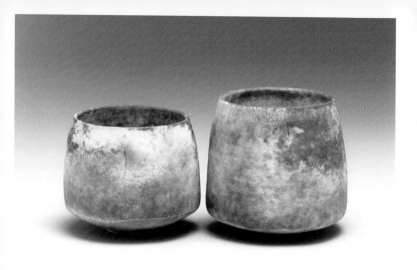

JACK DOHERTY Fellow

Leach Pottery, Higher Stennack, St Ives, Cornwall TR26 2HE
TEL 01736 799 703 EMAIL jack.doherty@virgin.net WEB www.dohertyporcelain.com
Visitors welcome by appointment

The ceramic forms that I love are the most fundamental pieces, and most of my recent work is based on just two. Vessels to drink from are surely among the most intimate objects that we use. We hold and caress them and touch them to our lips. They can add pleasure to routine daily moments or they can be part of a celebration. Bowls are elemental – I think they are forms for sharing, which at their best are open and generous. They can be tiny and fragile or rugged and monumental in scale. I use one clay, one colouring material, and a single firing, believing that focusing on a simple process can produce work of complexity and depth.

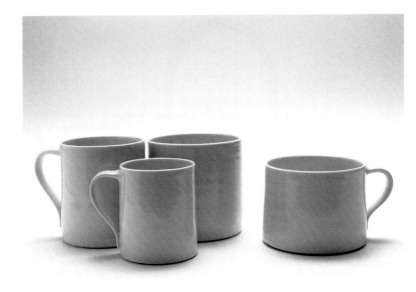

KAREN DOWNING

Richmond House, Gedgrave, Orford, Suffolk IP12 2BU
TEL 01394 450 313 EMAIL karen.downing@virgin.net

Karen Downing throws porcelain pots for use. Her choice of one material, a single glaze, and a limited vocabulary of form produce both unity and diversity as these elements combine into a multitude of subtle variations. After her BA at Georgetown University in Washington DC, she served apprenticeships with two potters in America and worked at Penland School of Crafts before coming to the UK in 1985. Living on the Suffolk coast, Karen finds many resonances of the landscape that have shaped both her aesthetic and her approach to the work. Her work is exhibited internationally, is included in many private collections, and is on the Crafts Council's Selected Makers Index.

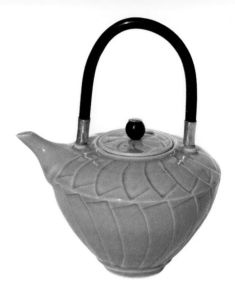

BRIDGET DRAKEFORD

Upper Buckenhill Farmhouse, Fownhope, Herefordshire HR1 4PU
TEL 01432 860 411 EMAIL bdrakeford@bdporcelain.co.uk WEB www.bdporcelain.co.uk
Visitors welcome by appointment

Porcelain, wheel-thrown Oriental inspired forms, specialising in celadon and copper red glazes. Well-established studio in beautiful Wye Valley. Exhibits widely in the UK and abroad. Award winner in Korea and Japan.

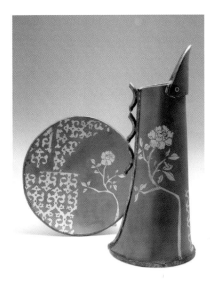

SARAH DUNSTAN

Gaolyard Studios, Dove Street, St Ives, Cornwall TR26 2LZ
TEL 07877 610 149 EMAIL sarahdunstanceramics@gmail.com
WEB www.sarahdunstan.co.uk • Visitors welcome by appointment

After graduating from Cardiff I moved to St Ives, where I established
my first pottery in 1993. For the past ten years I have worked from
the Gaolyard Studios. Using flat sheets of clay as a canvas, I paint
the surface with coloured slips, and then apply intricate fretwork
patterns, which are individually carved from a thin layer of porcelain.
The decorated sheets are assembled to create the finished form. Joins
are left as raw seams and the surface is treated to create the final
distinctive patina.

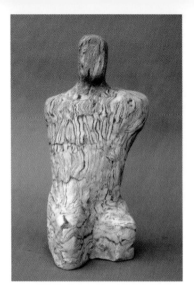

GEOFFREY EASTOP Fellow

The Old Post Office, Ecchinswell, Newbury, Berkshire RG20 4TT
TEL 01635 298 220 EMAIL geastop@talktalk.com
Visitors welcome by appointment

The main source of my ideas originates from the human form as often perceived in nature as a suggestion or implication. The mind supplies the conscious development from which the material expression is created. All my work is abstracted form, which to a degree acquires a symbolism that arises naturally without any deliberate intention. Work in public collections include: Victoria and Albert Museum, London; The Fitzwilliam Museum, Cambridge; and Ashmolean Museum, Oxford. Books include: *The Hollow Vessel*, Bohun Gallery (1980); *Geoffrey Eastop: A Potter in Practice*, Margot Coatts (1999), *John Piper: A memoir* (2011).

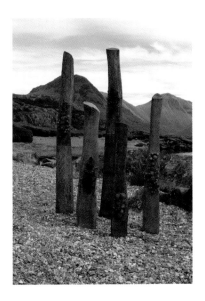

NIGEL EDMONDSON

Quaggs House Farm, Levens, Kendal, Cumbria LA8 8PA
TEL 01539 561 546 EMAIL nigel.libby@btinternet.com
WEB www.nigelandlibbyceramics.co.uk • Visitors welcome by appointment

Nigel Edmondson makes predominantly sculptural and/or functional work for the garden or conservatory. Much of the work incorporates landscape-based abstraction that reflects and responds to the Lakeland Fells, which lie on his doorstep and on which he enjoys walking. Craft-crank is used, fired to 1250°C in oxidation. Colour comes from oxides, coloured slips, and matt glazes.

FENELLA ELMS

Alma Cottage, Lottage Road, Aldbourne, Marlborough, Wiltshire SN8 2EB
TEL 0790 009 0790 EMAIL fenella@fenellaelms.com WEB www.fenellaelms.com
Visitors welcome by appointment

I am drawn to align small pieces, strips, and edges of porcelain clay into intricate structures and textures. The work builds with the connection of similar but separate parts and the interaction that comes about through placing in formation: shifting components form a co-operative body. In both sculptures and wall work, the parts are placed together onto a base-holding sheet of clay. All joined with slip, the work becomes one piece of clay, fired once in a bespoke electric kiln to 1260°+C, sometimes using a fine coat of translucent glaze for additional fixing.

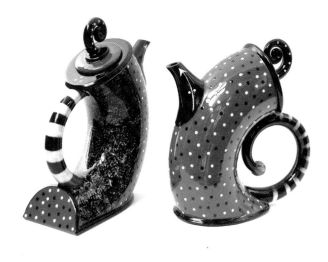

ROSS EMERSON

Old Trickey's Farm House, Blacksborough, Devon EX15 2HZ
TEL 01823 681 012 **EMAIL** ross@rossemerson.co.uk **WEB** www.rossemerson.co.uk
Visitors welcome by appointment

I make a range of handbuilt pieces in a red earthenware body,
decorated with a variety of coloured slips. I am interested in the playful
aspect of the pieces I produce. Mostly, these are represented as clocks,
as there are no rules other than the fact that they should tell the time.
I also make teapots, vases, and candlesticks. For me, the making
process is about fun and experimentation, both in methods of
production and decoration. The techniques used in handbuilding are
crucial to me as inventive tools that add to an individual quirkiness
for which my work is known. All my pieces are highly colourful and
finished under a transparent lead glaze.

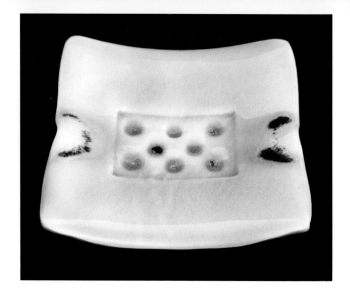

ANTJE ERNESTUS

Foundry Hill Cottage, Corpusty Road, Wood Dalling, nr Holt, Norfolk NR11 6SD
TEL 01263 587 672 EMAIL antje@gofast.co.uk WEB www.studiopottery.co.uk
Visitors welcome by appointment

Antje Ernestus makes platters, pots, vases, and wall pieces, both small
and larger in scale. She has been working with porcelain and high
temperature glazes, including celadon, wood ash, and copper reds,
since 2004. 'Working with materials, form, and firing is like speaking
in yet another language, with my hands. It is rich and complex, full of
questions, play, and challenges. It keeps me fascinated and reaching
out.' Originally from Germany, Antje studied at Camberwell College
of Arts, London. Work in private collections and galleries. Exhibits
throughout the UK; studio in North Norfolk.

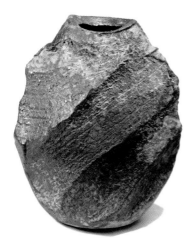

KATERINA EVANGELIDOU

Doras Green Cottage, Doras Green, Farnham, Surrey GU10 5DZ
TEL 01252 850 409 EMAIL katrina.ellerby@btinternet.com
Visitors welcome by appointment

Greek-born Katerina Evangelidou studied ceramics at the West Surrey College of Art and Design, Farnham. She established her studio in the mid-1980s in Farnham, Surrey, where she lives, works, and teaches. All the work is made on a kickwheel, where it is altered, reformed, wire-cut, and on occasions re-thrown. The forms echo ancient Cycladic and Archaic Greek sculpture, while the textures are reminiscent of the classical marble fragments of drapery. Wood-fired to 1300°C, with a small amount of salt introduced towards the end of the firing, wood ash and salt combine with the clay body and slips to give a distinctive surface.

ANNABEL FARADAY

6 Victoria Park Square, London E2 9PB
TEL 020 8980 4796 EMAIL annabel@bethnalgreen.biz WEB www.annabelfaraday.co.uk

I make individual, illustrated stoneware vessels that record the
richness of places in flux. From years of playful experimentation,
I have developed ways of printing maps, documents, and my own
photographs onto slip-painted raw clay using iron filings. The vessels
are handbuilt from the printed slabs, the forms retaining a simplicity
that provides a canvas for the richness of imagery, which appears on
both the inner and outer surfaces.

Annabel
Faraday

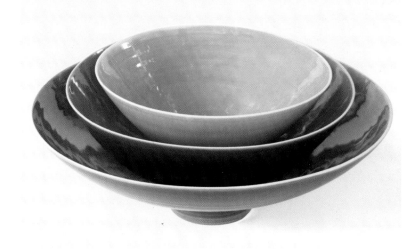

STANLEY FIELD

4 Arlington Road, Richmond, Surrey TW10 7BY
TEL 020 8940 1069 EMAIL stanleyfield@talktalk.net WEB www.stanleyfield.co.uk
Visitors welcome by appointment

I make functional pots, mostly from porcelain, all intended to be
used. Influenced by a love of English medieval ware, early Chinese
glazes, and my former career as a research scientist, my work is
characterised by simplicity of design, clarity, and restrained elegance.
The majority is wheel-thrown and fired either with electricity or gas
reduction, depending on a continuously expanding range of glazes.
The relationship between harmony and function and the quality of the
finished product are critically important to me. My work can be seen in
the Geffrye Museum, London, and the Paisley Museum and
Art Gallery.

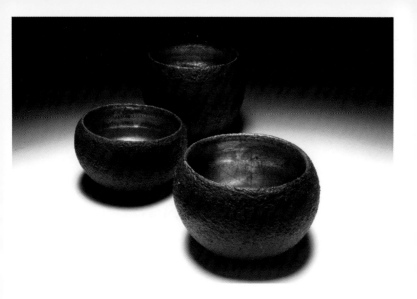

SOTIS FILIPPIDES

Sotis Studio Ceramics, Studio 1.17, OXO Tower, Barge House Street, London SE1 9PH
TEL 07733 151 276 EMAIL sotis@sotis.co.uk WEB www.sotis.co.uk
Gallery open Tues-Sat, 11am-6pm; at all other times by appointment

Since I was young I have loved the feel of things – the texture of sand and seashells, the surface of a stone – and it is these tactile memories from my childhood in Greece that I try to recapture. Each texture is the key to a bigger picture, carrying the same evocative power as a tune or scent. I try to put this sense of things remembered into each piece I make. I like to think that when you look at my work, when you pick it up and touch it, you might be reminded of a happy memory from your own past, even if it's just the faintest echo.

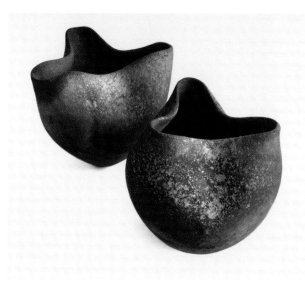

JUDITH FISHER

Huntswood House, St Helena Lane, Streat, nr Hassocks, Sussex BN6 8SD
TEL 01273 890 088
Visitors welcome by appointment

My current work consists of individual wheel-thrown and altered forms, fired by the raku process to produce unpredictable and exciting colours and textures from metallic glazes. In contrast, porcelain pieces are left unglazed and removed from the red-hot kiln to be rolled in animal hair. This burns and shrivels to create intriguing carbonised markings, which are absorbed into the body of the pot to become permanent. My work is always on display and for sale at the Sussex Guild's Shop and Gallery, North Wing, Southover Grange, Southover Road, Lewes, East Sussex BN7 1TP.

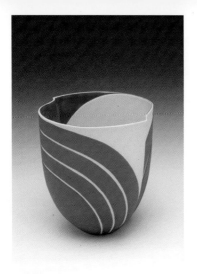

PENNY FOWLER

84 Middleton Road, Hackney, London E8 4LN
TEL 020 7254 2707 EMAIL penny.fowler@blueyonder.co.uk
WEB www.pennyfowlerceramics.co.uk • Visitors welcome by appointment

As a London-based potter my work reflects twenty-first-century living and the city in which I live. It is characterised by clean forms and precise lines drawn with a strong colour palette. I aim for a unity between form and decoration. I make bold simple sculptural vessel forms, layered and carved with contrasting coloured clays. Inspiration comes from my drawings of the urban landscape, the human body, and natural forms. I enjoy the challenge of exploring light, shade, translucency, and opacity through the interplay of the layers of colour and variety of line. My work is individually made using bone china or porcelain clays.

ALAN FOXLEY

26 Shepherds Way, Saffron Walden, Essex CB10 2AH
TEL 01799 522 631 EMAIL foxleyalan1@waitrose.com WEB www.studiopottery.co.uk
Visitors welcome by appointment

Trained at Corsham, a full-time potter from 1977 following a career teaching art in schools and ceramics in colleges, his current themes have evolved since 1997. All pieces are mainly coiled using Crank clay with the addition of porcelain, oxides, and matt glazes, then reduction fired to 1280°C, and in some cases, polished post-firing with abrasives. Ideas are developed from natural and man-made forms. Textures and the apparent effects of the elements and time upon the forms are of paramount importance in achieving a timeless contemplative feeling. Scales varies, but the work is generally large, and is principally suited to outdoor display.

ALAN FOXLEY

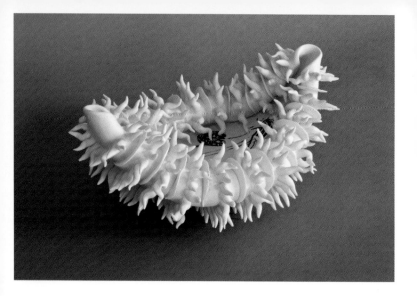

LORNA FRASER

WASPS Studios, Patriothall, Stockbridge, Edinburgh EH3 5AY
TEL 07884 352 711 EMAIL lornafraser@hotmail.co.uk WEB www.lornafraser.co.uk
Visitors welcome by appointment

The inspiration for my work comes from the plant world, where I take
elements from different parts of plants, particularly water lilies, to
create my own hybrids. I explore the sculptural quality of plants,
aiming to capture a sense of their vulnerability and sensuality.
The work is handbuilt using porcelain clay. I use a monochrome
palette to contrast translucent white and dense black porcelain and
have introduced printmaking techniques to add plant imagery as
surface decoration.

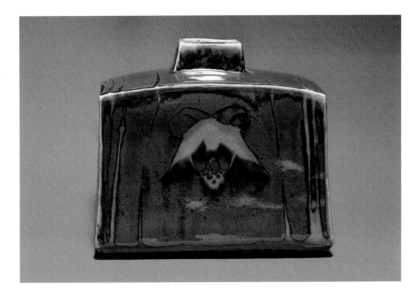

DAVID FRITH Fellow

Brookhouse Pottery, Brookhouse Lane, Denbigh, Denbighshire, Wales LL16 4RE
TEL 01745 812 805 EMAIL frith@brookhousepottery.co.uk
WEB www.brookhousepottery.co.uk • Visitors welcome by appointment

Born in 1943. The workshop was established in North Wales in 1963. My pots are wood-fired stoneware, mainly thrown or slabbed, and often on a large scale. I delight in making platters and bottles with altered forms by either squaring, faceting, or paddling the surfaces. I have many reduction glazes and use them in combination with ladle pouring, overglazing, wax motifs, and unglazed ashed surfaces. Fellow and past Vice Chairman of the CPA and Member of the Crafts Council Selected Index. Exhibited and worked abroad, especially Japan. Work in private and public collections at home and abroad.

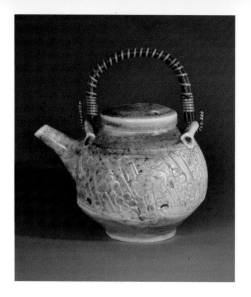

MARGARET FRITH Fellow

Brookhouse Pottery, Brookhouse Lane, Denbigh, Denbighshire, Wales LL16 4RE
TEL 01745 812 805 EMAIL frith@brookhousepottery.co.uk
WEB www.brookhousepottery.co.uk • Visitors welcome by appointment

Born 1943, and trained in Stoke-on-Trent with Derek Emms, I have
shared the workshop with David in Denbigh, North Wales, since
1963. My work is all wood-fired porcelain. Decorative techniques
include freely drawn brushwork with poured glazed areas and
ashed surfaces, or celadon glazes over carved motifs. I have worked
and exhibited abroad, especially Japan. Work in private and public
collections at home and abroad. Council Member CPA.

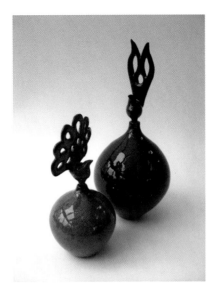

TESSA FUCHS Fellow

Trinity Cottage, Chediston, Halesworth, Suffolk IP19 0AT
TEL 01986 875 724 EMAIL tessafuchs@tiscali.co.uk WEB www.tessafuchs.co.uk
Visitors welcome by appointment

Born in Knutsford, Cheshire, studied at Salford Royal Technical College Art School and Central School of Arts and Crafts, London, Tessa set up studio as an individual artist-potter making sculptural pieces and some domestic ware in high-fired earthenware with colourful matt and glossy glazes. Her work is inspired by the natural world, particularly influenced by her travels, which have included China, Mexico, Africa, India, and Iceland. The work has an element of fantasy and humour. She is now painting larger than life colourful portraits and Suffolk landscapes in oils, and is potting part-time.

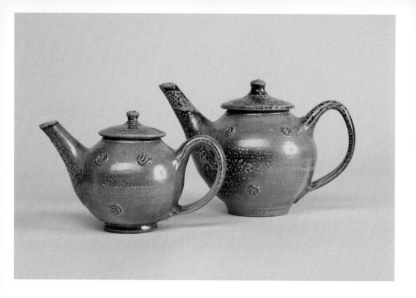

LIZ GALE Fellow

Taplands Farm Cottage, Webbs Green, Soberton, Southampton SO32 3PY
TEL 02392 632 686 EMAIL lizgale@interalpha.co.uk WEB www.lizgaleceramics.co.uk
Visitors welcome by appointment

I trained as a teacher specialising in textile arts and I taught in primary schools for ten years. I divided my time between teaching and ceramics and became a full-time potter in 1988. I moved into a purpose-built workshop and showroom in 1992. My early work focused on domestic reduction stoneware, decorated using latex sponge trailing and wax resist. I began salt-firing in 2001. My main source of inspiration is my enjoyment of food. I believe this should be combined with the good use of form and function. I became a Fellow of the Craft Potters Association in 1997 and was a Council Member for fifteen years. Currently I am Trustee and Secretary to the Craft Pottery Charitable Trust.

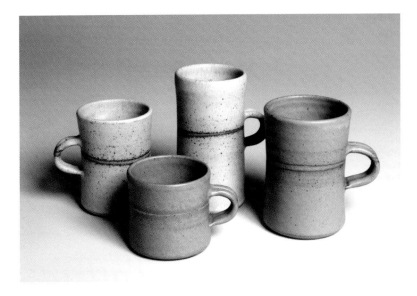

TONY GANT Fellow

53 Southdean Gardens, Southfield, London SW19 6NT
TEL 020 8789 4518 WEB www.tonygantpottery.com
Studio open Mon-Sat, 10am-5pm; please phone first

Tony Gant makes stoneware bowls, dishes, plates, jugs, mugs, and
vases. Established in 1961, he has been in his present studio since 1968.
He was a student of the late Gwilym Thomas at Hammersmith School
of Art, London.

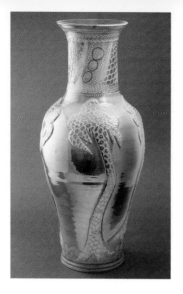

MARGARET GARDINER

Glebe House, Church Road, Great Hallingbury, Bishop's Stortford, Herts CM22 7TY
TEL 01279 654 025 EMAIL info@maggygardiner.com WEB www.maggygardiner.com
Visitors welcome by appointment

My current work is mainly porcelain, thrown on the wheel and slab-built, for both domestic use and visual enjoyment. Once I have designed the forms, I love playing with them as a palette for textural patterns and then choosing how to place them in the kiln for emphasis. The random element at this stage is very exciting, and the results, a constant motivator. I vapour-glaze with both salt and soda at 1300°C, then fume with stannous chloride to create random areas of lustrous iridescence.

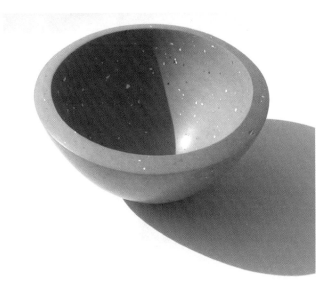

FRED GATLEY

Sir John Cass Department of Art, London Metropolitan University, Central House, Whitechapel High Street, London E1 7PF
TEL 020 7320 1912 **EMAIL** f.gatley@londonmet.ac.uk • Visitors welcome by appointment

There is a narrative within my most recent work that is concerned with various additions I have introduced into my bodies. These are items found on various walks, and they include silts, mud, broken bricks and china, and rusting flakes of iron, among other things. These impart meaning to my work on several levels. They may be seen simply as materials that make marks within the piece, they may reference the places where the objects were found, or they may speak of the found items themselves. Presented through the use of my signature polished finish, these additions reference their history and the places they have been found.

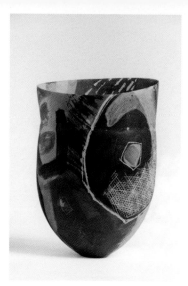

CAROLYN GENDERS Fellow

Oak Farm, Lewes Road, Danehill, East Sussex RH17 7HD
TEL 01825 790 575 EMAIL cgenders@btinternet.com WEB www.carolyngenders.co.uk
Visitors welcome by appointment

Carolyn Genders is well known for her individual pieces in white
earthenware with vitreous slip or burnished surfaces. Carolyn
trained at Brighton and Goldsmiths College, London. She exhibits
internationally and her work is represented widely in private and
public collections, including Cologne Museum, Brighton & Hove
Museum, and The Potteries Museum, Stoke-on-Trent. She is happy
to give lectures and demonstrations. Author of *Sources of Inspiration*
(2002) and *Pattern, Colour & Form* (2009), both published by A&C Black.

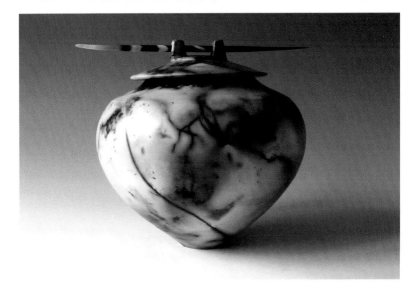

CHRISTINE GITTINS

Model House, Bull Ring, Llantrisant, Mid Glamorgan CF72 8EB
TEL 07768 736 166 EMAIL christinegittins@aol.com WEB www.christinegittins.com
Visitors welcome by appointment

My work is concerned with the simplicity or complexity of form created on the potter's wheel. At present I am exploring the effects of altering and adjusting the balance of the vessels, pushing boundaries as far as I can without upsetting stability. Surfaces are burnished and left for the fire to create colour and markings on the smooth receptive skin of the vessels. This is mostly done in a saggar inside a gas-fired raku kiln using salt, copper, and sawdust. Inspiration comes from my love for classical concepts of beauty, continuous links to my African roots, and the pure joy of clay as a medium of expression.

RICHARD GODFREY Fellow

1 Battisborough Cross, Devon PL8 1JT
TEL 01752 830 457 **EMAIL** rg@richardgodfreyceramics.co.uk
WEB www. richardgodfreyceramics.co.uk • Visitors welcome by appointment

I trained at Bristol Art College, graduating in 1972. My work is a mixture of both thrown and handbuilt forms. I use a white earthenware body made from Devon ball clays, decorated with my own range of coloured slips and glazes. The inspiration for my forms and decoration comes from the beautiful coastline and countryside around my studio. I am currently making a series of sculptural pieces glazed with local minerals, inspired by the cliffs and coastline. I sell my work throughout Europe, and have been guest demonstrator at many international events and seminars. For more information, visit my website.

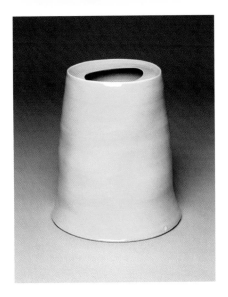

TANYA GOMEZ

74 Winterbourne Close, Lewes, East Sussex BN7 1JZ
TEL 07903 818 093 EMAIL tgceramic@yahoo.co.uk WEB www.tgceramics.co.uk
Visitors welcome by appointment

My work looks at large thrown vessels; the pieces are thrown in
parts and assembled to produce larger surfaces that are animated
through throwing and glazing. Working in porcelain, I use a range of
approaches in my throwing to create forms that will capture qualities
of fluidity, movement, and provide a sense of space. I make these works
conscious of natural phenomena and dramatic landscapes, absorbing
colour, shape, and the diverse qualities of the sea. I have also always
lived by the sea and have a studio on the south coast. All of these
influences inspire my work.

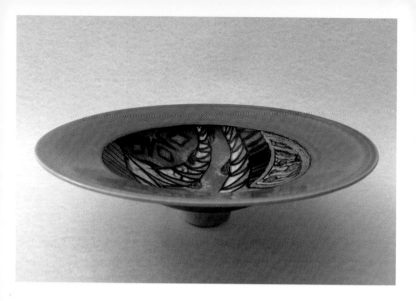

CHRISTOPHER GREEN Fellow

PO Box 115, Bristol BS9 3ND
TEL 0117 950 0852 EMAIL cguk@seegreen.com WEB www.glazecalc.com
Visitors welcome by appointment

Christopher Green formulates his own porcelain body to make
plates, bowls, and small sculptures, which are then fired to 1300°C
in a reduction atmosphere. He was born and educated in Zimbabwe,
trained in South Africa in the early 1970s, and then at Goldsmiths
College, London, in the early 1980s. He has developed software for
glaze formulation, which can be downloaded from
www.glazecalc.com.

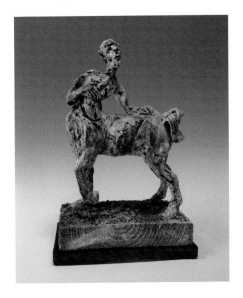

IAN GREGORY Honorary Fellow

Crumble Cottage, Ansty, Dorchester, Dorset DT2 7PN
TEL 01258 880 891 EMAIL ian@ian-gregory.co.uk WEB www.ian-gregory.co.uk
Visitors welcome by appointment

Figurative sculpture in clay and bronze.

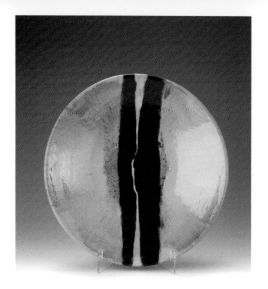

JAMES HAKE

Plough Barn, Kirkby Lonsdale Road, Over Kellet, Lancashire LA6 1DA
TEL 07769 945 487 EMAIL jms_hake@yahoo.co.uk WEB www.jameshake.co.uk
Visitors welcome by appointment

James makes wheel-thrown stoneware ceramics decorated with
Oriental glazes. His work ranges from huge platters to tiny delicate
bowls and lidded jars. At the wheel he makes work in a series,
producing families of similar forms, each with subtle variations.
Glazes are applied quickly by dipping, pouring, or brushing in different
combinations. During the firings, the glazes run and fuse together
to produce fluid, dynamic surfaces that complement the thrown
forms. James is currently developing a new range of glazes using local
materials from quarries, clay seams, and wood ashes.

JH

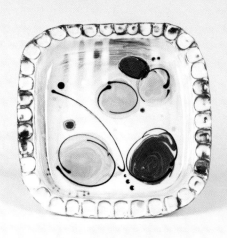

JENNIFER HALL

Spring Gardens, Llanwrthwl, Llandrindod Wells, Powys, Wales
TEL 01597 810 119 EMAIL jennythepotter@hotmail.com
Visitors welcome by appointment

Jennifer's ongoing aim is to develop a comprehensive range of pots that would enliven the daily rituals of taking nourishment. Her pots do not challenge, but comfort and enrich food times. Jennifer's studio is near Rhayader in mid-Wales. She pots on her kickwheel, making slip-decorated earthenware for oven and table use, with a softness of edge and warmth of colour.

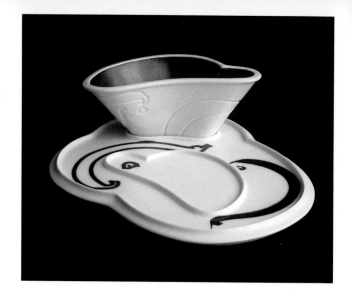

MORGEN HALL Fellow

Chapter Arts Centre, Market Road, Canton, Cardiff CF5 1QE
TEL 02920 238 716 EMAIL morgen@morgenhall.co.uk WEB www.morgenhall.com
Visitors welcome by appointment

I make a wide range of domestic tableware for everyday use, including *Tea Cabaret Sets*, *Spaghetti Jars*, and *Vegetable Tureens*. The pots are a celebration of food, with surface patterns and forms derived from the food itself. Most of the tableware is wheel-thrown and turned, from tin-glazed red earthenware, and decorated with cobalt slip. I am also now using CAD-CAM to make a small range of porcelain tableware on my ram press, like the *French Bean Terrine Dish* and *Plate* set shown here. The ram pressed pots have individually embossed and printed stencil patterns. Further details available on my website.

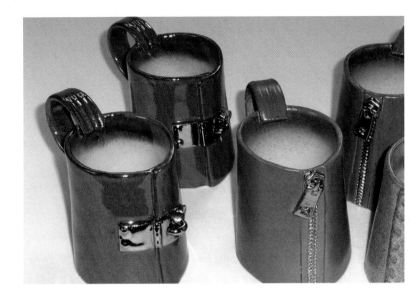

JANET HALLIGAN

The Old School, Church Minshull, Nantwich, Cheshire CW5 6EA
TEL 01270 522 416 EMAIL info@janethalligan-ceramics.co.uk
WEB www.janethalligan-ceramics.co.uk • Visitors welcome by appointment

Janet makes *trompe l'oeil* sculpture and handbuilt vessels in stoneware. The sculptural pieces include bags, shoes, cardboard boxes full of items such as tools, sewing items, paint tubes, and larger pieces, such as sports bags or tool boxes. Recently she has embarked on a new range of sculptural work based on landscape. These were initially inspired by the Alpujarra Mountains in Southern Spain. She uses a wide range of stoneware glazes, together with oxides and low-fired metal lustres, which add to the realism of the *trompe l'oeil* pieces.

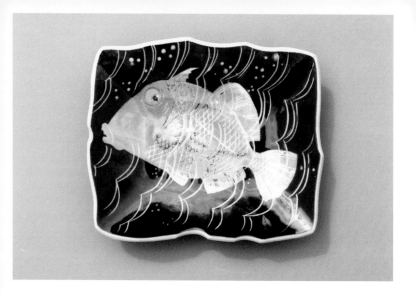

FRANK HAMER Honorary Fellow

Llwyn-On, Croes-yn-y-Pant, Mamhilad, Pontypool, South Wales NP4 8RE
TEL 01495 785 700 WEB www.pottersdictionary.com
Visitors welcome by appointment

I design and make press-moulded plates with fish for imagery.
The plates incorporate ceramics with my interests in drawing and
decoration. They should be read on four levels: as plates, as overall
decorative objects, as specific imagery, and as ceramic happenings.
The smooth glaze enlivening the coloured slip is to be enjoyed. Fish
shapes cut from newspaper provide resists for layers of slip. Details are
more slips, pigments, and sgraffito. I exaggerate body movement and
humanise the eyes, an anthropomorphic device used 3000 years ago in
the Middle East. Fish plates have a long pedigree!

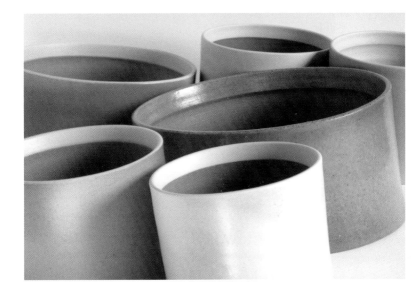

JANE HAMLYN Fellow

Millfield Pottery, Everton, nr Doncaster, South Yorkshire DN10 5DD
TEL 01777 817 723 EMAIL janehamlyn@saltglaze.fsnet.co.uk WEB www.saltglaze.fsnet.co.uk
Visitors welcome by appointment

Jane Hamlyn's *Empty Vessels*, related groups of contrasting form and
surface, have a formal abstract clarity and extend her familiar blue/
green salt-glazed palette to include rusts, ochres, and rich deep orange.
A full-time potter since 1975, she also continues to make functional
pots for use and ornament. Work in many public collections,
including the Crafts Council; Victoria and Albert Museum, London;
Princessehof Ceramic Museum, Netherlands; and the American
Museum of Ceramic Art, California.

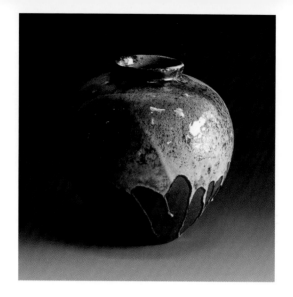

LISA HAMMOND Fellow

Kigbeare Studio Pottery, Kigbeare Manor, Southcott, Okehampton, Devon EX20 4NL
TEL 07912 497 690 **EMAIL** lisa@lisahammond-pottery.co.uk
WEB www.lisahammond-pottery.co.uk • Visitors welcome by appointment

For the last thirty years I have been making vapour-glazed pots, concentrating on producing functional high temperature soda-glazed pots for the preparation, cooking, and serving of food. Raw-glazing using slip and firing schedules gives the work its rich colour and texture. A range of work, *Soda Shino*, uses shino-type glazes soda-fired alongside the slipware pots. Inspired by Japanese Mino, my mission is not to mimic, but to find my individual voice. I have lectured and exhibited widely, and my work is represented in collections both in the UK and abroad, including Japan, Korea, and the US. I am Deputy Chair of the CPA, and founded the Adopt a Potter Charitable Trust. (Alternative address: Maze Hill Pottery, The Old Ticket Office, Woodlands Park Road, Greenwich, London SE10 9XE / 020 8293 0048)

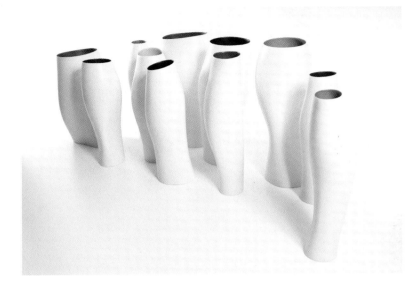

ASHRAF HANNA Fellow

Pen-y-Daith, Chapel Lane, Keeston, Haverfordwest, Pembrokeshire, Wales SA62 6EH
TEL 01437 710 774 EMAIL ashrafhanna.ceramics@btinternet.com
WEB www.ashrafhanna.net

My work is concerned with exploring form through scale, colour, texture. These elements inform our perception and understanding of objects. Scale and the space an object occupies have a significant role in determining our relationship with it. Colour, whether bright, soft, or intense, has a powerful effect in defining its character. Texture invites us to touch and to examine the tactile qualities of the surface, influencing our ability to read and comprehend it. I am interested in the lines and spaces that develop through both the manipulation of the volume within the forms and their relationship to one another.

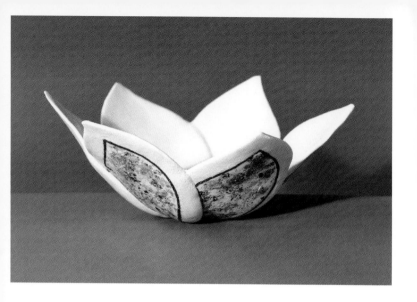

KEIKO HARADA

Park Lea, 36 West Park Crescent, Roundhay, Leeds LS8 2EQ
TEL 01132 663 462 EMAIL keiko17@ntlworld.com
Visitors welcome by appointment

Originally from Japan, I obtained the degree of BA Art and Design
at Leeds Metropolitan University in 1999. Oriental influences are
strong in my clay work, which springs from my long involvement
with Japanese calligraphy and textiles. I express my feeling for nature
and the human spirit in an abstract way, using calligraphy brushes
to emphasise the spontaneous movement of line. I am interested in
photography as well, mainly landscape and nature. My pieces have
been selected for international ceramics competitions: Fletcher
challenge in New Zealand; Mashiko and Mino in Japan. I have been
invited to workshops and symposia held in Serbia, Japan, Slovenia,
Turkey, and Latvia.

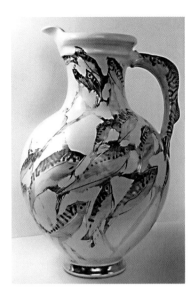

BILL AND BARBARA HAWKINS Fellow

Port Isaac Pottery, Roscarrock Hill, Port Isaac, Cornwall PL29 3RG
TEL 01208 880 625 EMAIL portisaacpottery@btconnect.com
Open throughout the year; Summer, 10am-5pm; Winter, Thurs-Sun only, 10am-4pm

All of our pieces are hand-thrown stoneware ceramics made to the highest standards. Precious metal lustres and gold are applied and each piece has at least three firings in both our electric and gas-fired kilns. The bold and elegant forms complement the watercolour-style decoration, which is often inspired by the rugged North Atlantic coastline, which is on our doorstep. Our gallery is situated in a beautiful old Methodist chapel in the picturesque fishing village of Port Isaac. We also make and sell porcelain jewellery and paintings. We have been joined in recent years by our daughter, Faye, who also makes and sells pottery.

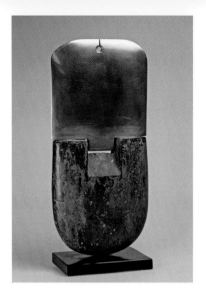

PETER HAYES Fellow

2 Cleveland Bridge, Bath BA1 5DH
TEL 01225 466 215 **EMAIL** peter@peterhayes-ceramics.uk.com
WEB www.peterhayes-ceramics.uk.com • Visitors welcome by appointment

Over the past few years I have spent time travelling again. I have
visited New Zealand, Australia, Egypt, and India. I have worked with
the indigenous craftsmen, who with their incredible knowledge of
craftsmanship, using the most basic materials and tools, create the
most remarkable art. These experiences are inspiring me to create a
new body of work.

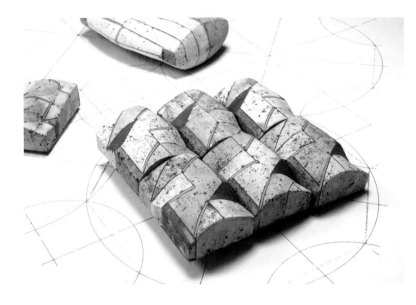

REGINA HEINZ Fellow

Studio A 208, Riverside Business Centre, Bendon Valley, London SW18 4UQ
TEL 07779 167 229 EMAIL regina_heinz@ceramart.net WEB www.ceramart.net
Visitors welcome by appointment

Regina Heinz is an award-winning ceramic artist, well known for her abstract 'pillow-shaped' ceramics, which are sold to private buyers, museums, and hotels. Constructed from soft slabs of clay and precisely decorated with brushed layers of matt glazes, oxides, and stains, her work is a unique combination of sculpture and painting. Regina says: 'My inspiration comes from nature, the gentle movement of water and abstract painting. I want my work to be sensual, tactile, and gorgeous to look at.' Regina's free-standing and wall-based sculptures have been bought by the National Art Collectors Fund and are included in private and public collections around the world.

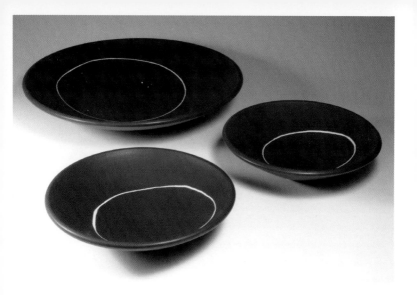

RICK HENHAM

Gaolyard Studios, Dove Street, St Ives, Cornwall TR26 2LZ
TEL 07880 794 544 EMAIL info@rickhenham.com WEB www.rickhenham.com
Visitors welcome by appointment

Shapes honed to a completely smooth finish suit best the feeling I aim
to instil in this work, while creating items that are spare and minimal.
These are mainly comprised of black and white bowls and vases in
thrown stoneware with a simple motif cut into the glaze. I trained on
the Harrow course 1993-96, and set up studio at the Chocolate Factory
in Hackney, London, where I worked for several years before moving to
Cornwall. I have been based at Gaolyard Studios in St Ives since then.

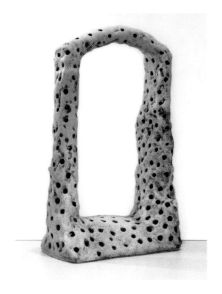

ANDRE HESS Fellow

32 Seaman Close, St Albans, Hertfordshire AL2 2NX
TEL 01727 874 299 **EMAIL** andre_hess@btinternet.com
Visitors welcome by appointment

Andre Hess's abstracted and elusive shapes require the viewer to question what the pieces mean, rather than what they resemble or represent. The work is simultaneously familiar and fugitive, and always evocative. The sizes vary from private and domestic to large public pieces. He uses any technique, traditional or otherwise, the handling of the raw clay significantly informing the meaning of the work. Surface treatments only qualify what is already there at the raw stage, achieved using slips, oxides, frits, and glazes, and fired using gas, electricity, or both. A CPA Fellow since 1995, he has received several awards, including the Fletcher Challenge (New Zealand), the South African Ceramics Biennale, and the World Ceramics Competition (South Korea).

KARIN HESSENBERG Fellow

72 Broomgrove Road, Sheffield S10 2NA
TEL 0114 266 1610 **EMAIL** mail@karinhessenberg.co.uk **WEB** www.karinhessenberg.co.uk
Visitors welcome by appointment

I make large-scale handbuilt ceramic sculptures and ornaments for gardens. Recently I have been developing my figurative sculptures as pieces in their own right, drawing on my range of ceramic techniques and processes to create them. Some of the sculptures include imaginative representations from card games or chess, while others may represent *The Four Seasons* or *The Four Elements*. My work is made in high-fired Craft Crank stoneware clay with matt glazes. Techniques include freehand modelling, slab building, and some coiling. All the work is raw-glazed and fired to 1260°C in oxidation.

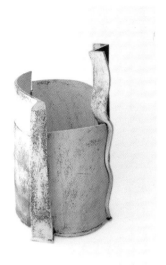

JOHN HIGGINS Fellow

32 Seaman Close, Park Street, St Albans, Hertfordshire AL2 2NX
TEL 01727 874 299 EMAIL johnceramics@aol.com WEB www.studiopottery.co.uk
Visitors welcome by appointment

Ceramics, in all its guises, continues to be a passion sustained throughout John's working life. Working in series, with references to architecture, painting, archaeology, and everyday objects, the surface qualities of the work usually have a common theme and imagery, though the forms may change. A format is decided, but room is always allowed for spontaneous and expressive handling of the medium through slab-formed or thrown elements. The clay is heavily grogged to withstand the unusual methods of making, and the surfaces are treated with slips, stains, oxides, and underglaze colours. John always makes pots, but the results continually question and criticise our perception of pottery.

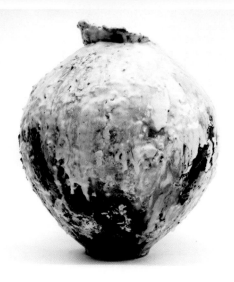

AKIKO HIRAI

Unit G3, The Chocolate Factory, Farleigh Place, London N16 7SX
TEL 07950 298 128 EMAIL akikohiraiceramics@hotmail.co.uk
WEB www.akikohiraiceramics.com • Visitors welcome by appointment

Akiko makes stoneware for domestic use. Included within this are utensils for the tea ceremony. Her work is influenced by the culture of her native Japan and aesthetic relativism. In this context it relates to the relationship between objects, environment, and users. It explains how the forms of her work create a sense of balance and comfort in the audience/user's eyes. Akiko's work often comes from short narratives/poems, which are written by herself. These add a contemporary element to the antiquity already present in her work.

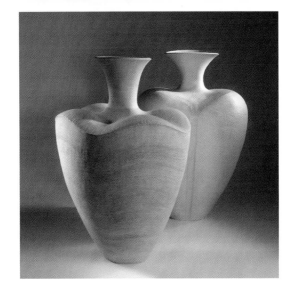

WENDY HOARE

135 Billing Road, Northampton NN1 5RR
TEL 01604 622 880 EMAIL wendyhoareceramics@tiscali.co.uk
WEB www.studiopottery.co.uk • Visitors welcome by appointment

Large scale, one-off sculptural pots, built with hand-rolled coils of clay – a feature for interior and exterior, domestic and commercial display. With a degree from Reading University in fine art, specialising in sculpture, life drawing, and a study of Greek ceramics, I learned to pot while teaching art. My pots are not functional, but are related to traditional vessel shapes, with ideas and details translated from the natural world. Textures are achieved through the building process, type of clay, and increasingly, deliberate planning. The muted colour range is a result of clay colour, texture, and washes of oxides, stains, and frit, which enhance, not mask, the clay body.

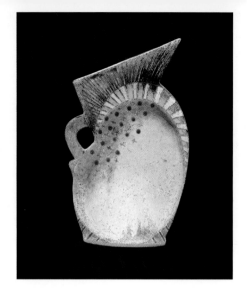

TERRI HOLMAN

Northcombe, Moretonhampstead Road, Bovey Tracey, Devon TQ13 9NH
TEL 01626 835 578 EMAIL terriholman@hotmail.co.uk
Visitors welcome by appointment

After graduating in 1981 from Cardiff University, I moved back to
Devon. I am fascinated in being able to create a simple vessel out of flat
pieces of clay, and I am very interested in the illusion of volume and
depth, which I emphasise by my choice of surface pattern, colour, and
texture. I am influenced by the colours and patterns of the landscape
around me, from the texture of granite boulders, flaking layers of lime
plaster on old cob barns, to the small blue geometric patterns found on
pieces of old pottery dug up in the garden.

TH.

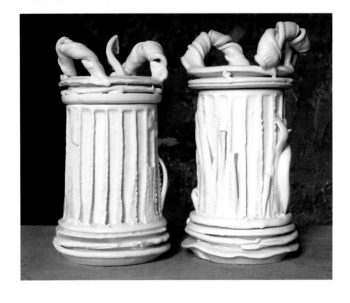

DUNCAN HOOSON

9 Birchington Road, Crouch End, London N8 8HR
TEL 0208 342 9032 EMAIL dhooson@btinternet.com WEB www.duncanhooson.com
Visitors welcome by appointment

I was born in Stoke-on-Trent in 1959, and trained in Bristol and Cardiff Universities. I produce work mainly to public or private commission and employ a wide range of ceramic techniques and scales – from high relief murals to domestic functional forms for internal or external locations. The pots I make are always wheel-thrown. I also work as an artist-in-residence in schools, hospitals, and on community projects, and enjoy facilitating commissions that engage a wider public. I am co-founder and Director of Clayground Collective Ltd, an organisation that develops ceramic skills-sharing projects and collaborative working with other disciplines. I teach ceramics at degree level and in adult education at Morley College, London.

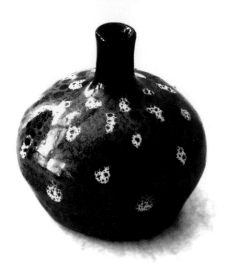

HARRY HORLOCK-STRINGER Honorary Fellow

King William House, Lopen, South Petherton, Somerset TA13 5JU
TEL 01460 242 135
Visitors welcome by appointment

Due to *Anno Domini* and high electricity prices I am reverting to earthenware pots with once-fired, naturally textured glazes. I no longer make production pots for tableware. I have always felt that clay should express its own plastic quality as a form, and that we, as potters, should assemble our glaze materials, which we then hand over to the fire, and hope that Nature will then give the 'magic kiss'. For personal history, please consult previous issues of *The Ceramics Book*.

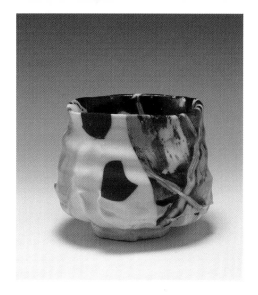

ASHLEY HOWARD Fellow

12 Pottery Lane, Wrecclesham, Farnham, Surrey GU10 4QJ
TEL 07970 424 762 EMAIL info@ashleyhoward.co.uk WEB www.ashleyhoward.co.uk
Visitors welcome by appointment

Ashley Howard produces porcelain and stoneware vessels. These are informed by a dialogue between Far Eastern and homespun pottery traditions that draw on his interest in ritual vessels, the spaces they occupy, and the ceremonies that surround them.

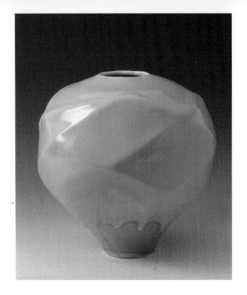

JOANNA HOWELLS Fellow

2 Cwrt Isaf, Tythegston, Bridgend, Mid-Glamorgan CF32 0ND
TEL 01656 784 021 EMAIL studio@joannahowells.co.uk WEB www.joannahowells.co.uk
Visitors welcome by appointment

My work concentrates on form and texture. I aim to make pieces
that are very simple, yet have a softness, a freedom, and a sculptural
quality. The work varies in size from small, intimate domestic
ware to large-scale pieces. I work in both porcelain and stoneware.
Porcelain, because it is such a beautiful material in itself – so fine,
white, and translucent – and because of the poetic imagery that it
evokes. Stoneware gives me access to another palette of colours and an
earthier, more robust style.

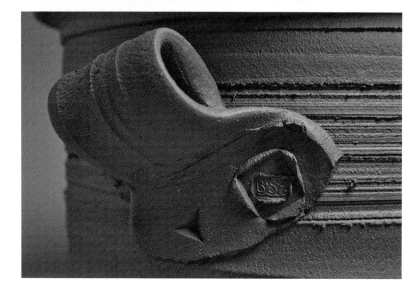

SIMON HULBERT Fellow

Brook Street Pottery and Gallery, Hay-on-Wye, Hereford HR3 5BQ
TEL 01497 821 070 EMAIL info@brookstreetpottery.co.uk
WEB www.brookstreetpottery.co.uk • Visitors welcome by appointment

Simon produces a wide range of terracotta gardenware from his studio
in Hay-on-Wye. The larger pieces, usually made to commission, reflect
a long-standing interest in classical form and proportion. While this is
an underlying theme, he takes pleasure in adopting a looser approach
that exploits the softer qualities of clay. Pots are constructed using a
combination of throwing, press-moulding, and coiling. They are then
high fired to bring out the rich colours of the clay and slips, and to
ensure that they are frost-proof. The workshop in Hay is a working
studio producing terracotta and has a permanent gallery space that
stocks contemporary British studio ceramics.

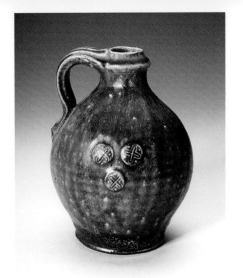

TIM HURN

Home Farm House, Bettiscombe, Bridport, Dorset DT6 5NU
TEL 01308 868 171 EMAIL tj.hurn@tiscali.co.uk WEB www.timhurn.co.uk
Visitors welcome by appointment

Wood-fired saltglaze. After graduating from Camberwell School
of Art and Crafts, London, in 1987, I took part in the International
Workshop of Ceramic Art in Tokoname, Japan, exhibiting at the
Tokoname Ceramic Festival. Following this, I was apprentice to John
Leach at Muchelney Pottery in Somerset for two years. I then moved to
Bettiscombe, Dorset, to build a wood-fired anagama kiln and establish
my studio, from which I have been potting for the last twenty years.
I make a range of hand-thrown oven, table, and garden ware, alongside
more individual one-off pots, which are placed in the firebox of the kiln.

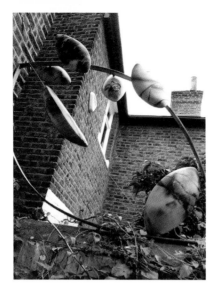

CLAIRE IRELAND

Studio 5, Kew Bridge Steam Museum, Green Dragon Lane, Brentford, Middlesex TW8 0EN
TEL 07902 027 970 **EMAIL** claireirelanduk@yahoo.co.uk
WEB www.claireirelandceramics.com • Visitors welcome by appointment

My new studio is at the Kew Bridge Steam Museum. I use the creative atmosphere, facilities, and special location to inspire my work. I have started to explore alternative hand-building techniques; larger more sculptural forms have emerged during my research. The smoky and painterly surfaces I achieve envelop my ceramic forms and are integral to the whole. I find great enjoyment and creative impulse through making collections and arranging man-made and natural forms. The discipline of drawing and my continuous sketchbook studies are of prime importance to me. I have recently completed commissioned work for specific locations in gardens and public spaces.

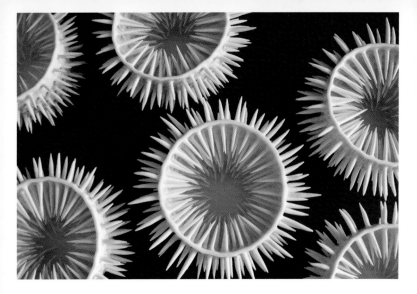

IKUKO IWAMOTO

Unit 51 Craft Central, 33-35 St John's Square, London EC1M 4DS
TEL 07734 592 791 **EMAIL** ikuko.iwamoto@network.rca.ac.uk **WEB** www.ikukoi.co.uk
Visitors welcome by appointment

I make exquisite cups and other objects for a bizarre tea ceremony.
They suggest the everyday, the ordinary, but are in fact *extra-ordinary*.
They are the vehicle to make visible an invisible microscopic world – a
world of intricacy and detail, of mathematical pattern and organic
chaos, of beauty and repulsion.

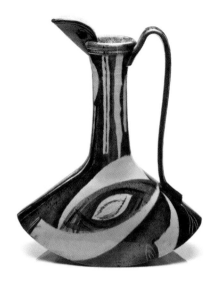

PAUL JACKSON Fellow

Helland Bridge Pottery, Hellandbridge, Bodmin PL30 4QR
TEL 01208 75240 **EMAIL** paul@paul-jackson.co.uk **WEB** www.paul-jackson.co.uk
Studio open week days 10am–5pm; visitors welcome by appointment

Thrown altered vessels in white earthenware or salt-glazed stoneware.
Life drawing and abstract decoration abound. The landscape of the
West Country inspired my work.

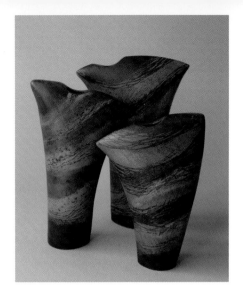

ANNE JAMES Fellow

7 Gloucester Road, Painswick, Gloucester GL6 6RA
TEL 01452 813 846 EMAIL annejames37@waitrose.com
Visitors welcome by appointment

My work is thrown and handbuilt in porcelain, with burnished coloured slips. After biscuit firing, pieces are decorated with precious metal lustres, fired as raku, and smoked with fine sawdust. Most forms are vessel-based, but some are purely sculptural. I try to combine form, colour, and subtle tactile surfaces. After years of drawing, photographing, and observing, inspiration comes from many sources – ancient tools and artefacts, landforms, time-worn buildings, and modern architecture. Surface decoration often derives from the richness of colour and pattern in tribal and ethnic textiles. I try to create forms and surfaces that recall and suggest their sources without imitating, and which celebrate the materials and processes I use.

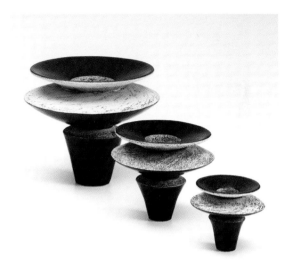

VICTORIA JARDINE

Glenwood Studio, Glenwood House, Longburton, Sherborne, Dorset DT9 5PG
TEL 01963 210 211 EMAIL victoriajardine@hotmail.co.uk WEB www.victoriajardine.com
Visitors welcome by appointment

It amazes me that humans are able to bring such grace and elegance of form to weighty lumps of stoneware clay. I like to think of my pots as light and corseted, and the movement of their making as a pirouette.

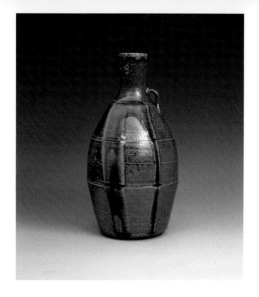

JOHN JELFS Fellow

Cotswold Pottery, Clapton Row, Bourton-on-the-Water, Gloucestershire GL54 2DN
TEL 01451 820 173 EMAIL john.jelfs@homecall.co.uk WEB www.cotswoldpottery.co.uk
Studio open most days 10am-5pm; please phone first

I set up my present studio in the Cotswolds in 1973 with my wife Jude,
after attending Cheltenham College of Art. My work is mainly thrown,
and fired to stoneware temperature using wood ash celadon and tenmoku
glazes. I also soda and wood fire. I have exhibited all over the UK and
occasionally abroad. My work is in many private and public collections.

J.J.

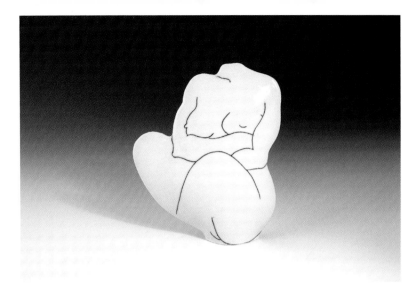

JUDE JELFS

Cotswold Pottery, Clapton Row, Bourton-on-the-Water, Gloucestershire GL54 2DN
TEL 01451 820 173 EMAIL jude.jelfs@homecall.co.uk WEB www.cotswoldpottery.co.uk
Studio open most days 10am-5pm; please phone first

I studied fine art, but became a potter when I married John Jelfs. Over the past few years I have returned to my roots, combining pottery with painting, drawing, and sculpture. I work in earthenware, porcelain, stonewares, and more recently, bronze.

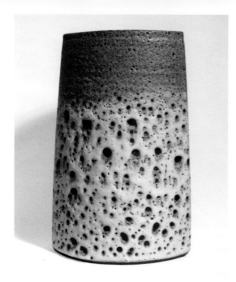

CHRIS JENKINS Fellow

19 Towngate, Marsden, Huddersfield HD7 6DD
TEL 01484 844 444 EMAIL chris@towngatepottery.co.uk
Visitors welcome by appointment

As a student I started as a sculptor and painter, first at Harrogate, then at the Slade School of Fine Art, London. Bill Newland encouraged an interest in ceramics, which I pursued in another year at the Central School. Since then I have worked in production potteries and taught as a lecturer while producing my own work. I now work full-time in the pottery, and make a range of thrown pieces in oxidised stoneware with a recurrent theme of asymmetric geometry. Surface treatments include overlaid glazes, engraved inlaid, and masked slips. In the summer I make functional wood-fired stoneware at my pottery in France.

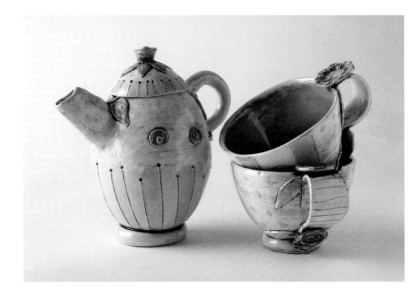

WENDY JOHNSON Fellow

8 Cromford Road, Wirksworth, Derbyshire DE4 4FH
TEL 07963 629 366 **EMAIL** wendyjohnsonceramics@gmail.com
WEB wendyjohnsonblog.wordpress.com • Visitors welcome by appointment

I make a range of functional and decorative pieces. All of my work
is handbuilt using slab, pinched, press-moulding, and modelling
techniques. My range includes decorative clocks, candlesticks, bowls,
teapots, cups, and jugs. I also make wall-mounted and free-standing
boxes with narrative. I enjoy the playful individual nature of the
pieces, each telling its own story. Often inspired by nature and travel,
the pieces have illustrative qualities.

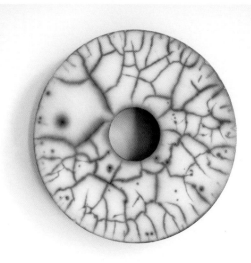

EMMA JOHNSTONE

The Blue Door Studio, c/o 34 Hawks Road, Kingston upon Thames, Surrey KT1 3EG
TEL 07970 672 535 **EMAIL** embluedoor@aol.com **WEB** www.emmajohnstoneceramics.com
Visitors welcome by appointment

Emma set up her studio in New Malden, Surrey, in 1996. Her work is
thrown, double-walled sculptural ceramics. All pieces are raku-fired
using the slip-resist technique. Some pieces are gilded using gold
and copper leaf. New work is monochrome and incorporates areas
of texture and burnishing. Many pieces now are designed for display
on a wall. Emma combines making with teaching, and regularly runs
throwing and glaze technology courses at her studio. Commissions
are welcome.

DAVID JONES Fellow

21 Plymouth Place, Leamington Spa, Warwickshire CV31 1HN
TEL 01926 314 643 EMAIL davidjonesraku@lineone.net WEB www.davidjonesceramics.co.uk
Visitors welcome by appointment

My work has evolved towards the making and placing of objects within installed environments; the ceramic pieces reference the handmade as well as personal meanings. I appropriate found objects to complement my ceramic making. While the pieces have an independent life, I am also concerned with how they communicate with one another in an installation, and then how dispersal subtly changes the concept of the work. The work is represented in international collections, and I lecture and demonstrate in the UK and internationally. I teach at Wolverhampton University, am a Member of the International Academy of Ceramics, and am author of *Raku: Investigations into Fire and Firing: Philosophies within Contemporary Ceramic Practice*.

143

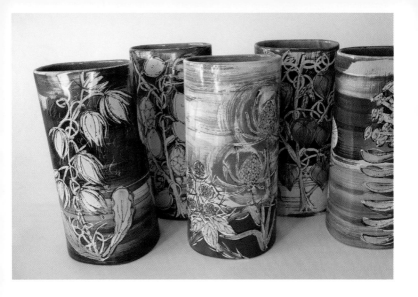

LISA KATZENSTEIN

24 Centurion Rise, Hastings, East Sussex TN34 2UL
EMAIL lisa@katzenstein.fslife.co.uk WEB www.lisakatzenstein.co.uk
Visitors welcome by appointment

If a weed is 'a plant in the wrong place', my vases are a home to them.
A little bit of wilderness on a domestic scale, hand-painted in tin-
glazed earthenware, each as unique as the plants it depicts.

L. Katzenstein

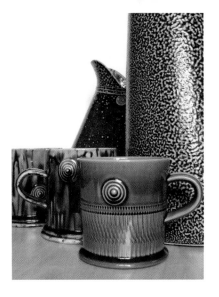

WALTER KEELER Fellow

Moorcroft Cottage, Penallt, Sir Fynwy, Wales NP25 4AH
TEL 01600 713 946
Visitors welcome by appointment

I make thrown (some lathe turned) functional pots in salt-glazed stoneware and creamware. My work is informed by European (especially British) utilitarian pottery from the Romans on, but it reflects me, the world I inhabit, and my love of my materials and processes.

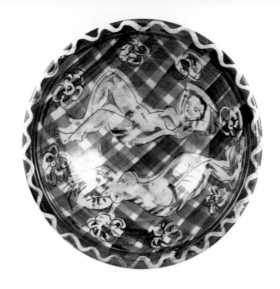

JIM AND DOMINIQUE KEELING

Whichford Pottery, Whichford, nr Shipston-on-Stour, Warwickshire CV36 5PG
TEL 01608 684 416 EMAIL theocatagon@whichfordpottery.com WEB www.theoctagon.co.uk
Open Mon-Fri, 9am-5pm; Sat & Bank holidays, 10am-4pm; Sun, 11am-4pm (Apr-Dec)

Jim and Dominique Keeling met at Cambridge in 1971, when Jim was studying archaeology and Dominique was reading English. They began making sgraffito earthenware soon after leaving university, but had a long pause while Jim set up his flowerpot pottery and Dominique had their family. They returned to glazed ware in 1995. The pots for glazing are thrown by Jim, their shapes inspired by Near Eastern and European traditions, then decorated by Dominique. Her designs are ever-varying and often feature mythology, domestic life, dance, and the human figure.

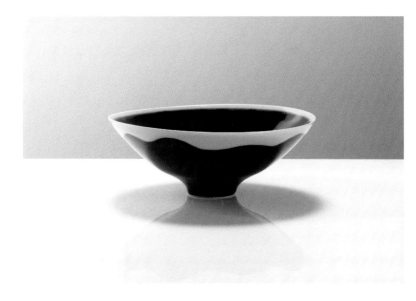

CHRIS KEENAN Fellow

Unit 7C Vanguard Court, r/o 36-38 Peckham Road, London SE5 8QT
TEL 020 7701 2940 EMAIL chriskeenan.potter@gmail.com WEB www.chriskeenan.co.uk
Visitors welcome by appointment

I make work for interior spaces – pots to be used or handled or looked at. Limoges porcelain is the clay; tenmoku and celadon the glazes. Making, for me, has always involved repetition: one has never been enough. A desire for consistency, achieved through careful and considered observation, exists simultaneously alongside the need to re-examine and alter. It is a continuous, interrogative dialogue.

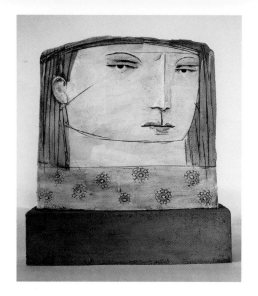

CHRISTY KEENEY

Doon Glebe, Newmills, Letterkenny, Co Donegal, Ireland
TEL 00353 7491 67258 EMAIL christykeeny2@gmail.com WEB www.christykeeney.co.uk
Visitors welcome by appointment

My work is based around the figure and the human head. I try to bring across a sense of identity in each piece I do. The clay is a stoneware clay containing flax and fine grog, which I paint with velvet underglazes and oxides. My firing temperature is 1040°C at bisque and 1140-50°C for glaze firing.

C. KEENEY

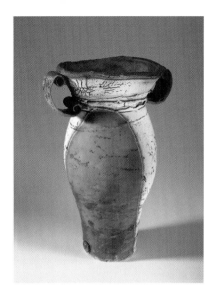

JOHN KERSHAW

47 Oakthwaite Road, Windermere, Cumbria LA23 2BD
TEL 01539 443 888 EMAIL john@kershawpottery.com WEB www.kershawpottery.com
Visitors welcome by appointment

Most of my work is thrown on the wheel. I like the process of creating in action rather than stillness, and the form and detail produced by that action. I like to create strong contrasting textures of clay and glaze, often using powdered clays on the wet thrown body to build up a heavily encrusted surface. I have a taste for ancient and primitive pottery, partly because often the means of production were direct and very simple, but also because ancient artefacts are disconnected from their time and immediate function, which gives them great peacefulness.

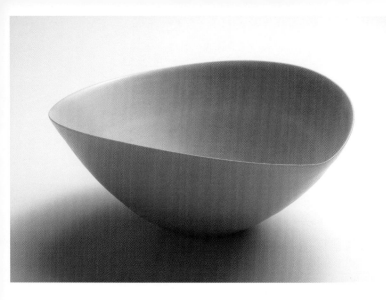

HYEJEONG KIM

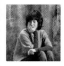

TEL/FAX 0082 (0)2379 5766 **EMAIL** hk@potspots.com **WEB** www.potspots.com

I love working on a wheel because it is fascinating to traverse the centripetal and centrifugal forces. The dynamism of the wheel creates the forms, and it always feels wonderful to be at the centre of these movements during the throwing, and watch the spontaneous changes taking shape in the clay. The body of my pots has recently started to show movement; they have become much thinner and more flexible in shape. I have welcomed this natural deformation while experimenting with the organic movements in the materials. My inspirations have always come from nature. The firing reaches stoneware temperature.

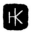

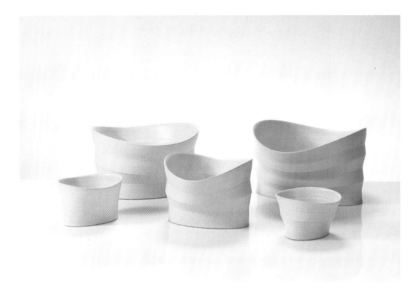

SUN KIM

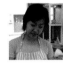

Studio 4a, Vanguard Court, 36-38 Peckham Road, London SE5 8QT
TEL 07976 039 552 EMAIL sunkim_77@yahoo.com WEB www.sunkim.co.uk
Visitors welcome by appointment

My work is focused on a range of functional ware where I explore
traditional and contemporary aesthetics. I use porcelain and also
stoneware as the main material. I'm very intrigued by cultural
connections I find within my work, and the making process is a
continual challenge for me and a personal investigation into form,
shape, and volume.

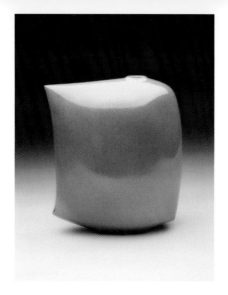

RUTH KING Fellow

Rose Cottage, Main Street, Shipton-by-Beningbrough, York YO30 1AB
TEL 01904 470 196 **EMAIL** ruthkingceramics@tiscali.co.uk **WEB** www.ruthkingceramics.com
Visitors welcome by appointment

Handbuilt non-functional vessels in salt-glazed stoneware. I trained
at Camberwell School of Arts and Craft, and in 1981 I moved to York,
where I still live and work. I have exhibited widely over the past thirty
years, and have work in many collections, both public and private, in
the UK and overseas.

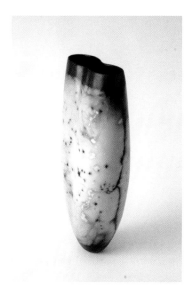

GABRIELE KOCH Fellow

Studio 147, 147 Archway Road, Highgate, London N6 5BL
TEL 020 8292 3169 **EMAIL** contact@gabrielekoch.co.uk **WEB** www.gabrielekoch.co.uk
Visitors welcome by appointment

I trained at Goldsmiths College, London. My work concentrates on
simple vessel forms. All pieces are handbuilt and burnished to achieve
a sensual, tactile surface. Recent developments incorporate texture
and contrasting surfaces. The distinctive patterning is the result of
carbonisation, which is achieved in a carefully organised secondary
firing. My work is represented in many UK and international public
and private collections, including the Victoria and Albert Museum,
London, and Sainsbury Collection, and I exhibit widely in the UK and
abroad. A new monograph entitled *Gabriele Koch: Handbuilding and
Smoke Firing* is available from Stenlake Publishing Ltd.

Gabriele Koch

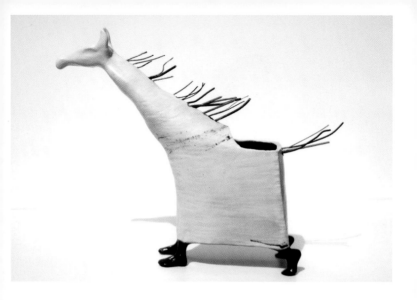

DAIVA KOJELYTE-MARROW

27 Beechey Avenue, Marston, Oxford OX3 0JU
TEL 01865 420 634 EMAIL daivakojelyte@hotmail.com WEB daivakojelyte.co.uk
Visitors welcome by appointment

I try to express an oasis of pure and sincere feelings in my ceramics, and keep out everything in the world that is repellent and frightening. I want to capture the brightness of the white Christmas at my daughter's birth. My surrealistic animals sometimes seem like toys; they're not to be thrown away and forgotten, but are here now with their magical reality. I'm serious, but not quite serious. I love people, and make sculptures that express friendship and affection. I've always loved painting and I use brushwork to create more expressive lines. I try to bridge visual and applied arts.

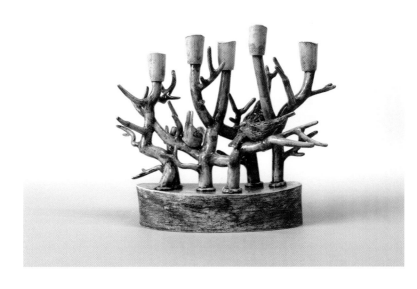

ANNA LAMBERT Fellow

Junction Workshop, 1 Skipton Road, Crosshills, nr Keighley, West Yorkshire BD20 7SB
TEL 01535 631 341 **EMAIL** anna@junctionworkshop.co.uk
WEB www. junctionworkshop.co.uk • Visitors welcome by appointment

Anna Lambert makes handbuilt earthenware vessels. Each unique piece is constructed by coiling, pinching, and manipulating the soft clay. Later, the leatherhard clay is scraped back and worked on with coloured slips, drawn and relief printed images, and modelling, before glazing with subtle underglaze colours. This work is a response to Anna's natural surroundings, and many pieces echo the form of nature described – hence bird's nest bowls and twig candlesticks. Each piece works as a sculptural object in its own right, whether put to domestic use or not.

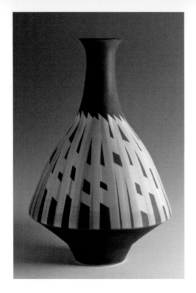

PETER LANE Honorary Fellow

Ivy House, Jacklyns Lane, New Alresford, Hampshire S024 9LG
TEL 01962 735 041 EMAIL peter@studioporcelain.co.uk WEB www. studioporcelain.co.uk
Small selection of pieces in studio by prior appointment only

Author of the books: *Studio Porcelain, Studio Ceramics, Ceramic Form, Contemporary Porcelain* and *Contemporary Studio Porcelain*. Widely exhibited, he demonstrates and lectures internationally, and is a Member of the International Academy of Ceramics. He makes individual vessel forms in porcelain, using designs inspired by landscape and natural phenomena. Public collections include: City Museum and Art Gallery, Stoke-on-Trent; National Gallery of Victoria, Melbourne; Royal Scottish Museum, Edinburgh; Canadian Clay & Glass Gallery, Ontario; Inchon World Ceramic Center, Korea; Benaki Museum, Athens; Design Museum, Ghent; Museum fur angewandte Kunst and Kolumba Museum, Köln; Mint Museum, US; American Museum of Ceramic Art, California; and Princesshof Ceramics Museum, Holland.

Peter Lane

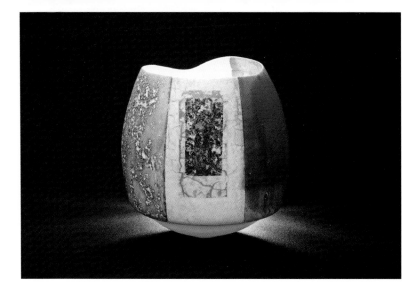

TONY LAVERICK

Ridgway House, Leek Road, Longsdon, Staffordshire ST9 9QF
TEL 01538 386 050 **EMAIL** tonylaverick@btinternet.com **WEB** www.tonylaverick.co.uk
Visitors welcome by appointment

My work is hand-thrown and turned porcelain (occasionally slabbed)
onto which I apply precious metal lustres in multiple refirings.
Recently I have been firing bisque to 1270°C with glaze and lustre
firings progressively lower. My influences include art ceramics from
the end of the nineteenth and early twentieth centuries by Royal
Doulton, Ruskin, Bernard Leach, Moorcroft, and Pilkington's Royal
Lancastrian. Also French potters such as Delaherche and Massier and
twentieth-century artists such as Kandinsky, Malevich, Mondrian,
Nicholson, and Brancusi. I am constantly expanding my own limits
and pushing boundaries. Taking risks is necessary for growth in
my work.

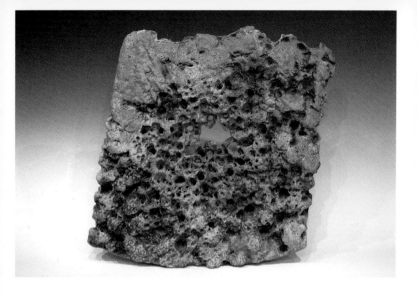

WENDY LAWRENCE

27a Love Lane, Denbigh, Denbighshire LL16 3LT
TEL 01745 799 629 / 07748 715 596 **EMAIL** wlawrenceceramics@hotmail.com
WEB www.wendylawrenceceramics.com • Visitors welcome by appointment

The inspiration for my work is derived from forms, textures, and surfaces found in eroded rock and the landscape of antiquity: architecture, culture, and worship. Making combines a number of handbuilding techniques: coiling, slab-building, and working from solid lumps of clay. I work spontaneously, and at other times, painstakingly by carving leatherhard clay, attempting to imbue pattern and a sense of erosion. Glazing involves layering reactive and eruptive materials, often very thickly, creating rich textural surfaces. This process aims to further the sense of eroded antiquity, while providing an exciting element of chance and uncertainty. My work is multi-fired in both gas and electric kilns, varying the atmosphere from oxidation to heavy reduction.

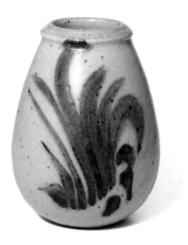

JOHN LEACH Fellow

Muchelney Pottery, Muchelney, nr Langport, Somerset TA10 0DW
TEL 01458 250 324 **EMAIL** john@johnleachpottery.co.uk **WEB** www.johnleachpottery.co.uk
Muchelney Pottery Shop and John Leach Gallery are open Mon-Sat, 9am-1pm, 2-5pm

John Leach, eldest grandson of renowned potter Bernard Leach and
son of David Leach, continues the family tradition at Muchelney
Pottery on the edge of the ancient village of Muchelney in the heart of
the Somerset Levels. Working with master potters Nick Rees and Mark
Melbourne, John produces a catalogue range of handmade wood-
fired pots suitable for use in the kitchen and dining room, as well as
one-off signed pieces for exhibitions. The pots are all hand-thrown
using local clays and wood-fired in the three-chambered kiln to the
high stoneware temperature of 1320°C, which creates their distinctive
'toasted' finish.

MUCHELNEY

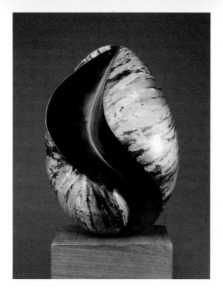

DEANA LEE

60 Lydden Grove, London SW18 4LN
TEL 07717 727 118 EMAIL dl@deanaleeceramics.com WEB www.deanaleeceramics.com
Visitors welcome by appointment

After an international marketing career, Deana pursued her passion to study ceramics, followed by an apprenticeship with Sandy Brown. Deana was one of thirty-nine emerging artists to be selected for the Chinese Arts Centre's PAD Scheme, and recently, was one of six international finalists for 2011 Potclays Emerging Maker Award. Deana's organic smoke-fired sculptures are inspired by nature. Her wall art and dishes are broken and rejoined with resin, coated in silver or 22-carat gold leaf, creating a rich vein. Deana's art is in private collections worldwide, and she specialises in commissions that incorporate sand provided by the clients.

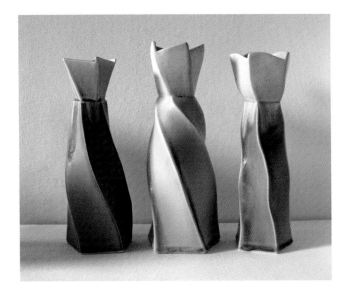

ROGER LEWIS

TEL 07952 985 729 EMAIL rogerlewisceramics@gmail.com
Visitors welcome by appointment

Born 1946, trained at Shrewsbury, High Wycombe, Cardiff, and Goldsmiths, London, senior lecturer of ceramics for over twenty years up to 1997. I am a handbuilder working in stoneware and porcelain, whose aim is to produce work using inventive making methods and interesting forms. Although some of my work can be useful, my main interest is in form rather than function.

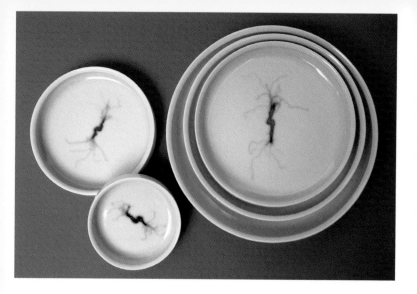

CLAUDIA LIS

'The Central', Princes Street, Montgomery, Powys, Wales SY15 6PY
TEL 01686 668 244 EMAIL ceramics@claudialis.co.uk WEB www.claudialis.co.uk
Visitors welcome by appointment

Since launching her studio in 2004, Claudia Lis has developed a quiet
body of celadon wares inspired by historic examples of Oriental
stoneware and porcelain. Iron oxide in a variety of forms and particle
sizes is central to Claudia's work. The soft green shades of her celadon
glazes are derived from additions of finely ground iron oxide to the
base glaze; the same material, in the form of rust flakes implanted
into the dusty glaze layer, migrates through the molten glaze during
firing, thereby creating intricate markings reminiscent of ink stains on
blotting paper. More recent experiments have included the use of wire
wool strands, bronze, and copper oxide powders to create variations on
the theme of metal-induced staining.

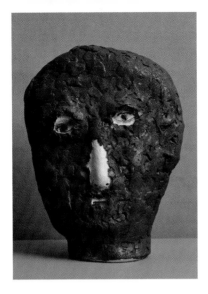

CLAIRE LODER

11 Frankley Terrace, Camden, Bath BA1 6DP
TEL 01225 335 521 EMAIL info@claireloder.co.uk WEB claireloder.co.uk
Visitors welcome by appointment

My work revolves around the depiction of the face and head. I don't deal with anything below the neck; I'm interested in the head as a metaphor for the complete body. Although shallow in physical depth, my sculptures play with psychological complexity: they rarely look directly at the viewer, are often lost in thought or seemingly otherwise occupied. Narrative is significant, recurring themes include: concerns over the beauty industry, ageing, and feminism; my personal search for calm; an anxiety over consumerism; the recession; my love of humour and word play; and my interest in the depiction of melancholy.

Loder

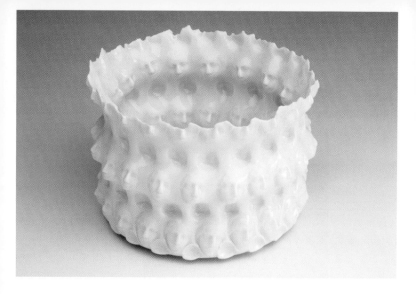

ANJA LUBACH

Studio 110, Cockpit Arts, Deptford, London SE8 3DZ
TEL 07946 841 249 EMAIL info@anjalubach.com WEB www.anjalubach.com
Visitors welcome by appointment

I explore porcelain, its unique translucency and ability to replicate surfaces. I am not religious, but am intrigued by the human need to create an idealised vision of itself, in icons and ritual and much strange paraphernalia created by people to make sense of life and death. The symmetry of thrown vessels is altered through the application of relief by manipulation with small moulds. Face details taken from religious figurines have been one of my most enduring designs. Torn rims indicate the object being a significant artefact, a fragment of a larger form.

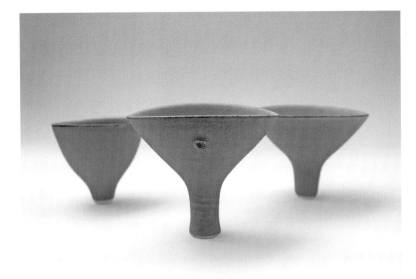

PHIL LYDDON

76 Richmond street, Brighton, East Sussex BN2 9PE
TEL 01273 691 770 **EMAIL** phillyddon@hotmail.com **WEB** www.phillyddon.co.uk
Visitors welcome by appointment

I have been making pots in Brighton since the 1970s. I have always been interested in the idea of the miniature, and I concentrate on small scale works, mainly hand-thrown porcelain bowls. I aim to make graceful forms with restrained surface decoration. I often distort the piece after throwing to add an element of asymmetry – a signature of my work. I use a wide range of glazes: turquoise, speckled cobalt blue, celadon, yellow, ash white, and a matt white, which I stain with tea to emphasise the crazing. Over the years I have featured in many exhibitions, and I currently sell my ceramics in galleries in Brighton and throughout the UK.

Phil
Lyddon

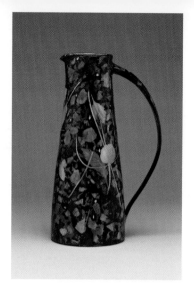

SOPHIE MACCARTHY Fellow

The Chocolate Factory, Farleigh Place, London N16 7SX
TEL 07754 947 340 EMAIL sophie_macc@yahoo.co.uk WEB www.sophiemaccarthy.co.uk
Visitors welcome by appointment

I paint with coloured slips directly onto the dry clay surface, using stencils and wax resist. A lot of my imagery is a response to what I see around me, mainly on the ground, where the natural world meets the urban environment. Something like tarmac can be multi-coloured; cars run over leaves, squashing them into the road surface, leaving the perfect leaf shape punctured with the texture of tarmac. Multi-coloured leaves gather in puddles, the blue sky reflected in the water. These are vivid images that I try to translate into my work through colour and through drawing. I bisque fire, and glaze to 1120°C.

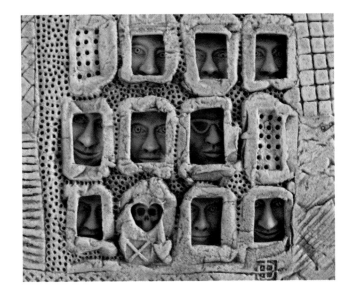

ALASDAIR NEIL MACDONELL

2 Kennington Road, Bath BA1 3EA
TEL 01225 465996 EMAIL neil@macdonell-ceramics.co.uk
WEB www.macdonell-ceramics.co.uk • Visitors welcome by appointment

I make a wide range of sculptural forms, mostly wall-hangings,
that use textures and patterns derived from found objects, wrappings,
and industrial scrap. Faces are a central theme, but the work also
reflects my interest in architecture, antiquities, and tribal art.
All pieces are unique.

ANM
BATH

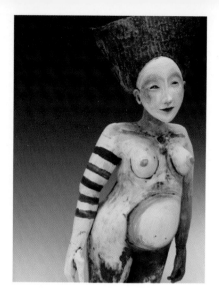

SALLY MACDONELL

2 Kennington Road, Bath BA1 3EA
TEL 01225 465996 **EMAIL** sally@macdonell-ceramics.co.uk
WEB www.macdonell-ceramics.co.uk • Visitors welcome by appointment

Sally MacDonell's constant fascination with people leads her to model figures with slabs of stoneware clay, forming tubes from which the work evolves. New developments include colouring with oxides/stains and glazes and firing to 1186°C. She lives and works in Bath with her husband Neil MacDonell.

*Sally MacDonell
Bath*

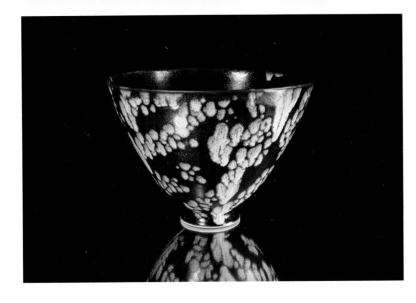

IVAR STUART MACKAY

Le Fanal, Village, 11240 Seignalens, France
TEL 0033 468 692 272 EMAIL ivar.porcelain@gmail.com
WEB www.ivarmackayporcelain.co.uk • Visitors welcome by appointment

I work within the classic tradition of wheel-thrown ceramics. My medium is porcelain and I use a blend of Limoges mixed with other porcelain bodies. I seek painterly effects in my glazes and prefer the natural characteristics of reduction firing to augment the decorative process. While I aim for control in my forms, I attempt to induce elemental or spontaneous qualities in my glazes. My work is an ongoing process of study and experimentation. This produces a high level of kiln failures. However, I feel this is an inevitable, but acceptable outcome, which has ultimately enabled me to express my ideas in many different ways.

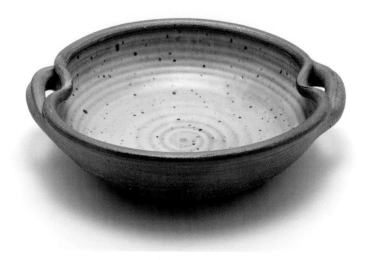

MADE IN CLEY

Made in Cley, High Street, Cley-next-the-Sea, nr Holt, Norfolk NR25 7RF
TEL 01263 740 134 **EMAIL** madeincley@aol.com **WEB** www.madeincley.co.uk
Gallery open all year round; Mon-Fri, 10am-5pm; Sun, 11am-4pm

Made in Cley is a craft co-operative established in 1981, which
comprises eight potters and a jeweller: Wolfgang Altmann, Gunhild
Espelage, Christiane Guenther, Richard Kelham, Mary Perry, Rosalind
Redfern, Nicole Schumacher, Barbara Widdup, and Quay Proctor-
Mears (jeweller). We produce a wide range of wheel-thrown reduction
and oxidised fired stoneware for domestic use. In addition to our
domestic range we make individual sculptural pieces in stoneware for
the house and garden. Commissions undertaken. We sell our work in
our own gallery where we also have our workshops.

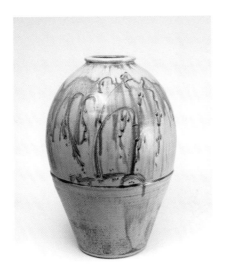

JIM MALONE Fellow

Dairylea Cottage, Lessonhall, Wigton, Cumbria CA7 0EA
TEL 01697 345 241
Visitors welcome by appointment

Mostly stoneware.

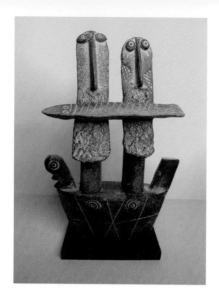

JOHN MALTBY Honorary Fellow

The Orchard House, Stoneshill, Crediton, Devon EX17 4EF
TEL 01363 772 753

I like to think that my work is a confirmation of our national art
achievements: some small body of work that pays homage to my
chance of Birth and inevitable place in the Historic Continuum.

JOHN MALTBY

HANNE MANNHEIMER

Manifold / Arch 33, Ermine Mews, Laburnum Street, London E2 8BF
TEL 07763 111 664 **EMAIL** hanne@hannemannheimer.com
WEB www.hannemannheimer.com • Visitors welcome by appointment

More often than not, it begins with a found object, like the texture of
a thread or the memory of a porcelain figurine. Sometimes the found
can be a story, even a few words describing something, or a feeling that
needs to be made in a tactile and fragile material. The combination
of the found and made, a tangible object and an abstract idea is what
motivates me the most. This allows the material qualities of the clay
to interact with the refined details of the found elements. I love the
clumsy, awkward, and sometimes ugly qualities that can be found in
old and discarded objects.

WILL LEVI MARSHALL Fellow

Holm Studio, Auchencairn, Castle Douglas, Dumfries, Scotland DG7 1QL
TEL 01556 640 399 EMAIL will.levi.marshall@btinternet.com WEB www.holmstudio.com
Visitors welcome by appointment

'There is a conceptual ecology at work in Marshall's practice. The artwork takes up no room. It does not suppose itself into the space: rather it takes possession of the architecture working with and through its fabric. It pursues contemporary sculptural preoccupations with site, intervention and architecture as sculptural material.' (Shirley MacWilliam). Award winning public and private architectural commissions. Experience includes: consultation/arts strategy development, lead artist/project management, community engagement, 3D models and working drawings (CAD), negotiating permissions, manufacture and subcontracted construction, and implementation/installation. Designs use a number of materials, although ceramics often plays a key role.

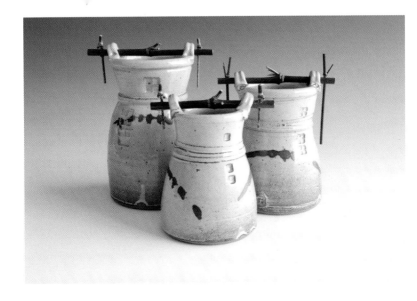

JOHN MATHIESON

50 Ridgeway, Weston Favell, Northampton NN3 3AN
TEL 01604 409 942 EMAIL jemathieson@talktalk.net WEB www.studiopottery.co.uk
Visitors welcome by appointment

I started making pots at evening classes, began teaching pottery at secondary level a year later, and have subsequently taken a degree in ceramics. Since leaving full-time education I have taught adult classes, and in a hospital, college, and prison. I am the author of *Raku* and *Techniques Using Slips*, both published by A&C Black. I make individual pieces in stoneware and porcelain on a Leach kickwheel, strongly influenced by Japanese ceramics and English slipware. Work is reduction-fired in a gas kiln to cone 10 using a variety of slips and glazes. I want my work to continue to evolve, and to show the marks of the maker's hands.

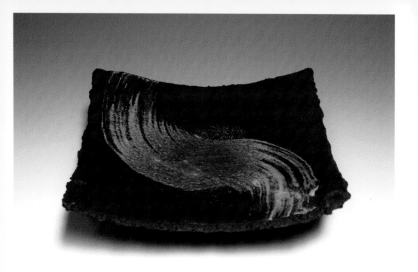

MARCIO MATTOS Fellow

Unit 7, Broadway Market Mews, London E8 4TS
TEL 07910 499 156 EMAIL m-m-ceramics@hotmail.com WEB www.musiclay.co.uk
Visitors welcome by appointment

Marcio Mattos works in red and black stoneware and paperclay, reduction fired in a gas kiln. Vessel-oriented individual pieces are entirely handbuilt, with dry, sprayed glazes and brushed decoration emphasising surface texture. Typical forms are large plates, jugs, sculptural vessels, and bottles, boat-shaped vases and decorative wall pieces. 'Being a musician as well as a potter, I bring into my work the same creative process behind Improvisation in music – the spontaneity and intuitive 'free-ness' of the moment of creation – to leave impressed in clay the immediacy of this process, in texture and in form.' He has work in private and public collections worldwide.

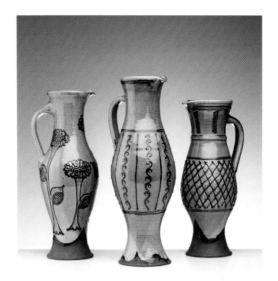

HANNAH MCANDREW

Studio 3, Lochdougan House, Kelton, Castle Douglas, Galloway, Scotland DG7 1SX
TEL 01556 680 220 EMAIL info@hannahmcandrew.co.uk
WEB www.hannahmcandrew.co.uk • Visitors welcome by appointment

I love clay – whether throwing it, using it as a liquid to pour and trail across my pots, or spending time preparing, wedging, and getting it to the perfect state for making. I use the strong traditional techniques of slipware with the aim of using it to give my work something of me and something of today. I mainly make functional pots, pots with a purpose, to enjoy with food. Commemorative wares are made to commission. My pots are thrown in red earthenware, decorated with coloured slips and honey glazes, and fired in either an electric or wood-burning kiln.

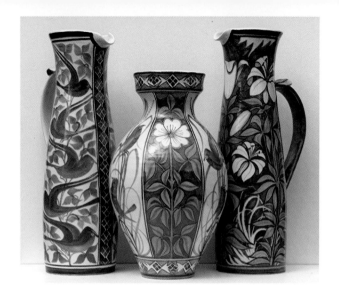

LAURENCE MCGOWAN Fellow

6 Aughton, Collingbourne Kingston, Marlborough, Wiltshire SN8 3SA
TEL 01264 850 749 EMAIL potteringabout2000@yahoo.co.uk
WEB www.laurencemcgowan.co.uk • Visitors welcome by appointment

Traditional majolica brushwork techniques employed on quiet wheel-thrown functional forms. Stains and oxide mixtures are painted on zirconium-opacified Cornish stone based glazes, which are electric fired to cone 8 (1260°C). Decorative motifs are taken from plant and animal forms, applied to both enhance the pot's form and reflect something of the exuberance of nature. Interests relating to the work include lettering, the Arts and Crafts Movement, and the decorative arts of the Islamic world.

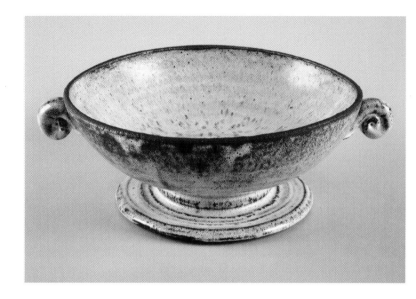

LESLEY MCSHEA

Church Street Workshops, Guttridges Yard, 172 Stoke Newington Church Street,
London N16 0JL **TEL** 020 7241 3676 **EMAIL** les_pot@yahoo.co.uk
WEB www.lesleymcshea.com • Visitors welcome by appointment

I have been passionate about ceramics for as long as I can remember.
Trained in Australia, where I gained a thorough knowledge of making,
firing, and glazing techniques, I returned to England in 1984. I
completed a BA(Hons) at Middlesex University in 1992. I have been
running my studio, Church Street Workshops, Stoke Newington,
London, since 1997. My work is mainly wheel-thrown grogged
stoneware, vessel orientated with textural press-moulded components
– mostly functional one-off pieces with a Gothic influence. I have
worked in adult education since 1985, a pleasure as well as a challenge.
I feel privileged to have the opportunity to pass on my skills and keep
the art of ceramics alive.

Lesley McShea

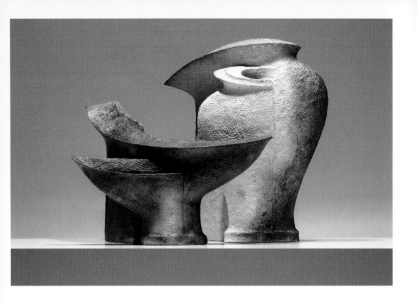

MARTIN MCWILLIAM Fellow

Martin McWilliam, Auf dem Koetjen 1, 26209 Sandhatten, Germany
TEL 0049 4482 8372 EMAIL ceramics@martin-mcwilliam.de
WEB www.martin-mcwilliam.de • Visitors welcome by appointment

'McWilliam is able to create a connection between the world as we
know it, and the space that is beyond human consciousness, precisely
because his works adapt and incorporate the postmodern reality.
The play with dimensions openly tells the story of postmodern
deconstruction, but still, essence has not been lost. The extended
awareness that is created as time and space merge offers us a possibility
to get in touch with those deeper layers of human existence. The most
existential experiences expressed in the humble form of a vessel. Clay,
water, and fire. Form leading to the formless. Space dissolving space.'
(Dr L Mazanti)

PETER MEANLEY Fellow

6 Downshire Road, Bangor, County Down, Northern Ireland BT20 3TW
TEL 02891 466 831 EMAIL pjmeanley@yahoo.co.uk
Visitors welcome by appointment

I have become a portrait artist who works in salt-glaze. Pieces are
individual, up to 50cm tall, and time consuming. But I love making
them and welcome commissions.

pm
11

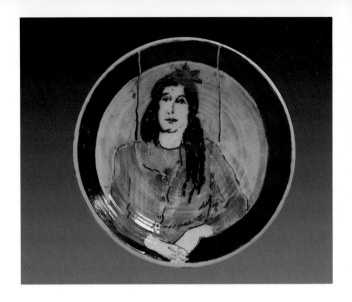

ERIC JAMES MELLON Honorary Fellow

5 Parkfield Avenue, Bognor Regis, West Sussex PO21 3BW
TEL 01243 268 949
Visitors welcome by appointment

Born 1925, studied at Watford, Harrow, and Central School of Arts
And Crafts, London, Eric James Mellon creates brush-drawn decorated
ceramics, fired to 1300°C using tree and bush ash glazes. Represented
in the Victoria and Albert Museum, London, and collections in
Britain and internationally. A book, *Decorated Stoneware and the Art
of the Brush*, published by University of Chichester (2007), containing
complete ash glaze recipes and working methods to achieve decoration
at 1300°C, is available from home address, limited signed and
numbered hard back edition of 500 copies, or in paperback.
See CR Nos. 42, 43, 65, 114, 172, 183, 226

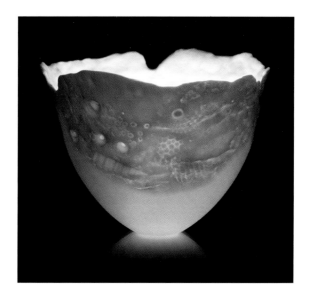

ANGELA MELLOR

38a St Mary's Street, Ely, Cambridgeshire CB7 4ES
TEL 01353 666 675 EMAIL angela@angelamellor.com WEB www.angelamellor.com
Visitors welcome by appointment

Angela Mellor BFA(Hons), MA, is an elected Member of the
International Academy of Ceramics, Geneva. She taught art and design
before undertaking ceramics full-time from 1995, investigating the
translucency of bone china and its potential for transmission of light.
Her MA research explored translucent paper clay – an area that she
continues to develop. She has exhibited in Europe, Asia, Australia,
and the US. She is represented in public and private collections in
China, Japan, Korea, US, France, Latvia, UK, and Australia, and her
work has been published in many books. Landscape, light, and coastal
environments are reflected in her work.

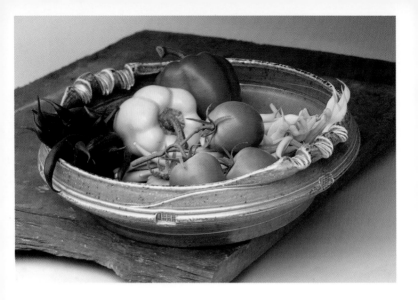

TOFF MILWAY Fellow

Conderton Pottery, Conderton, nr Tewkesbury, Gloucestershire GL20 7PP
TEL 01386 725 387 EMAIL toffmilway@toffmilway.co.uk WEB www.toffmilway.co.uk
Workshop and showroom open Mon-Sat, 10am-5pm; phone at other times.

Well known for my devotion to food-based salt-glazed functional
pots, I also make large extravagant pieces, frequently referred to as
banqueting pots. My passion is for how people live and eat, and I make
pots to inspire them. I live, work, and sell my pots in the beautiful
Cotswold stone village of Conderton.

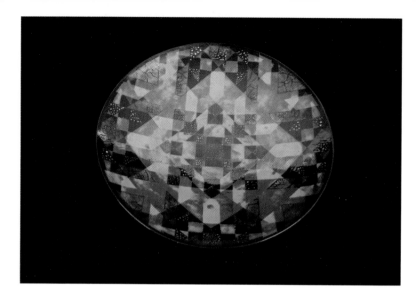

PETER MOSS

19 St Giles Avenue, Lincoln LN2 4PE
TEL 01522 529 124 **EMAIL** petermossceramics@btinternet.com
WEB www.petermoss.me.uk • Visitors welcome by appointment

My ceramic practice falls into three broad and often interchangeable categories: decorative surfaces, sculpture, and architectural works. After the expressionistic mark making of earlier years, my decorative surfaces have gradually become more restrained and understated as I strive for harmony and balance from an ever-changing combination of colour, pattern, and form. My sculptural work shares similar concerns, and I remain wary of drawing too many distinctions between these two branches of my oeuvre. In my architectural works I collaborate with a broad range of society and make use of both my decorative and sculptural experience, often as a communal activity.

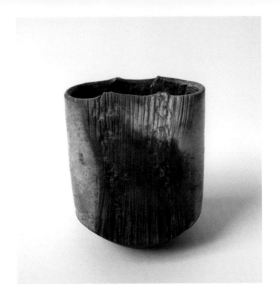

STEPHEN MURFITT

The Workshop, 18 Stretham Road, Wicken, Ely, Cambridgeshire CB7 5XH
TEL 01353 721 160 EMAIL t.murfitt@sky.com WEB www.stephenmurfitt.co.uk
Visitors welcome by appointment

Influences are diverse and come from the natural and built environment. The forms are mainly handbuilt and raku-fired, often beginning with a thrown base, then altered by pressing, cutting, and beating. These processes leave significant marks and textures, which are enhanced and revealed by the subsequent use of glaze and oxides. Smoked and carbonated areas of the clay, resulting from the post-firing reduction process, are left exposed to form a contrast with the glazed surfaces.

SM

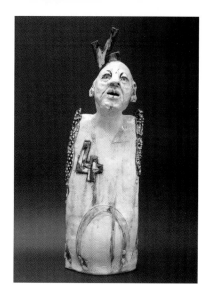

CLAIRE MURRAY

The Old Coach House, Ashreigney, nr Chulmleigh, Devon EX18 7NB
TEL 01769 520 775 EMAIL clairemurray@btinternet.com
WEB www.clairemurray-ceramics.co.uk • Visitors welcome by appointment

My figurative pieces are exclusively hand-modelled. They are based on my continuing fascination with the complexities of human communication and the central question of how we interconnect our inner and outer personae. My figures seek to evince both strength and tenderness but also physical vulnerability. Inspiration comes from many eclectic sources but especially the constant observation of people. I use Scarva ST clay and finish with oxides, UG colours, crayons, decals, and earthenware transparent glaze. Recent work has been shown in the Bevere Gallery (Worcester), the Affordable Art Fairs (London, Amsterdam, and New York), and a solo exhibition in Amsterdam.

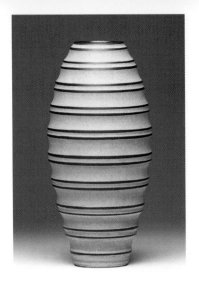

EMILY MYERS Fellow

2 Chalkpit Cottages, Tangley, Andover, Hampshire SP11 0RX
TEL 01264 730 243 **EMAIL** emily@emilymyers.com **WEB** www.emilymyers.com
Visitors welcome by appointment

Emily Myers graduated in ceramics at Bristol Polytechnic in 1987, went
on to receive a Crafts Council Setting Up Grant, and then became
a Fellow of the Craft Potters Association in 1990. Since then, she
has worked as a studio potter, first in London and now at home in
North Hampshire. Emily is currently working with both porcelain
and red stoneware clay and fires to 1220°C in an electric kiln. Well-
proportioned forms are thrown on the wheel and often faceted or
carved at the leatherhard stage.

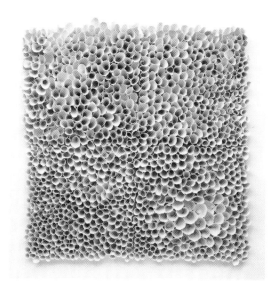

VALÉRIA NASCIMENTO

248b, Kingston Road, Teddington, London TW11 9JF
TEL 020 8977 1433 EMAIL info@valerianascimento.com
WEB www. valerianascimento.com • Visitors welcome by appointment

My inspiration is drawn mostly from the natural world, and porcelain has the smoothness and the malleability that I need to create new shapes, manipulating it to appear in some cases defiantly weightless. My work is about repetitive sequencing with separate elements to form a cohesive sculptural group. I am principally interested in large-scale wall installation projects.

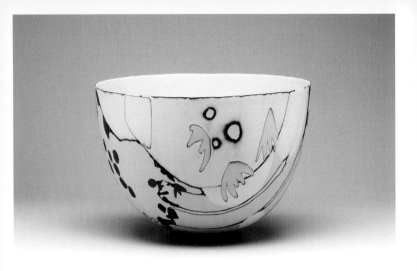

SUSAN NEMETH Fellow

97 Albion Road, London N16 9PL
TEL 07855 002 678 **EMAIL** susannemeth@talktalk.net
WEB www.chocolatefactoryn16.com/susannemeth • Visitors welcome by appointment

Susan Nemeth trained at Wolverhampton Polytechnic (1975-1978) and the Royal College of Art, London (2010-2012). She exhibits in Britain and abroad, and has work in public and private collections.

Nemeth

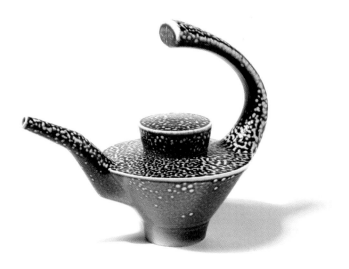

JEREMY NICHOLS

Baas Farm Studios, Baas Hill, Broxbourne, Hertfordshire EN10 7PX
TEL 020 8961 0409 EMAIL info@jeremynichols.co.uk WEB www.jeremynichols.co.uk
Visitors welcome by appointment

I make salt-glazed domestic pots that are designed to be both functional and visually interesting, and to possess a sense of movement and balance in the way they look and handle. This work has been evolving since 1998 when I started experimenting with open handles as an alternative to the closed loops conventionally used in ceramics. The handle continues to be the starting point for the designs, which are otherwise influenced by early interests in aviation and the precision of engineered objects (I have a degree in aeronautical engineering), together with interests in modernist design and contemporary architecture.

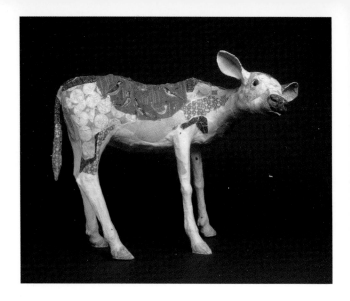

SUSAN O'BYRNE

Glasgow Ceramics Studio, WASPS, 77 Hanson Street, Glasgow G31 2HF
TEL 01415 508 030 EMAIL susanobyrne@hotmail.co.uk WEB www. susanobyrne.com
Visitors welcome by appointment

My ceramic animals are creatures that inhabit other, imaginary
worlds. Each animal is inspired and informed by my perceptions
of what that world might be like. During making I'm engaged in a
dialogue with the work; I need it to lead me and surprise me. I sketch
out a wire framework, onto which pieces of patterned porcelain paper
clay are added. It's impossible to prevent the thin wire meandering this
way and that; elements of chance like this and the shrinkage of the
clay around the framework during firing are allowed to help dictate the
final posture of the animal.

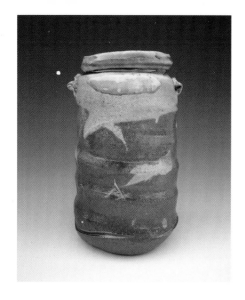

MARCUS O'MAHONY

Glencairn Pottery, Lismore, Co Waterford, Ireland
TEL 0035 3585 6694 EMAIL moceramics@eircom.net WEB www.marcusomahoney.com
Visitors welcome by appointment

I established Glencairn Pottery near Lismore, Co Waterford, Ireland, in 1993. The pots I make are generally wheel-thrown and functional. I attempt to make pots that express my love of the material and the ceramic process. When throwing with soft clay I try to capture a sense of immediacy, movement, and freshness in my forms. The pots are further developed by altering the forms. The work is decorated with a variety of slips, and celadon and shino glazes. I then fire the work in a three-chambered wood-fire kiln, which I increasingly find to be a compelling part of the creative process. I also run workshops and courses at the pottery.

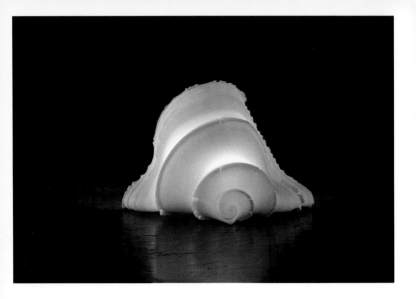

MARGARET O'RORKE

Corpus Christi Farm House, Sandford Road, Littlemore, Oxford OX4 4PX
TEL 01865 771 653 EMAIL margaret.ororke@btinternet.com WEB www.castlight.co.uk
Visitors welcome by appointment

Margaret trained in painting at Chelsea School of Art, and in ceramics
at Camberwell School of Art, London. She set up her studio in 1980.
The translucency of fine high-fired porcelain led her to create thrown,
fine sculptural forms that give light. She has exhibited and given
workshops in many countries. She has developed cast lit porcelain
forms designed for industrial manufacture in Stoke-on-Trent and
Jingdezhen, China. In 2010 her book *Clay, Light and Water* was published.
A former Visiting Creative Fellow, she is now an Honorary Member of
Common Room at Wolfson College, Oxford. Commissions welcome.

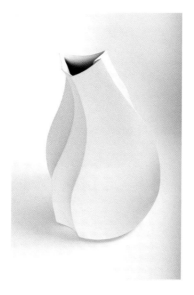

JAMES OUGHTIBRIDGE

3 Field End Lane, Holmfirth, Huddersfield, West Yorkshire HD9 2NH
TEL 01484 680 312 EMAIL jamesoughtibridge@yahoo.co.uk
WEB www.jamesoughtibridge.co.uk • Visitors welcome by appointment

Curved sections of clay are constructed with numerous planes and perspectives, inviting the viewer to peer inside to a world of contorted shadows. Sculptures often appear to float, with no visible flat base, creating a tension with their surroundings. The structures, initially overpowering, hold delicate and enticing surfaces, with many hours spent refining, scraping, and sanding the clay to create gentle, flowing curves. Layers of underglaze, stains, and oxides are applied and are fired to 1240°C. The dark and light granulated surface and imposing colour creates shadows and areas that invite a closer inspection.

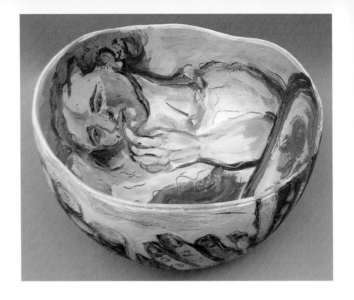

JITKA PALMER

3 Florence Park, Westbury Park, Bristol BS6 7LS
TEL 01179 243 473 EMAIL jitkapalmer@gmail.com WEB www.jitkapalmer.co.uk
Visitors welcome by appointment

My work is figurative, expressive, and narrative. I love watching people, their body language, and facial expressions. I am on the lookout for special moments and situations that accompany every human activity. My sketchbooks are a valuable source of ideas and inspiration for me. I coil and pinch large clay vessels; their curved surfaces are my canvases. I paint them freely with oxides and slips. I model from life, using stoneware and earthenware clay. I love working to commission. In this complicated world I draw on personal experiences, past and present, with a view to reflect the spontaneity of ordinary human life.

Jitka

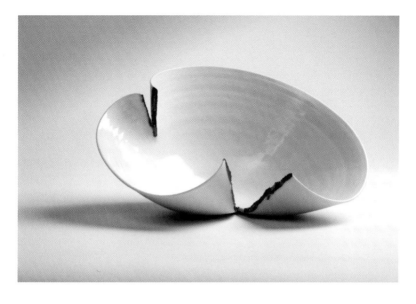

SUE PARASKEVA

22a Green Street, Ryde, Isle of Wight PO33 2QT
TEL 07968 336 485 EMAIL sue@paraskevapots.com WEB sueparaskeva.co.uk
Visitors welcome by appointment

Throwing porcelain on a momentum wheel and reduction firing in
a gas kiln have been fundamental to the creation of my work during
the last sixteen years. Altering these finely thrown porcelain forms
dramatically by throwing or hitting them, creates splits in the perfect
form. I use oxides and slips to bring colour to this expressive mark
(video on my website). I also throw porcelain tableware and a range of
stoneware/porcelain mixes using recycled porcelain. The bowls are
altered, offering their contents, and the plates are simple and strong,
glazed inside, unglazed outside.

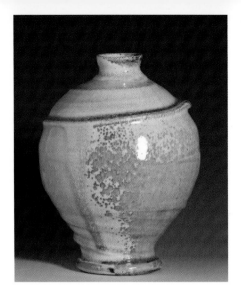

STEPHEN PARRY

Ryburgh Pottery, May Green, Little Ryburgh, Fakenham, Norfolk NR21 0LP
TEL 01328 829 543 EMAIL sparry@gofast.co.uk WEB www.spwoodfiredceramics.co.uk
Large showroom at the pottery open all year; please phone first

After training at Croydon College of Art and then Dartington Pottery,
I set up my present pottery in Norfolk in 1981. The pots are thrown
on a momentum wheel using porcelain and stoneware clays. They
range from large individual pieces, some up to five feet tall, to smaller
domestic ware. All pots are wood-fired, some glazed with wood ash
then fired in a 120 cu.ft. downdraft kiln, while others are fired in an
anagama kiln for three to four days.

JANE PERRYMAN Fellow

Wash Cottage, Clare Road, Hundon, Suffolk CO10 8DH
EMAIL jane.perryman@btinternet.com WEB www.janeperryman.co.uk
Visitors welcome by appointment

Trained at Hornsey College of Art and Keramisch Werkcentrum.
My work alludes to the timeless vessel form as well as referencing
contemporary urban architecture. It explores tension and balance,
where two forms are placed together, and the ambiguity of weight
through internal volume. The composite pieces are not static and
invite interaction through repositioning into new compositions.
Exhibits and lectures internationally and has work in public and
private collections worldwide. Published books: *Smoke Fired Pottery*
(1995), *Traditional Pottery of India* (2000), *Naked Clay* (2004), and *Smoke
Firing Contemporary Artists & Approaches* (2008) – all A&C Black.
Member of the International Academy of Ceramics.

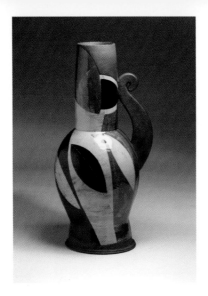

RICHARD PHETHEAN Fellow

2 Hillfield, Sibford Ferris, Banbury, Oxfordshire OX15 5QS
TEL 01295 780 041 EMAIL richard@richardphethean.co.uk
WEB www. richardphethean.co.uk • Visitors welcome by appointment

Richard trained at Camberwell School of Art and Crafts, London, and
in the studios of tutor Colin Pearson and Janice Tchalenko during
the 1970s. He makes thrown, altered, and assembled vessels using
coarse textured terracotta with brushed slips and resist techniques.
His current work combines references to ancient pottery, European
slipware traditions, and twentieth-century abstract painting. For over
thirty years, Richard has been a visiting teacher and demonstrator
of throwing at many colleges, centres, and symposia, and has
run intensive short courses at his studio. He is an author of three
publications on throwing techniques.

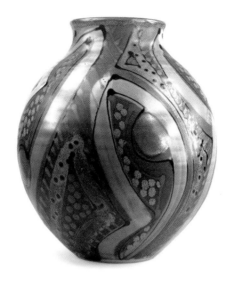

LEA PHILLIPS

Unit 2, Coombe Park, Ashprington, Totnes, Devon TQ9 7DY
TEL 07736 371 427 EMAIL lea.phillips@virgin.net WEB www.leaphillips-pottery.co.uk
Studio open Mon-Sat, 11am-6pm; please phone first

I make a range of high-fired stoneware pots, as well as some larger, one-off pieces. All pots are thrown on the wheel; I like simple well-defined forms, which grow naturally out of the making process. I am also a compulsive decorator and my surface designs reflect a long-standing interest in pattern and colour. The pots are individually decorated with free and abstract designs using multiple layers of colourful stoneware glazes.

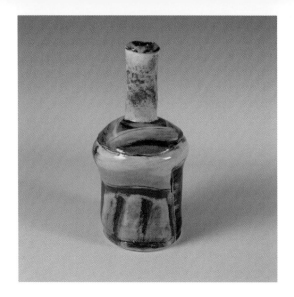

JOHN POLLEX Fellow

Stowford House, 43, Seymour Ave, St Judes, Plymouth, Devon PL4 8RB
TEL 01752 224 902 EMAIL john@johnpollex.co.uk WEB www.johnpollex.co.uk
Visitors welcome by appointment

Studied as technician on the Harrow Pottery course from 1968-70 and then as assistant to Bryan Newman and Colin Pearson. I moved to Plymouth in 1971 and established a reputation making traditional slipware. In the 1980s I felt the need to change direction and bring colour into my work. I dispensed with slip-trailers in favour of paintbrushes and sponges, and more recently plastic spatulas; intensely coloured earthenware slips are applied in a free and painterly abstract manner. The change has been clean and dramatic and appears to owe nothing to the slipware of before. I consider the pots to be canvases upon which to paint the images that appear on them.

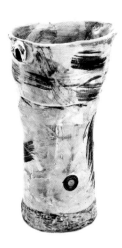

PHILOMENA PRETSELL

Rose Cottage, 10 Fountain Place, Loanhead, Midlothian EH20 9EA
TEL 0131 440 0751 EMAIL philomenapretsell@hotmail.co.uk
Visitors welcome by appointment

Influenced by various painting and printmaking methods, I make
marks on the clay using brushes, sticks, found objects, and my fingers.
The various domestic vessels are then dipped in stains, slips, and
oxides, or mono-printed, helping to define the form. Often playful in
content, the pots are completed by the addition of open stock transfers
and personally researched images from contemporary life. The
challenges of handbuilding offer a never-ending source of discovery
and pleasure. Work can be found in various public and private
collections at home and abroad, including Museo Internationale,
Faenza; Aberystwyth Arts Centre; and the British Council.

MARIE PRETT

Singing Soul Gallery, 19 Stone Street, Cranbrook, Kent TN17 3HF
TEL 01580 714 551 EMAIL marieprett@yahoo.co.uk WEB www.singingsoulgallery.co.uk
Visitors welcome by appointment

Marie's work is about the human and animal form, with an interest in the narrative of the magic of transformation, an expression for the desire for mischief, passion, and wild magic, with snippets of everyday life thrown in. Her work has been described as 'sensual and gently mischievous'. She says of her work, 'It is my constant aim to create an infusion of energy, movement, colour, and humour in each piece, to inspire curiosity and to make people smile.' In December 2010 Marie opened the Singing Soul Gallery, a contemporary art and craft gallery, showing work from many leading artists and craftspeople.

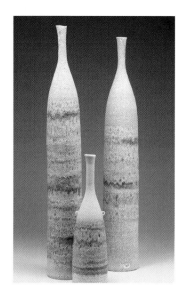

JACQUI RAMRAYKA

Archway Ceramics, 410 Haven Mews, 23 St Paul's Way, London E3 4AG
TEL 07973 771 687 EMAIL jacqui.ramrayka@virgin.net WEB www.jacquiramrayka.com
Visitors welcome by appointment

Jacqui Ramrayka trained at Harrow College, University of
Westminster, London. She graduated in 1994, gaining a BA(Hons) in
ceramics. Before embarking on this course she travelled extensively
around South East Asia and the Caribbean; these experiences have
been a great influence on her work. Currently, she works from her
studio, a converted railway arch in the East End of London, which
she set up with three other potters after leaving college. From here
she produces a range of mainly thrown ceramics, working in series
and making one-off pieces, using richly textured and vibrantly
coloured glazes.

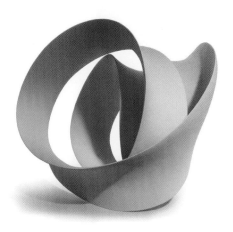

MERETE RASMUSSEN Fellow

4a Vanguard Court, 36-38 Peckham Road, London SE5 8QT
TEL 07908 866 241 EMAIL mr@mereterasmussen.com WEB www.mereterasmussen.com
Visitors welcome by appointment

I work with abstract sculptural form. I am interested in the way one defines and comprehends space through physical form. I am intrigued by the idea of a continuous surface, with one connected edge running through the whole form. Soft curves contrasting with sharp edges; concave shifting to convex surface; the discovery and strength of an inner/negative space – these are all form expressions that appeal to me and result in my continuous exploration and expression in many different variations.

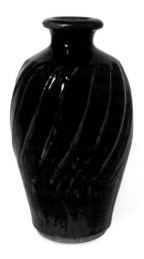

NICK REES Fellow

Muchelney Pottery, Muchelney, nr Langport, Somerset TA10 0DW
TEL 01458 250 324 EMAIL nick@nickreespotter.co.uk WEB www.nickreespotter.co.uk
Visitors welcome by appointment

Nick celebrates forty years at Muchelney Pottery in 2012. The Leach tradition has given a clear foundation with technique, form, and process, while Nick's personal pieces also showcase a subtle and refined approach to shape and design, accentuated through carving, fluting, and experimentation with slips and glazes. This surface detail combined with the uniqueness afforded by the wood-firing process, allows Nick to produce a range of work that is both distinctive and organic. The addition of an electric kiln at Nick's home studio sees a new journey begin, as he explores other avenues for the future of his potting.

MUCHELNEY

ANETA REGEL DELEU

The Chocolate Factory, Unit G2, Farleigh Place, London N16 7SX
TEL 07726 910 182 EMAIL anetaregel@yahoo.co.uk WEB www.anetaregel.com
Visitors welcome by appointment

Polish-born Aneta Regel Deleu combines the natural qualities of materials such as organic rock with malleable materials such as clay. 'Seeing them fight against each other,' says Aneta, 'reinforces the sense of movement and transformation that objects undergo throughout the making process.' In Aneta's mostly abstract forms stone mixed with clay is offset with dramatic, often radioactive colours, and the textures are equally unusual – all of which serve to heighten the tension reflected within the work. She studied sculpture in Gdansk and ceramics at the Royal College of Art, London. She held a Crafts Council Development Award and has exhibited in Korea, Europe, and the UK.

Aneta Regel Deleu

MARY RICH Fellow

The Pottery, Cowlands Creek, Kea, Truro TR3 6AT
TEL 01872 276 926 EMAIL mary@maryrich.co.uk WEB www.maryrich.co.uk
Visitors welcome by appointment

Mary Rich has been working as a full-time potter in Cornwall since 1962. The work is hand-thrown porcelain, mostly decorated with liquid bright gold and lustres. She is a Member of the Devon Guild of Craftsmen and the Cornwall Crafts Association.

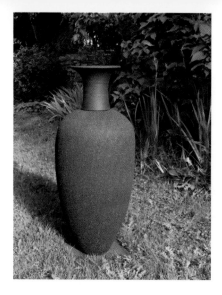

CHRISTINE-ANN RICHARDS Fellow

Chapel House, High Street, Wanstrow, Somerset BA4 4TE
TEL 01749 850 208 EMAIL mail@christineannrichards.co.uk
WEB www.christineannrichards.co.uk • Visitors welcome by appointment

Having trained at Harrow School of Art under Mick Casson, Christine-Ann's interest in porcelain led her to work for David Leach before founding her first workshop in London in 1975, where she specialised in monochrome and crackle glazes. The 1978 CPA China trip consolidated the influence of the East on her ceramics, and continued visits, sometimes accompanied by other artists, have carried on that exchange. A Winston Churchill Travelling Fellowship to Japan in 1996 to 'look at the way water is used in landscape and architecture' has been an ongoing source of inspiration for her larger garden ceramics. Works to commission.

CAR (CAR)

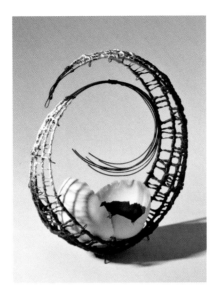

LESLEY RISBY

113 Draycott Avenue, Harrow, Middlesex HA3 0DA
TEL 020 8907 5600 EMAIL mail@lesleyrisby.co.uk WEB www.lesleyrisby.co.uk
Visitors welcome by appointment

With nature as a starting point I am examining the essence of fragility
and vulnerability. The skeletal nature of the work represents the
susceptibility of living organisms to environmental forces. My main
materials are porcelain and nichrome wire; the addition of oxides,
stains, and silicon carbide produces stark contrasts in colour and
texture. The work is mainly raw-glazed and fired to cone 7 in an
electric kiln. The disparate qualities of the materials produce a
visual and physical tension, causing a partial fragmentation and
apparent fragility of the pieces, while retaining the essential
potency of their forms.

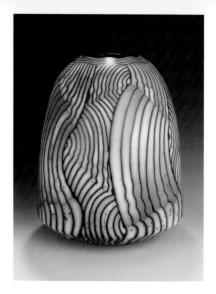

DAVID ROBERTS Fellow

Cressfield Barn, 60 Upperthong Lane, Holmfirth HD9 3BQ
TEL 01484 685 110 **EMAIL** david@davidroberts-ceramics.com
WEB www.davidroberts-ceramics.com • Visitors welcome by appointment

David Roberts is well known for his large scale, coil-built and raku-fired ceramics. His work has been exhibited throughout the UK and abroad, and is represented in many UK and international public collections. He has recently established a second studio in northern Tuscany where he presents regular summer workshops and also engages in personal research and drawing. In 2009 a second edition of his book *Painting With Smoke* was published by Greendrake Press. David Roberts is a Member of the International Academy of Ceramics.

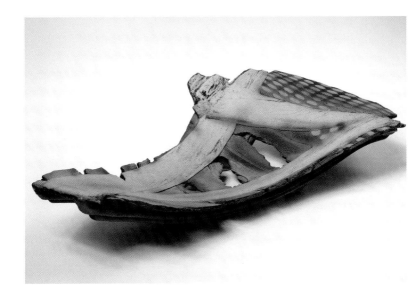

JIM ROBISON Fellow

Booth House Gallery, 3 Booth House Lane, Holmfirth HD9 2QT
TEL 01484 685 270 EMAIL jim.robison@boothhousegallery.co.uk
WEB www.jimrobison.co.uk • Visitors welcome by appointment

Born and educated in the US, in 1972 Jim came to Yorkshire, where he
lives and works. His Booth House Gallery and Studio has promoted
artist/potters since 1975. The work is usually slab-built, often large-
scale, and combines multiple layers of clay and slip with a painterly
application of glazes. A range of functional work is also produced with
the assistance of Jane Barker. All works are stoneware, reduction-fired
using a gas kiln. He regularly gives presentations to ceramic groups
and has written for numerous ceramic publications. He is author of
Large Scale Ceramics and co-author of *Slab Techniques*.

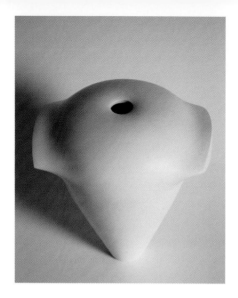

LORRAINE ROBSON

Linlithgow, West Lothian, Scotland
TEL 07939 301 721 EMAIL info@lorrainerobson.co.uk WEB www.lorrainerobson.co.uk
Visitors welcome by appointment

Lorraine Robson makes beautiful, thought-provoking, handbuilt ceramics that pay homage to ancient skills while embracing contemporary influences. She creates intuitively, fusing ideas and drawing on a kaleidoscope of images and observations to make work with a unique identity, balanced between manufactured, machine made, and organic references. Her ceramics, often dictated by classic vessel form and containment, are not designed as functional. Coiling is her method of construction, with slab and pinching for more complex forms. The surface is refined using metal scrapers and worked using abrasive papers when dry. Each vessel is fired a minimum of three times, the surface sanded and polished using silicon carbide, then diamond abrasives, between each firing.

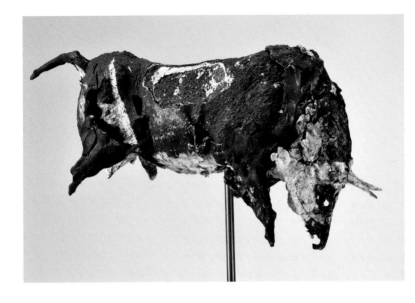

EMMA RODGERS Fellow

Ridgewood, Noctorum Road, Noctorum, Wirral, Cheshire CH43 9UQ
TEL 0151 652 8919 EMAIL emma@emmarodgers.co.uk WEB www.emmarodgers.co.uk
Visitors welcome by appointment

'Emma Rodgers' art gets straight to the core of her subject. She really inhabits the spirit of her creatures, just as they inhabit hers. It is about the flesh and bone beneath the skin, pulsing visceral forms that express the physicality and raw energy of the animal world. There is something dark about this vision too – nature at its most untamed. Her creative process involves not only great technical skill and acute observation, but a powerful intuition and imagination. This is what makes Emma's work so fresh and alive.' (David Whiting)

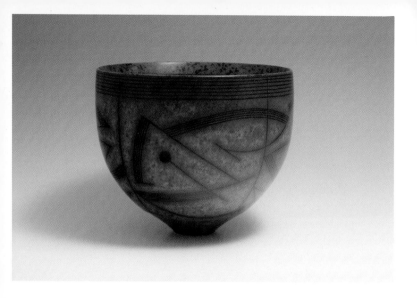

DUNCAN ROSS Fellow

Daneshay House, 69A Alma Lane, Upper Hale, Farnham, Surrey GU9 0LT
TEL 01252 710 704 **EMAIL** duncanross.ceramics@virgin.net
WEB www.duncanrossceramics.co.uk • Visitors welcome by appointment

Duncan Ross established his studio near Farnham, Surrey, in 1989 after a period of exploration into terra sigillata techniques. His work is thrown and burnished using many layers of a fine terra sigillata slip with resist and inlay decoration. Colours are achieved by smoke firing. He aims to develop a rich surface integral to the clay that has a feeling of depth, allowing the smoke process to play its essential and unpredictable part. His work is represented in many important public and private collections, including the Victoria and Albert and Fitzwilliam Museums. He is on the Crafts Council Index of Selected Makers.

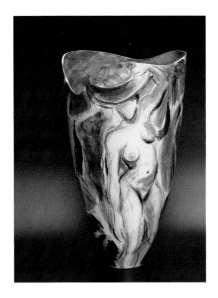

INGRID SAAG

57 Cobham Road, Kingston Upon Thames, Surrey KT1 3AE
TEL 020 8974 5465 / 07917 608 218 **EMAIL** info@ingridsaag.com **WEB** www.ingridsaag.com
Visitors welcome by appointment

Drawing on my past life as an illustrator, I paint on my pots. Artists such as Pablo Picasso and Ivon Hitchens have been a major influence. The human figure is a favourite subject, sometimes with reference to incidents in my life, or inspired by poetry and other written material about human passions. Landscape and the natural world are also a huge inspiration for much of my more abstract designs. Most of my work is slip-cast in white earthenware clay. Some pieces are altered after removal from the mould.

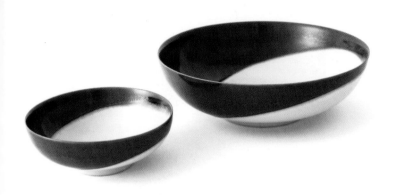

SULEYMAN SABA

64 Grosvenor Terrace, Camberwell, London SE5 0NP
TEL 020 7277 1812 **EMAIL** oilspot@tiscali.co.uk **WEB** www.suleymansaba.com
Visitors welcome by appointment

After formal studies at the Camberwell College of Arts, London,
Suleyman Saba pursued an apprenticeship with Kevin Millward at the
Gladstone Museum in Stoke-on-Trent. A London-based workshop was
established in 1997. A range of stoneware bowls, vases, and tableware
is produced and decorated with celadon and iron-saturated glazes and
fired to 1280°C. His work is highly sought-after by collectors, and is held
in the public collections of the Ashmolean (Oxford), National Gallery
of Wales, York Art Gallery, and Art Gallery of South Australia. He is a
professional Member of the CPA and Contemporary Applied Arts.

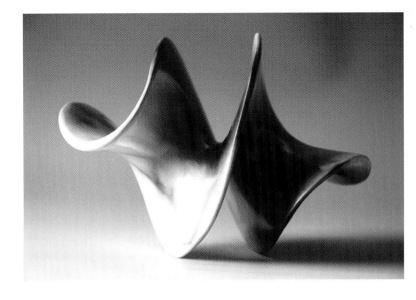

ANTONIA SALMON Fellow

20 Adelaide Road, Nether Edge, Sheffield S7 1SQ
TEL 01142 585 971 **EMAIL** antoniasalmon@blueyonder.co.uk
WEB www.antoniasalmon.co.uk • Visitors welcome by appointment

The forms that I am most drawn to have clarity of line or strong
underlying geometry. I am inspired by forms in the natural world
and traditional artefacts. Within each work my interest is in capturing
a quality of movement and also a quality of stillness. The processes
of handbuilding and honing forms, burnishing, and smoke-firing the
finished pieces imbue a subtle depth and timelessness to this work.
Antonia's work is represented in public and private collections in
Europe, North America, and Japan. She is a CPA Fellow, a Member
of the Society of Designer Craftsmen, and is on the Crafts Council
Selected Index.

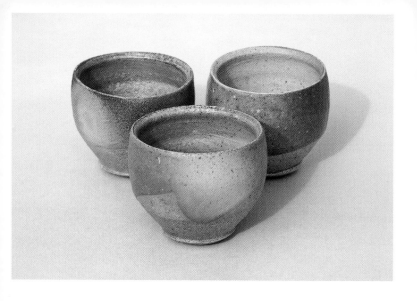

ROBERT SANDERSON Fellow

PO Box 612, Scariff, Co Clare, Ireland
TEL 00353 6192 2918 EMAIL robert@thelogbook.net WEB www.thelogbook.net

I have been wood firing since graduating from Bournemouth and Poole College of Art in 1975. Currently living in Ireland with my wife Coll Minogue, together we founded *The Log Book* – the international wood-fired ceramics publication in 2000, which is published quarterly. We also wrote *Wood-fired Ceramics: Contemporary Practices* (A & C Black). Grants: British Council, British American Arts Association. Awards: Scottish Arts Council Crafts Bursary; Winston Churchill Travelling Fellowship. Have conducted wood-fire kiln building workshops in Canada, Denmark, Sweden, South Africa, and the UK. My work has evolved to reflect that spontaneity found only by firing with wood, accepting the unpredictable and anticipating the unknown.

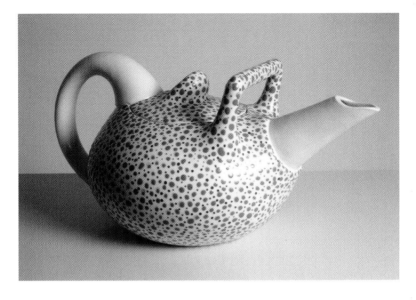

COLIN SAUNDERS

3 Chapel Cottages, Withersdale Street, nr Harleston, Norfolk IP20 OJG
TEL 01379 588 278
Visitors welcome by appointment

Pieces often evolve from a hunch or from a request for something practical. They might then develop in unforeseen ways, sometimes remaining functional, sometimes not. Modelling in soft clay is the technique I enjoy most. The resulting forms might then be translated into plaster moulds for slip-casting. Standard industrial glazes usually prove enough to complete a piece, but if they fail to, I will fire and fire again, using colours and transfers, until the piece emerges with either that elusive quality of surprise, or with a look that satisfies me I have done my best.

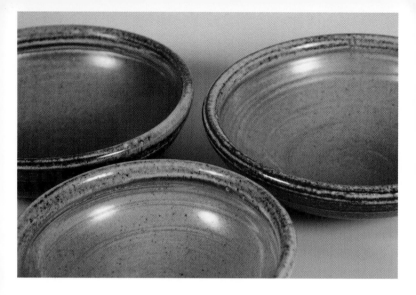

MICKI SCHLOESSINGK Fellow

Bridge Pottery, Cheriton, nr Llanmadoc, Gower, Swansea SA3 1BY
TEL 01792 386 499 EMAIL micki@mickisaltglaze.co.uk WEB www.mickisaltglaze.co.uk
Gallery open Easter to Christmas, Tues-Sat

Micki Schloessingk trained in studio pottery at Harrow School of Art
and has since been exploring the challenging process of wood-firing
and salt-glazing. Micki makes a range of individual and functional
pots, both thrown and handbuilt. She established her present studio,
Bridge Pottery, on the Gower peninsula in South Wales in 1987.
Visitors to the Gallery are very welcome. Please phone or check website
for opening times.

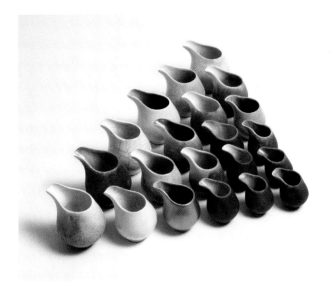

KATE SCHURICHT

The Old Farmhouse, Frogs Hill, Newenden, Kent TN18 5PX
TEL 07786 576 039 EMAIL kate@kateschuricht.com WEB www.kateschuricht.com
Visitors welcome by appointment; specialist short courses offered

I specialise in raku and stoneware slip-cast ceramics in subtle glazes and smoky finishes. Boxes, jugs, vessels, and containers are arranged as small scale installations, placed to highlight the relationships between the interior and exterior of the pieces. Wood, slate, and precious metal gilding are combined with the ceramics to create a sense of balance and harmony. I have recently developed a series of curvaceous cast and assembled jugs that are either tilted or upright, evoking a sense of movement and interplay. Positioned in groups, they appear animated, capturing fleeting moments of conversations and intimate human connections.

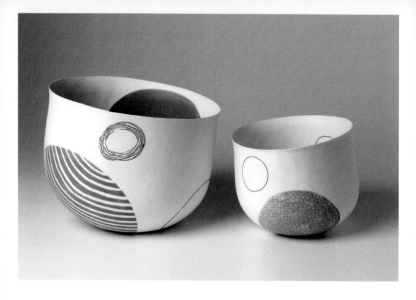

LARA SCOBIE

1 Claremont Bank, Edinburgh EH7 4DR
TEL 01315 566 673 EMAIL lmscobie@dundee.ac.uk WEB larascobieceramics.com
Visitors welcome by appointment

My current work is predominantly concerned with the dynamic
interplay between form and pattern. This is explored through the
cohesive integration of drawing, surface mark making, and volume. I
am interested in the space that surrounds pattern as much as the hue
and texture of the decorated surface. This theme has been developed
further within my tilted bowls, which articulate the symbiotic
relationship between pattern and form. I studied at Camberwell,
London, and Edinburgh College of Art, and have been making
ceramics for over twenty years. Throughout my career I have exhibited
extensively and have work in both private and public collections.

Lara Scobie

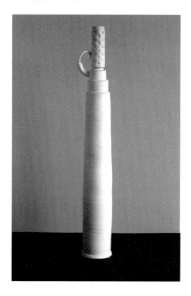

DAVID SCOTT Fellow

9 Fosse Way, Radford Semele, Leamington Spa, Warwickshire CV31 1XQ
TEL 01926 613 560 EMAIL d.scott1@lboro.ac.uk
Visitors welcome by appointment

The work are mainly vessel forms. The functional wares are often finely made wheel-thrown teapots, cups and saucers, tea bowls, etc, drawing on diverse influences such as eighteenth- and nineteenth-century industrial wares and certain Chinese periods. The more expressive pieces can be interpretations of usable pottery or simply one–off 'statement' pieces. I am a lecturer in the School of the Arts at Loughborough University, teaching principally in the BA 3D and MA studio ceramics programmes, and have recently moved to Warwickshire, where I am currently re-establishing my studio.

David Scott

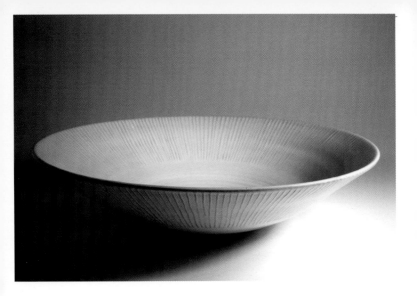

KATE SCOTT

21 Iliffe Yard, Kennington, London SE17 3QA
TEL 020 7622 0571 EMAIL katescott102@gmail.com WEB www.katescottceramics.co.uk
Visitors welcome by appointment

I make tin-glazed earthenware. I use terracotta, which shows through
the glaze and softens its whiteness. Decoration is by slip-trailing or by
painting with cobalt oxide.

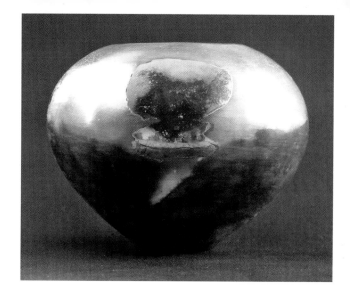

CLAIRE SENEVIRATNE

15 Romeo Arbour, Warwick Gates, Warwick CV34 6FD
TEL 07972 634 455 **EMAIL** claire@seneviratne.co.uk **WEB** www.claireseneviratne.co.uk
Visitors welcome by appointment

My work is concerned with strong contrasts, for which I use very light and dark glazes or different smoke-firing techniques. I try to capture the 'essence' of a feeling, such as the experience of seeing a dramatic landscape or the pleasure of hearing beautiful music. Glazes and lustres are used to create texture, circles, lines, and curves. The vessels are all carefully hand-painted or burnished, and often smoke-fired. I strive to balance the painting on the vessel with the form itself to create a joyful harmonic counterpoise.

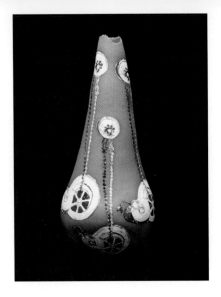

GEORGIA SHEARMAN

27 Stevens Crescent, Totterdown, Bristol BS3 4UH
TEL 01179 710 071 EMAIL injoygeorgia@hotmail.co.uk WEB www.studiopottery.co.uk
Visitors welcome by appointment

I work out some of my personal, social, and political issues through my pot making. I aspire to make work that embodies an aesthetic awareness, and also holds ideas and wisdom. This is expressed through repeat images, often of domestic objects. The work is mostly coil-built in terracotta clay. I make my drawings into decals, firing them onto glaze, leaving the red clay exposed. The pots are sometimes sprigged and painted with underglaze colours and lustres.

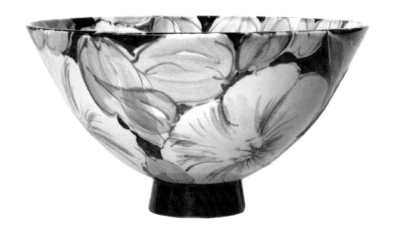

SHELTON POTTERY

18 Heath End Road, Alsager, Stoke-on-Trent ST7 2SQ
TEL 01270 872 686 **EMAIL** sheltonpottery@aol.com **WEB** www.sheltonpottery.co.uk
Visitors welcome by appointment

Ken throws the pots as finely as possible and turns them so they are
light and smooth, creating a canvas for Valerie's painting. Ken is a
consultant to the craft pottery industry; years of contact with many
of the leading potters has informed and inspired his shapes. Trained
in fashion and textiles, Valerie's painting brings a brightness and
spontaneity unusual in ceramics. She works freehand on bisque using
underglaze colours. Paint is applied with a watercolour technique,
allowing light to reflect through the colour to give added depth.
Pots are glazed with a transparent low-solubility glaze, producing
a brilliant shine.

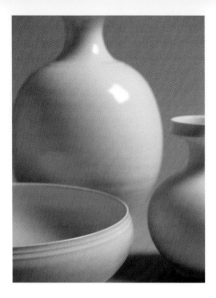

ANNA SILVERTON

41 Burghill Road, London SE26 4HJ
TEL 020 8659 0767 **EMAIL** annasilverton@hotmail.com
Visitors welcome by appointment

I trained at Camberwell and then the Royal College of Art, London, graduating in 1987. All my vases and bowls are wheel-thrown as individual pieces. I like to interrupt and repeat structures to find new combinations of classic form. I then repeat and refine the process, giving emphasis with subtle details to edges and curves with texture and/or inlay. I have two clay ranges: unglazed polished cream stoneware and glazed oxidised porcelain in shades ranging from pure white to vivid yellow, for example. My pots vary in scale from 65cms down to 16cm.

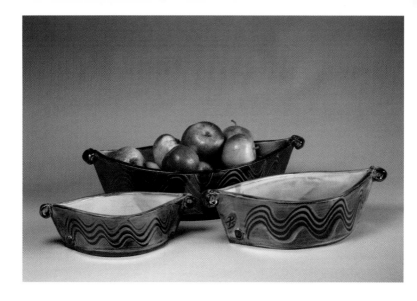

PENNY SIMPSON

The Studio, 44a Court Street, Moretonhampstead, Devon TQ13 8LG
TEL 01647 440 708 EMAIL psimpson@thestudiopots.fsnet.co.uk
WEB www.pennysimpsonceramics.co.uk • Open Mon-Fri, 9.30am-5pm; Sat, 10am-12 noon

Penny Simpson started making pots during a three-year stay in Japan. She is the author of *The Japanese Handbook* (Kodansha 1979). During 1979-81 Penny trained at Dartington Pottery in Devon. Penny uses red earthenware clay, decorated with coloured slips, to produce a range of hand-thrown domestic ware. She loves cooking and is especially interested in making pots for the presentation of food. She also decorates tiles, making panels for kitchens and bathrooms as well as a range of individual tiles. She sells a full range of work from her own showroom and also exhibits widely in the UK and Japan.

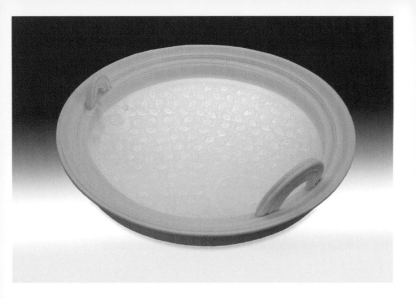

ELIZABETH SMITH

Millhead House, Millhead, Bampton, nr Tiverton, Devon EX16 9LP
TEL 01398 331 442 EMAIL smithmillhead@aol.com WEB www.crafts.org.uk
Visitors welcome by appointment

I make elegant white translucent bone china vessels and handbuilt forms with thrown additions. A tactile impressed decoration, using my own hand-carved clay stamps, complements smooth sensuous wet/dry polished surfaces. I am motivated to search for ways in which the form, function, and patterns of my work might evolve to enhance the translucent qualities of the fired clay and produce pieces that will dominate a space in a dramatic way. The predominance of symmetry and grace in my work is inspired by a two-year artist's residency at Sultan Qaboos University, Muscat, Oman, in the Middle East.

MARK SMITH

61 High Street, Rocester, Staffordshire ST14 5JU
TEL 01889 591 311 **EMAIL** mark@marksmithceramics.com
WEB www.marksmithceramics.com • Visitors welcome by appointment

Mark's work is inspired by coastal life, architecture, and the effects the natural environment has on materials such as wood, metal, and stone. The main fabric of the work is ceramic with additions of reclaimed timber and metal. The pieces have impressions of found objects discovered on journeys. They are finished in matt colours, which give the impression of sea-bleached, painted timber. Each piece has a story to tell.

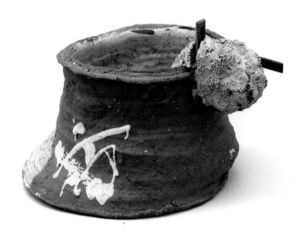

PETER SMITH Fellow

Higher Bojewyan, Pendeen, Penzance, Cornwall TR19 7TR
TEL 01736 788 820 EMAIL petersmith1@lineone.net WEB petersmithceramics.com
Visitors welcome by appointment

Most of my work is in earthenware, using various body mixes and often left unglazed. This lays a visual stress on the fired characteristics of the body, making techniques, and form. I have written occasional articles on aesthetic/technical matters, recently 'The First Leach Climbing Kiln', published in *The Log Book 2011*.

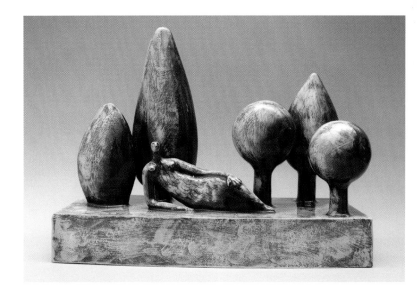

JENNY SOUTHAM

11 Prospect Park, St James, Exeter, Devon EX4 6NA
TEL 01392 437 555 EMAIL jennysoutham@fsmail.net WEB www.jennysoutham.co.uk
Visitors welcome by appointment

Recently, a number of new directions have opened up with my figurative sculptures. These include a large series of small individual sculptures of birds and trees where I find the high level of decorative painterly detail highly absorbing. I have also begun a series of large statuesque horses decorated with glazes. I find the challenge of working with a full range of scales invigorating. The latest pieces have moved my figures into a group of night-time scenes, where humans and wild creatures interact in hidden glades. This doesn't mean that I have abandoned any of my previous narrative approaches, which continue to flourish.

JS

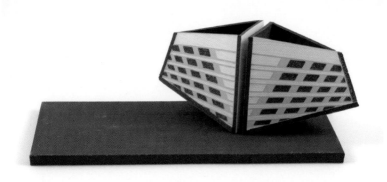

DAN STAFFORD

3 Westfield Cottage, Breach Lane, Lower Halstow, Sittingbourne, Kent ME9 7DD
TEL 07974 770 939 EMAIL contact@danstafford.co.uk WEB www.danstafford.co.uk
Visitors welcome by appointment

Dan's work investigates exterior and interior perspective, man-made structures, industrial landscape, and high-rise architecture. The exploration of composition and the configuration of structures and their component parts are presented as abstract forms. The work continues to investigate a dialogue between physical and emotional responses to optical illusions, pattern, rhythm, and balance. Each piece is slab-built with coloured clay that has been decorated with coloured slips using stencils. The patterns of the stencils are made using a mixture of different techniques to get the desired line, then hand-cut, giving me the ability to add or subtract different layers.

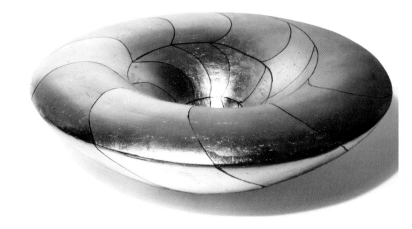

GARY STANDIGE

Yew Tree Barn, Windermere Road, Lindale, Cumbria LA11 6LB
TEL 01539 533 944 EMAIL garystandige@btinternet.com WEB www.garystandige.co.uk
Visitors welcome by appointment

I want to make something of my time, something that reflects the time
in which I live, something of substance, something with resonance.
My main preoccupation is with ideas and their communication,
e.g. *The Mitosis Bowl – Cell Division*. Computer technology is used
for modelling and drawing applications, together with traditional
ceramic techniques. Underlying the work is the all-important process
of drawing. I still work in clay, and in the main, make vessels – it is a
language I understand and a material I love. 'My natural media are the
earth and the pencil. I have drawn all my life. I began with drawing;
I have never stopped drawing.' Auguste Rodin (1913)

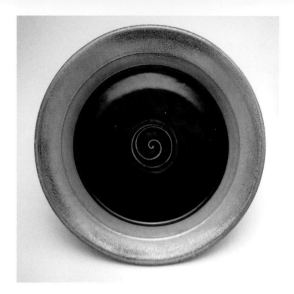

PETER STARKEY

Pine Cottage, The Doward, Whitchurch, Ross-on-Wye, Herefordshire HR9 6B9
TEL 01600 890 823 EMAIL peter.starkey@btinternet.com
Visitors welcome by appointment

Although decorative, my work is essentially useful, rooted in function. Building on the historical continuum of ceramics as well as contemporary issues, my pots show their references while being appropriate to their time. I enjoy the interplay of form, surface, and colour inherent in ceramics. While the use of a pot may dictate shape or scale, it is the outcome of a series of decisions and actions. However, the firing process provides an intuitive phase of making, giving life to the salt-glaze stoneware and porcelain. My work can be found in public and private collections, including the Victoria and Albert Museum, London; the Crafts Council; and Museum of Wales, Aberystwyth.

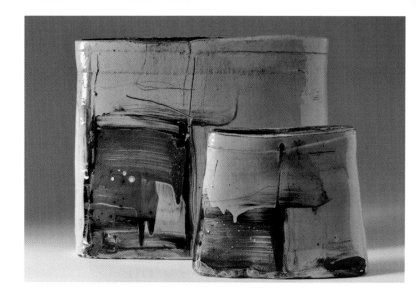

BARRY STEDMAN

113 Station Road, Flitwick, Bedfordshire MK45 1LA
TEL 07932 367 515 **EMAIL** bstedman@btinternet.com **WEB** www.barrystedman.co.uk

The experience of drawing and painting out in the field often inspires and informs my work in clay. I like to draw in places that are exciting to me, which involve the changing patterns of light and weather, sounds, colours, and a sense of anticipation. My work is made with red earthenware clay, thrown and altered, then painted with coloured slips and stains. I try to work intuitively to make vessels that are fluent and lively, with spontaneous marks and gestures, aiming for some kind of meaning and coherence, before the work goes too far and loses its freshness.

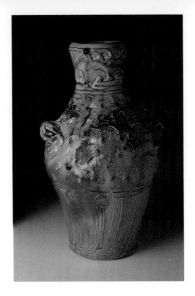

JEREMY STEWARD Fellow

Wobage Farm Workshops, Upton Bishop, Ross-on-Wye, Herefordshire HR9 7QP
TEL 01989 562 498 EMAIL info@jeremysteward.co.uk
WEB www.jeremysteward.co.uk • Visitors welcome by appointment

'Alongside a driving motivation to make a wide range of functional
pots, I am inspired by the soft fluidity of the materials themselves: clay
on the wheel, slip, and raw-glaze. I often draw while the pot is still on
the wheel or after the pot has been slipped. Otherwise, they might be
embellished with stamps, roulettes, brushed resist, or finger wipes,
a vocabulary of abstract marks that are forever changing, but which
consistently provide movement and fluidity in their accentuation or
distortion of form. The pots are wood-fired and salt-glazed.' Jeremy is
available for lecture and demonstration. He leads a diverse programme
of ceramics courses from a dedicated education space at Wobage in
rural Herefordshire.

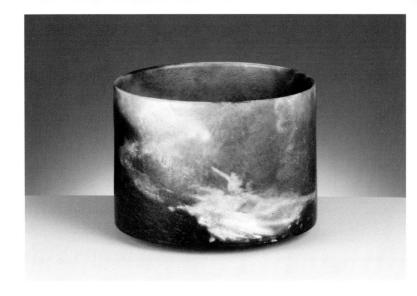

JOANNA STILL

4 Beckford Cottages, Hindon, Salisbury, Wiltshire SP3 6ED
TEL 01747 820 478 EMAIL joanna.still@talk21.com
Visitors welcome by appointment

The vessel remains my primary interest for its historical context and cultural significance, durability, and the information it contains. My development as a potter has evolved over thirty years of studio practice, enhanced and informed by projects in Mexico and Ethiopia, where I have worked with indigenous potters and studied traditional ceramic culture. I make simple smoke-fired forms. Practical considerations of function have shifted as I explore what the vessel can contain or hold in a fundamental sense, what it can reveal, evoke, or recall.

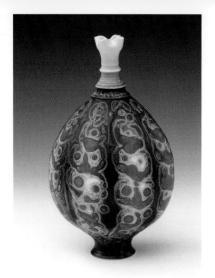

GEOFFREY SWINDELL Fellow

18 Laburnum Way, Dinas Powys, Cardiff CF64 4TH
TEL 02920 512 746 EMAIL geoffswindell@tiscali.co.uk
WEB www.geoffreyswindellceramics.co.uk • Visitors welcome by appointment

Some say my ceramics are like washed-up sea creatures, some still alive, some just remnants turning slowly to dust. Others see unidentified objects from a faraway galaxy, unsure whether they are organic or constructed, friendly or malevolent. They want to touch and take them home in their pockets like a newly found treasure. For over forty years I have been compelled to make these curious forms. Usually they are vases, but sometimes they become teapots, bowls, or jugs. Their creation has given me joy, despair, friends, money, and backache. Over forty museums and public collections own them, including the Crafts Council and the Victoria and Albert Museum, London.

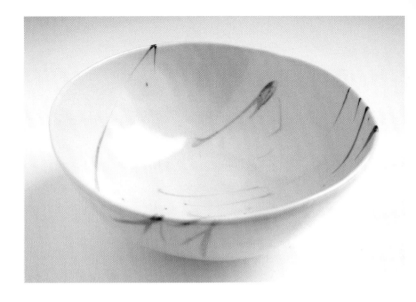

TAJA

38 Cross Street, Moretonhampstead, Devon TQ13 8NL
TEL 01647 440 782 **EMAIL** hitaja@hotmail.com **WEB** www.tajaporcelain.com
Visitors welcome by appointment

Maybe because of my age, my interest in pottery has become much quieter, and I have started to enjoy the tranquillity of porcelain. It suits the Japanese side of my nature. My aim has been to make simple slab-built bowls without any fuss – bowls anyone can use for any occasion. I have been constantly developing a seiji blue glaze to enhance my slab-built porcelain tableware. This will be my ongoing project. The quality of porcelain, its durability and delicacy, suits my aim.

Taja

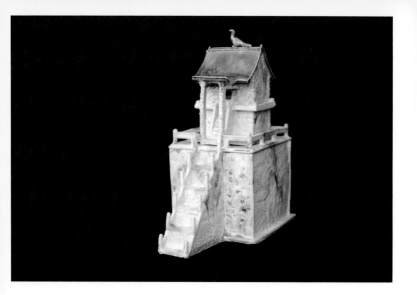

HIRO TAKAHASHI

The Haven, Gare Hill Road, nr Witham Friary, Frome, Somerset BA11 5EX
TEL 01373 836 171 / 07767 279 420 EMAIL hirotakahashi_coates@yahoo.com
Visitors welcome at the showroom; please phone first

I graduated from Bath Academy (Bath Spa University) and I am still
making soul houses and other poetic forms: allegorical boats, the tree
of life, picturesque ruins, and narrative boxes. I combine handbuilding,
throwing, and model-making to create birds and animals in sculptural
forms that represent my inner world. I like the subtle blended colours
of stoneware glazes on a textured surface, but sometimes I also fire my
work raku for a different quality.

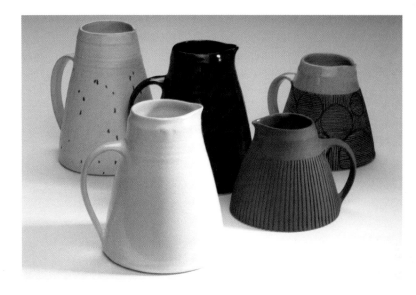

NICOLA TASSIE

Standpoint Studios, 45 Coronet Street, London N1 6HD
TEL 020 7729 5292 EMAIL nicola.tassie@netclick.org.uk
Visitors welcome by appointment

I originally trained as a painter but started working in ceramics soon after leaving college. I established my current studio in London in 1992. My functional pottery consists of a small range of domestic ware – jugs, bowls, bottles – whose surfaces are decorated with incised, grooved, or drawn lines and marks. In my sculptural works I use these forms to create still life groups that explore perception and certain narrative ideas. I exhibit and sell my work in galleries and shops in the UK and Japan.

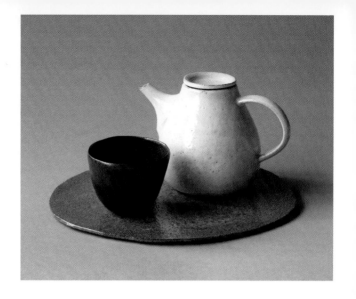

KAORI TATEBAYASHI

401 1/2 Workshops, 401 Wandsworth Road, London SW8 2JP
TEL 07816 422 033 **EMAIL** info@kaoriceramics.com **WEB** www.kaoriceramics.com
Visitors welcome by appointment

For me, making pots is like breathing – a simple, natural thing. I want my work to embody nature and create an experience of it in some small, intimate way. I hope the quietness and simplicity of my work allows it to fit into how different people live and inspires pleasurable use.

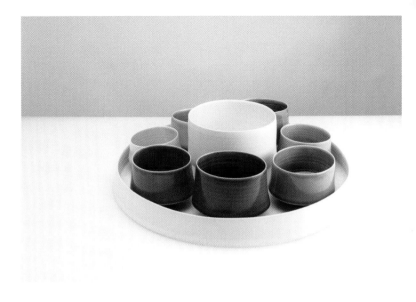

LOUISA TAYLOR

Studio 200, Cockpit Arts, 18-22 Cockpit Arts, Creekside, London SE8 3DZ
TEL 07779 620 130 EMAIL louisa@louisataylorceramics.com
WEB www. louisataylorceramics.com • Visitors welcome by appointment

My inspiration stems from museum collections of eighteenth-century
porcelain. I am fascinated by the rituals of dining and the role of
tableware in contemporary dining. Each piece is thrown in porcelain
and freely assembled. I deconstruct the colours on hand-painted
historical tureens, matching the colours with new glazes. The content
of the decoration informs the composition; for example the height
of the vessel correlates to the proportion of the colour in the pattern,
jug forms suggest birds or figurative details. The intention is to create
works that describe the pattern from which they derive. Author of
Ceramics: Tools and Techniques for the Contemporary Maker (Jacqui Small
Publishing, 2011).

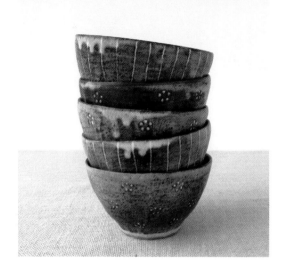

YO THOM

The Old Cricket House, North Street, Fontmell Magna, Shaftesbury, Dorset SP7 0NS
TEL 01747 854 671 EMAIL yo@yothom.com WEB www.yothom.com
Visitors welcome by appointment

My work is thrown and handbuilt functional stoneware with influences
from both British and Japanese traditional pottery and food culture.
I try to create tableware that will become 'clothes for food', as Rosanjin
once said. It serves as a background for food and yet retains a strong
personality. Now that I have relocated to the beautiful Dorset
countryside, the landscape has become another source of inspiration,
one that encourages the development of the work as an interesting
marriage of East and West.

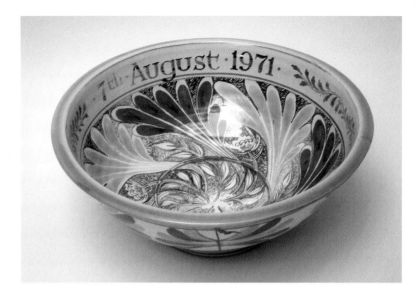

OWEN THORPE Fellow

Old Chapel, Priestweston, Chirbury, Montgomery, Powys, Wales SY15 6DE
TEL 01938 561 618 EMAIL owen.thorpe@yahoo.com
WEB www.owenthorpeceramics.co.uk • Visitors welcome by appointment

Owen Thorpe works in stoneware with additions of enamels and lustres, combining brush and wax-resist patterns with lettering. Celebration pots by commission.

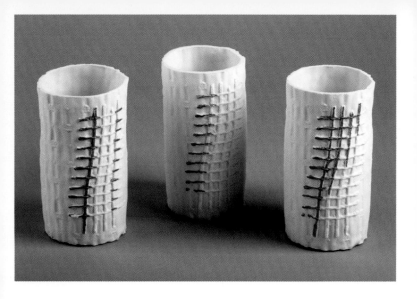

DEBORAH TIMPERLEY

59 Smithbarn, Horsham, West Sussex RH13 6DT
TEL 01403 265 835 EMAIL deborah.timperley@btinternet.com
WEB www.studiopottery.co.uk • Visitors welcome by appointment

Deborah Timperley is an artist who works with bone china, making bowls, vessels, and framed compositions. Inspiration is from the surface details of textiles, and architecture and textiles are used in the making process. Deborah gained her degree at Middlesex University in glass and ceramics and works across both disciplines. Deborah's work is available through galleries and craft fairs.

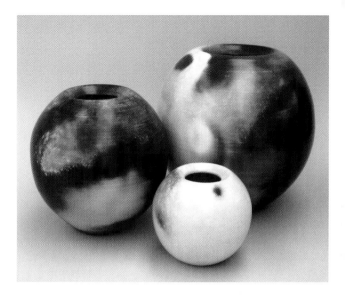

FRAN TRISTRAM

Seymour Road Studios, 42 Seymour Road, West Bridgford, Nottingham NG2 5EF
TEL 01159 822 681 EMAIL fran.tristram@googlemail.com
WEB www.seymourroadstudios.co.uk • Visitors welcome by appointment

Questions of our sense of home and our place in the natural world
are key themes in my work. Both my functional and my smoked work
are very much for the domestic setting and scale, and seek to appeal
to the hand as well as the eye. After many years of full-time production
enlivened by wide-ranging workshop opportunities, a period of
prolonged injury led to the reshaping of our studios from a one-potter
factory to an education space, where I, with my artist husband Rod
Bailey, teach regular, one-off, and bespoke classes in painting, drawing,
and printmaking, as well as pottery.

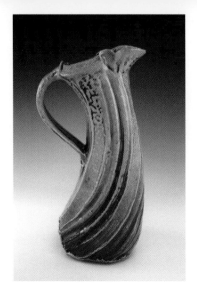

RUTHANNE TUDBALL Fellow

Temple Barn Pottery, Solomon's Temple, Welborne, Dereham, Norfolk NR20 3LD
TEL 01362 858 770 EMAIL ruthanne.tudball@btopenworld.com
WEB www.ruthannetudball.com • Visitors welcome by appointment

My pots are thrown on a momentum wheel where they are
manipulated and assembled wet, inspired by the organic life of clay,
tide and earth patterns, and the human body. I mainly make pots
for use, as well as more individual contemplative pieces. Work is
stoneware, slip-decorated, and once-fired in a wood/gas kiln, where it
is soda vapour-glazed. I regularly give lectures, demonstrations, and
workshops throughout the UK and abroad, and have written the book,
Soda Glazing (A&C Black). My work is represented in collections in the
UK, Europe, Asia, and the US.

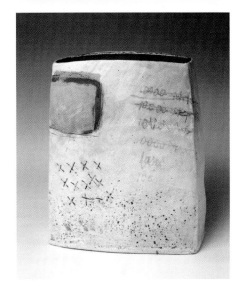

CRAIG UNDERHILL

8 Prescot Road, Stourbridge, West Midlands DY9 7LD
TEL 01384 376 559 EMAIL craigunderhill@waitrose.com WEB www.craigunderhill.co.uk
Visitors welcome by appointment

Landscapes and places on a big or small scale are my inspiration. The visual effects that are created by the actions of mankind on natural landscapes and of nature on man-made landscapes are a particular interest. The possibilities for exploring surface mark making appear endless with clay, and this is my main fascination and motivation. I combine various mark-making techniques along with engobes, glaze, oxides, and stains to create rich painterly surfaces. Occasionally, I deviate from slab-building, but always return to this as a favoured technique. I show my work at galleries and exhibitions across the UK and abroad.

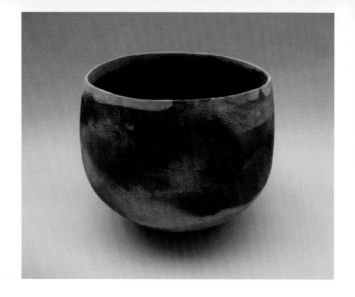

SUE VARLEY

54 Elthorne Road, Uxbridge UB8 2PS
EMAIL davidvarley@btconnect.com
Visitors welcome by appointment

I studied at Bath Academy of Art, Corsham, where I specialised in ceramics and was taught by James Tower. All my work is handbuilt, and is often unglazed. I colour clays with metal oxides, and sometimes burnish or part-burnish the bowl or pot as part of the final design. After firing in an electric kiln I post-fire each individual piece of work in sawdust in a small brick-built kiln. Landscape, shadows, reflections, and patterns in nature are some of the images that inspire my work.

SV

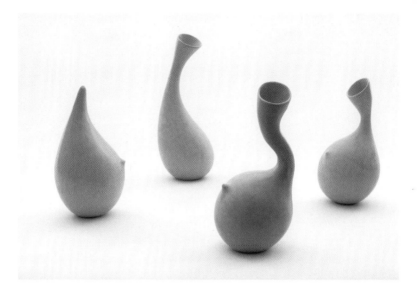

TINA VLASSOPULOS Fellow

29 Canfield Gardens, London NW6 3JP
TEL 07817 396 016 EMAIL tina@tinavlassopulos.com WEB www.tinavlassopulos.com
Visitors welcome by appointment

Vlassopulos's work is an exploration of the relationship between shape, volume, and negative space, drawing visual ideas from nature and her interest in the performing arts. She is concerned with instilling a sense of movement and poise in each piece, while also creating harmony. The pots are made with an eye to the possibility of function, but this is balanced by a sculptural context to the forms, and the concept of container carries only an aesthetic and symbolic value. In her latest body of work, *Silent Sounds*, she has tried to represent the aural in a playful and pleasing form.

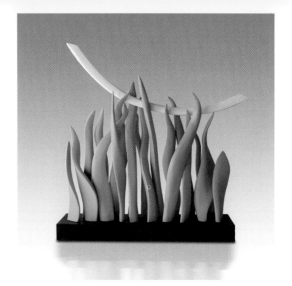

PATRICIA VOLK

The Workshops, Stowford Manor Farm, Wingfield, Wiltshire BA14 9LH
TEL 07894 451 542 EMAIL info@patriciavolk.co.uk WEB www.patriciavolk.co.uk
Visitors welcome by appointment

I have been producing ceramic sculpture for the last twenty years, and have pieces in collections across the UK and abroad. During this time I have developed a fascination with how one line or form has an effect upon another next to it. Juxtapositions of shape and colour can create wonderful contradictions of power and fragility, stability and precariousness, which, to me, always reflect human relationships. Their closeness is tender, but also tentative; sometimes I am creating a balanced structure that seems as if it might topple, but keeps standing.

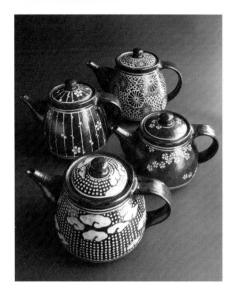

MOTOKO WAKANA

713-30 Shimotakano, Sugito, Kitakatsushika, Saitama 345-0043 Japan
TEL +81 (0)480 33 3646 EMAIL wakanamoto@hotmail.com

Motoko Wakana was born in Tokyo, and started potting in Japan.
After working in the UK from 1999 to 2006, she returned home.
She makes slip-decorated tableware with influences from British
and Japanese life.

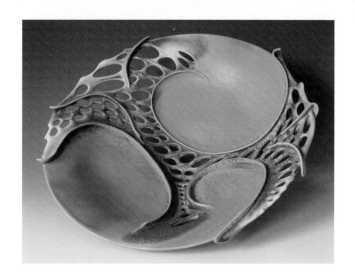

CLARE WAKEFIELD

10 Station Road, Walmer, Deal, Kent CT14 7QR
TEL 01304 239 771 **EMAIL** clarewakefield@sky.com **WEB** www.clarewakefield.co.uk
Visitors welcome by appointment

Porcelain and Earthstone waves, movement and form emerging from the deep. The constant flow of the sea carries the smoothing and sculpting sands over ever-changing contours. In silky cool waters and tempestuous seas, the wind fills curved sails while racing over the surf, a wash of sea spray in the wake, an image of energy, power, and motion. These inspiring scenes are interpreted by thrown, coiled, and sculpted forms using Earthstone Original clay body or porcelain. I bisque fire to 1000°C, spray or sponge glaze, then fire to between 1215°C and 1225°C.

JOSIE WALTER Fellow

22 Nan Gells Hill, Bolehill, Matlock, Derbyshire DE4 4GN
TEL 01629 823 669 EMAIL josie@josiewalter.co.uk WEB www.josiewalter.co.uk
Visitors welcome by appointment

Josie Walter trained as an anthropologist, then a secondary school teacher, before taking the studio ceramic course at Chesterfield College of Art (1976-9). After six months' apprenticeship with Sue Atkins at the Poterie Du Don, Auvergne, France, she shared a workshop with John Gibson in Matlock, Derbyshire, before moving to a workshop at home. Pots are thrown on a momentum wheel or slab-built in earthenware. Slip decoration is by pouring thinly or applying thickly by brush on the wheel to give a 'wrapped' look. The pieces are raw-glazed, decorated with coloured glazes, and once-fired to cone 03 in an electric kiln.

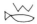

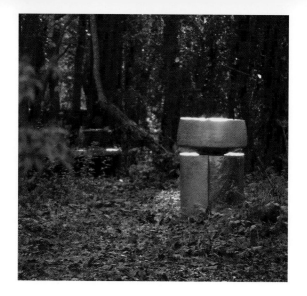

SARAH WALTON Fellow

Keepers, Bo-peep lane, Alciston, nr Polegate, East Sussex BN26 6UH
TEL 01323 811 517 EMAIL smwalton@btconnect.com WEB www.sarahwalton.co.uk
Visitors welcome by appointment

I've decided now to concentrate on the birdbaths I make. Alongside those that are reduction-fired salt-glaze are some that are oxidised stoneware – a black birdbath on a burnt oak base that in turn stands on a polished blue welsh slate slab. At the same time, I'm hoping to also develop work, possibly on a similar physical scale, that means as much to me as the birdbaths have over these last twenty-six years.

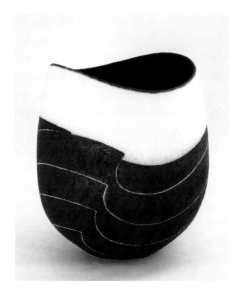

JOHN WARD Fellow

Fachongle Uchaf, Cilgwyn, Newport, Pembrokeshire SA42 0QR
TEL 01239 820 706 EMAIL john.ward50@yahoo.com
Visitors welcome by appointment

My aim is to make pots that have simple forms with integral decoration and aspects that can interact with the environment in interesting ways, to try to express a balance between these dynamic qualities and a sense of stillness or containment. The way light falls across objects in my workroom has suggested black and white designs; the movement of water and waves and the dips and folds of cliff face strata have affected my use of banded decoration. Colours are echoes from the landscape. All pots are handbuilt by adding flattened coils to a pinched base. They are fired to 1250°C.

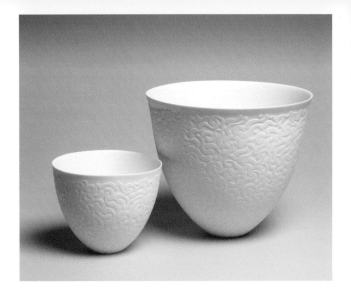

SASHA WARDELL Fellow

36 Tory, Bradford-on-Avon, Wiltshire BA15 1NN
TEL 07855 110 603 EMAIL sasha@sashawardell.wanadoo.co.uk
WEB www.sashawardell.com • Visitors welcome by appointment

I have been working in bone china since 1982 after studying in both the UK and France, with industrial training periods in Stoke-on-Trent and Limoges. Both experiences have strongly influenced the way in which I currently work, resulting in a fascination and intrigue for methods and materials that present a challenge. Architectural detail and sections of structures, combined with an interest in illusions, provide the starting point for the pieces, while the inherent qualities of the clay do the rest. Its whiteness offers a pure blank canvas for the inclusion of colour, and its translucency enhances any varying degree of luminosity.

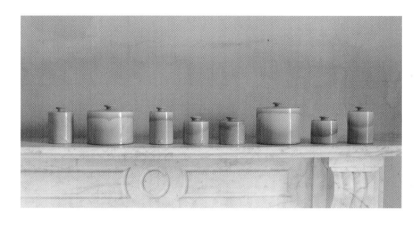

JAMES AND TILLA WATERS

Bryndyfan Farm, Llansadwrn, Llanwrda, Wales
TEL 01550 777 215 EMAIL info@jamesandtillawaters.co.uk
WEB www.jamesandtillawaters.co.uk • Visitors welcome by appointment

We both trained as painters, then met some years later while doing
apprenticeships with the potter Rupert Spira. All of our work is made
in collaboration with each other. We make functional domestic pots, as
well as pieces that are intended to be purely expressive. Unifying factors
are strong, clean forms, with subtle use of colour and decoration.

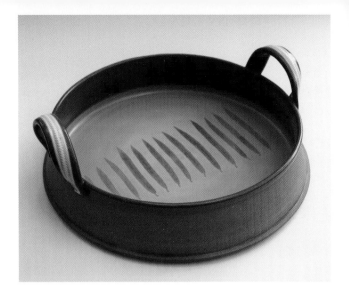

ANNETTE WELCH

21 Colyton Road, East Dulwich, London SE22 0NE
TEL 020 8693 9400 EMAIL annettewelch@mac.com
Visitors welcome by appointment

I enjoy finding ways of placing related forms together. Stacking or grouping dishes that are subtly different in form, proportion, and colour can create a different whole and change the identity of the single element. Large, shallow platters provide me with a canvas to explore the decorative techniques of stencilling and inlay, using porcelain clay and slips. Graduating clay mixes and tinted glazes combine to create the overall earth tones and textures. All work is wheel-thrown and stoneware fired.

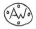

NICOLA WERNER

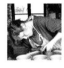

Burcombe Farm, Bolham Water, Clayhidon, Cullompton, Devon EX15 3QB
TEL 01823 680 957 **EMAIL** nwpot@btinternet.com **WEB** www.nicolawerner.com
Visitors welcome by appointment

For twenty-five years I have made a living creating thrown and painted
tin-glazed earthenware (majolica) as functional ware, commemorative
pieces, and tiles.

· MW-XI ·

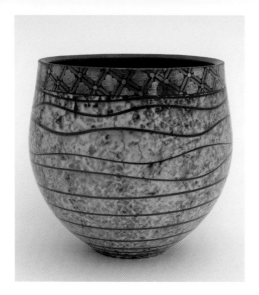

JOHN WHEELDON Fellow

4 West End, Wirksworth, Derbyshire DE4 4EG
TEL 01629 822 356 EMAIL ejw@johnwheeldonceramics.co.uk
WEB johnwheeldonceramics.co.uk • Visitors welcome by appointment

I make raku-fired vessels decorated with terra sigillata and smoke. I am influenced mainly by the materials I use, by the place that I live, and its history. I enjoy working with a limited group of materials, some of which are locally sourced, and through a process of development and observation, refining the pots that I make from them. This has led to my recent work being simpler, calmer, and less formally decorated than previously – a direction that I am enjoying for its new possibilities.

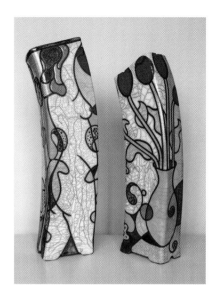

TONY WHITE

Upper Hafod Lodge, Cwmystwyth, Ceredigion SY25 6DX
TEL 01974 282 202 **EMAIL** tonyjohnwhite@btinternet.com
WEB www.tonywhiteceramics.co.uk • Visitors welcome by appointment

I look and interpret what I see into form and decoration using a
colourful palette of glazes. The majority of the work is fired using the
raku technique. My work is in public and private collections, and is
available through gallery shops, exhibitions, ceramic fairs, and also by
visiting my home studio or via the website.

TW

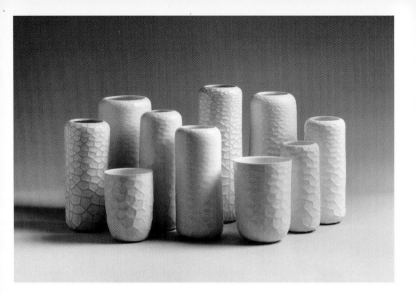

ANDREW WICKS

Cowshed 2, Wick Yard, 15a Bath Road, Farleigh Wick, Wiltshire BA15 2PU
TEL 01225 469 159 **EMAIL** andrew@andrewwicks.co.uk **WEB** www.andrewwicks.co.uk
Visitors welcome by appointment

Thrown porcelain vessels are treated with a water-etching process that emphasises the refined nature of the clay and satisfies the inquisitive hand. Subtly textured surfaces evoke patterns found in the natural world, such as fossils, coral reefs, and magnified plant forms. Glazes appear liquid and lucid and emphasise the surface details. Andrew Wicks graduated from the Royal College of Art Ceramics & Glass MA course in 1997 and was awarded a Setting Up Grant by the Crafts Council in 1999. His work has been featured in many galleries and ceramic exhibitions in the UK and Europe.

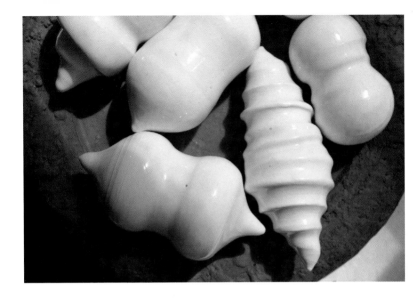

JON WILLIAMS

Eastnor Pottery, Home Farm, Eastnor, Ledbury, Herefordshire HR8 1RD
TEL 01531 633 886 EMAIL admin@eastnorpottery.co.uk
WEB www.jonwilliamspottery.co.uk • Visitors welcome by appointment

Jon's definition of 'making' has evolved along with his practice. Early work was concerned with commercial commodity. More recently, his art is about relationships. In his capacity as the Flying Potter, he tours the West Midlands and beyond, working with participants of all ages and abilities, developing creativity via the medium of clay. He still aspires to make beautiful objects, but beautiful objects that explore the contribution of art and making on society and the wider world. He is currently excited by and engaged in finding interesting and innovative ways to merge his social engagement practice with his own ceramic vocabulary.

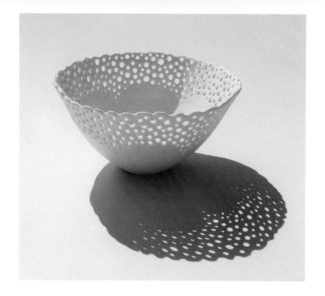

MAGGIE WILLIAMS

Poulders, 65 Ospringe Street, Faversham, Kent ME13 8TW
TEL 01795 531 768 EMAIL maggie.williams@canterbury.ac.uk
Visitors welcome by appointment

Vessel-based work explores the dialogue between form, surface, and space, and the balance and integration of these elements. These forms often depart from function and play with fragility, light, and shadow. The works are in porcelain and employ a variety of techniques to allow line and space to enclose volume, define form, and create pattern. Sculptural works continue these ideas using modularity and repetition, individual components echoing fundamental building blocks in nature and also the processes that underpin the production of traditional ceramics. Studio based in Faversham, Kent, since 1984. Programme Director, Fine & Applied Arts, Canterbury Christ Church University.

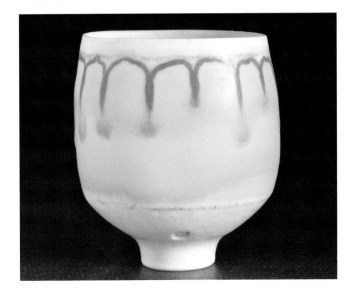

PETER WILLS

44 Newcastle Hill, Bridgend, Mid-Glamorgan CF31 4EY
TEL 01656 662 902 EMAIL peter@peterwills.co.uk WEB www.peterwills.co.uk
Visitors welcome by appointment

The last few years have had their complications. From temporary
studio to temporary studio and into unplanned diversification, all has
had a large impact on my work and a very limited number of pots have
been made. As this book goes to print I'm again packing up my studio
and not expecting to make pots for awhile. When I am working I feel
myself drawn increasingly to looser throwing and quieter glazes; this
is something of an anomaly as many of my most recent pots have been
vivid turquoise...

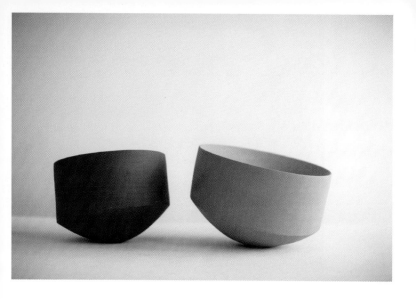

DEREK WILSON

25-51 York Street, Belfast, County Antrim BT15 1ED
TEL 07860 533 681 **EMAIL** studio@derekwilsonceramics.com
WEB www.derekwilsonceramics.com • Visitors welcome by appointment

My practice as a ceramist centres on the making of a diverse range of contemporary objects – from the functional to the sculptural. I always start with the same process, the potter's wheel being my predominant tool, but my work is never static or fixed, and in some ways, reflects the multifarious identities of contemporary ceramics. My ideas spring from a complex blending of the abstract to the familiar, evident in both the functional ware and sculpture that I make. My objects, in their colour, shape, and materiality, reference the ideas of restraint, containment, and minimalism.

DEREK
WILSO
N..CER
AMICS ™

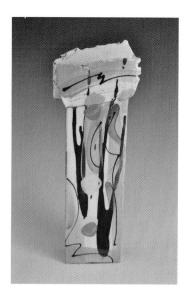

RICHARD WILSON

The Old Timber Yard, West Bay, Bridport, Dorset DT6 4EL
EMAIL rwilsonpots@surfree.co.uk WEB www.chapelyard.co.uk
Studio open Tues-Sat, 10am-5pm

My pots reflect the spontaneity of the slipware tradition, decorating with coloured clays on semi-dry pots. Slips are applied in different ways, with brushes, sponges, and slip trailers, building patterns around the pots as on a three-dimensional canvas. I've found much inspiration from the work of Impressionists such as Monet and Matisse, who draw one into their paintings through colour and dance. But my background influence is found in English and European ceramic folk art. I like developing form with colour in ceramics, and my more recent flat profile pots have textured surfaces or are plain black, adding to the dynamics of the decoration.

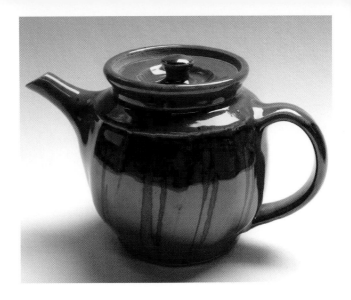

DAVID WINKLEY Fellow

Vellow Pottery, Lower Vellow, Williton, Taunton, Somerset TA4 4LS
TEL 01984 656 458 EMAIL david@vellowpottery.co.uk WEB www.vellowpottery.co.uk
Gallery shop and workshop open Mon-Sat, 9am-6pm

My focus is on a wide range of hand-thrown, press-moulded, and extruded reduction-fired stoneware and porcelain, with a bias towards pots to use, pots that will fit the context of lives other than my own. Other individual pieces continue this commitment. Born in Lancashire, I studied at the School of Fine Art, Reading University, and at Pembroke College, Cambridge. I began making pots with the late Bernard Forrester while teaching at Dartington, opened my first workshop in Bristol in 1964, and have been in my present workshop in West Somerset since the end of 1966. In 2012 the pottery will celebrate fifty years of continuous production.

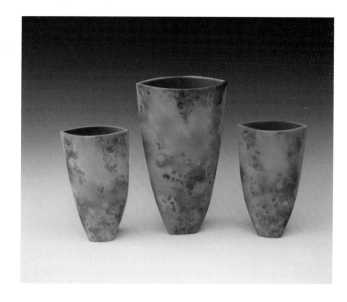

TESSA WOLFE MURRAY

38 Lorna Road, Hove, East Sussex BN3 3EN
TEL 01273 777 574 EMAIL tessa@wolfemurrayceramics.co.uk
WEB www.wolfemurrayceramics.co.uk

I trained at Goldsmiths College, London, 1982-4. Surface decoration
on my work is a layering of coloured textured slips, often with a tracery
of incised line drawing, on both elliptical slab-built pots and wall
hanging panels. Smoke-firing is minimal and controlled. I work with
both white earthenware and Earthstone clays, fired to 1130°C. Pots are
glazed internally. I sell my work through craft and fine art galleries,
ceramic fairs, and direct from the studio.

Wolfe Murray

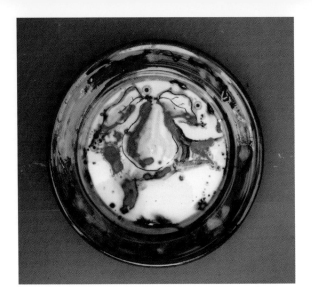

MARY WONDRAUSCH OBE Honorary Fellow

The Pottery, Brickfields, Compton, nr Guildford, Surrey GU3 1HZ
TEL 01483 414 097
Visitors welcome by appointment

After making slip-trailed honey glazed commemorative plates in the 1970s in the seventeenth-century tradition, I migrated to using the same glaze, sans iron, on cheese platters for the 'blue and white' people. These had the names of loved cheeses scribed on the rims. Now I am using brushed slips and oxides over a spare, scratched drawing inspired by my voluptuous old quince tree. This is possible because I was a painter in my early life. Alongside this, the commemorative work continues daily, and I love that intimate connection with my familiar patrons. I have written two books: *Slipware* (A&C Black 1986/2001) and *Brickfields* (Mary Woodrausch 2004).

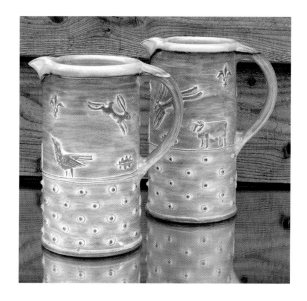

PHILIP WOOD Fellow

Linden Mead Studio, Linden Mead, Whatley, Somerset BA11 3JX
TEL 01373 836 425 EMAIL philipwood1@gmail.com
Visitors welcome by appointment

Formerly in Nunney in Somerset, now in the neighbouring village of Whatley, Philip continues to make the detailed sprigged pots and tableware, with their softly washed exteriors, for which he is well known. Playful and thoughtful, the work has its roots in the slipware and earthenware traditions found in Britain and Europe. Represented in many homes and kitchens worldwide.

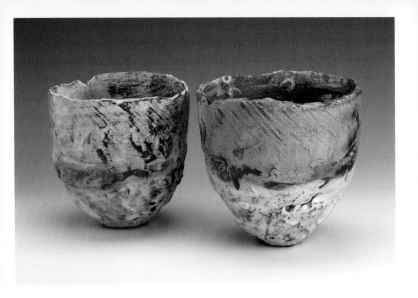

RACHEL WOOD

7 West Workshops, The Harley Foundation, Welbeck, Worksop S80 3LW
TEL 01623 642 425 EMAIL rachel.wood2@tiscali.co.uk
WEB www.rachelwoodceramics.co.uk

I work intuitively and let the energy of the clay create the character of
each piece. Inspired by the world around me, I select slips and glazes to
reflect the rich palette and textures provided by the natural landscape.
I want the marks to reflect the journey of exploration and learning in
each pot, just as a wrinkle or dimple depicts expression and character
in the landscape on a human face. Integral to each stage of the making
process is my personal sensitive touch on the surface of the pots. I use
both throwing and handbuilding techniques. My fingerprints alone
serve as my potter's mark.

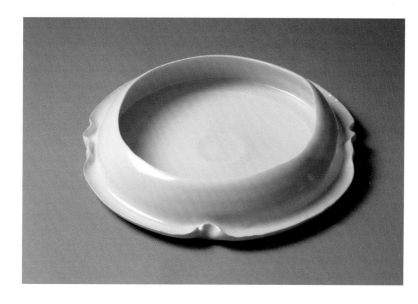

TAKESHI YASUDA Honorary Fellow

1&2 Dafford Street, Larkhall, Bath BA1 6SW / Red House Design Studio @
The Sculpture Factory, 139 East Xinchang Road, Jingdezhen 333001 PRC
TEL 01225 334 136 (UK) **EMAIL** takeshi@takeshiyasuda.com **WEB** www.takeshiyasuda.com

Takeshi Yasuda was trained at Daisei Pottery in Mashiko, Japan (1963-65). He has worked in UK since 1973. He exhibits widely and has work in public and private collections abroad and in the UK, including the Victoria and Albert Museum. He is the former director of the Pottery Workshop, Jingdezhen, and founder and Director of Red House Design Studio, Jingdezhen. Most of his work is made in porcelain in Jingdezhen, China. He is a guest tutor at the Royal College of Art, London.

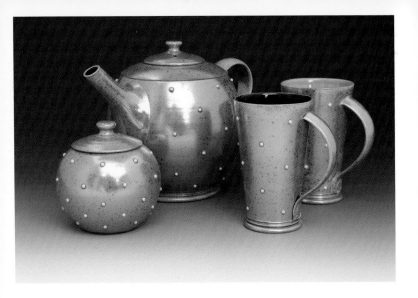

ALISTAIR YOUNG

Guy Hall Cottage, Awre, Newnham-on-Severn, Gloucestershire GL14 1EL
TEL 01594 510 343 EMAIL alistair@alistairyoung.co.uk WEB www.alistairyoung.co.uk
Visitors welcome by appointment

Studied ceramics at Bath Academy of Art before establishing his
first studio in Gloucestershire in 1978 producing thrown domestic
stoneware. His interest in Victorian pottery is reflected in his work,
which is thrown and often altered by pressing, denting, and applying
porcelain details. Great attention is paid to the surface textures, which
are emphasised by the salt kiln firing, which also enhances the colour
of the clay body. Smooth glazes often provide a contrast to these
textures and colours. Alistair continues to work full-time from his
studio, making pots that range from large decorative wall plates to
smaller functional items.

PAUL YOUNG Fellow

Station Pottery, Shenton Lane, Shenton, nr Nuneaton, Warwickshire CV13 0AA
TEL 07711 628 337 EMAIL potterpaulyoung@hotmail.com
WEB www.paulyoungceramics.co.uk

Working in both red and white earthenware clays, I produce a range of domestic and decorative earthenwares. The wares are thrown on a momentum wheel, handbuilt, or very often using a combination of these techniques, and decorated with coloured slips and glazes. My work is inspired by early English slipwares and European folk arts.

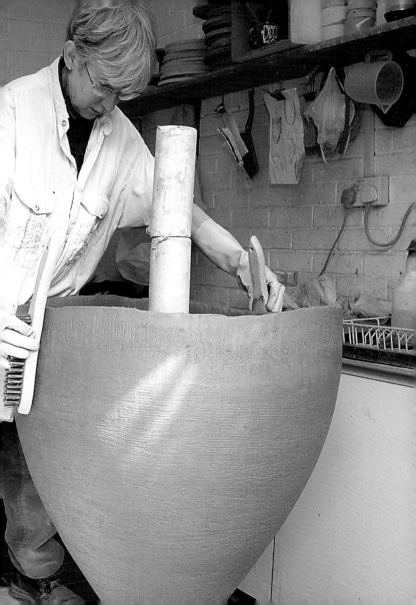

ARTISTS BY REGION

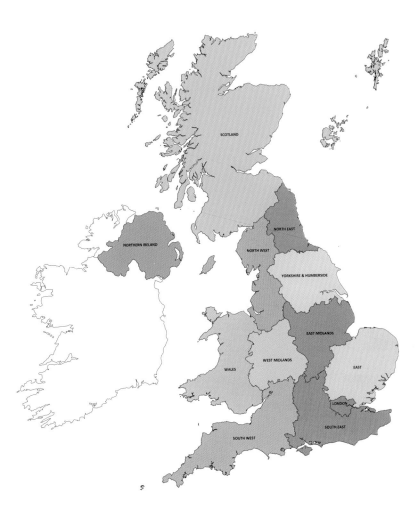

SCOTLAND

NORTHERN IRELAND

NORTH EAST

NORTH WEST

YORKSHIRE & HUMBERSIDE

EAST MIDLANDS

WALES

WEST MIDLANDS

EAST

LONDON

SOUTH EAST

SOUTH WEST

NORTH EAST

EDDIE CURTIS Fellow

Middle Rigg, Wearhead, Co Durham DL13 1HS
TEL 01388 537 379 EMAIL eddie@eddiecurtis.com WEB www.eddiecurtis.com
Visitors welcome by appointment

MARGARET CURTIS Fellow

Middle Rigg, Wearhead, Co Durham DL13 1HS
TEL 07816 865 043 EMAIL margaret@margaretcurtis.com WEB www.margaretcurtis.com
Visitors welcome by appointment

NORTH WEST

CHRIS BARNES

The Knott, Ainstable, Carlisle, Cumbria CA4 9RW
TEL 01768 896 421 EMAIL tempest2000@hotmail.co.uk WEB www.morvernpottery.co.uk
Visitors welcome by appointment

MAGGIE ANGUS BERKOWITZ Honorary Fellow

21/23 Park Road, Milnthorpe, Cumbria LA7 7AD
TEL 01539 563 970 EMAIL maggie@maggieberkowitz.co.uk
WEB www.maggieberkowitz.co.uk • Visitors welcome by appointment

KIRSTI BÜHLER FATTORINI

5 Broadway Hale, Altrincham, Cheshire WA15 0PF
TEL 0161 980 4504 EMAIL kfattorini@hotmail.com WEB www.kirstifattorini.com
Visitors welcome by appointment

JOHN CALVER Fellow

23 Silverdale Road, Yealand Redmayne, Carnforth, Lancashire LA5 9TA
TEL 01524 781 362 EMAIL jandvcalver@gmail.com
Visitors welcome by appointment

HALIMA CASSELL Fellow

155 Lammack Road, Blackburn, Lancashire BB1 8LA
TEL 07817 053 308 EMAIL info@halimacassell.com WEB www.halimacassell.com
Visitors welcome by appointment

DEREK CLARKSON Honorary Fellow

1 The Poplars, Bacup, Lancashire OL13 8AD
TEL 01706 874 541
Visitors welcome by appointment

LIBBY EDMONDSON

Contact through the CPA

NIGEL EDMONDSON

Quaggs House Farm, Levens, Kendal, Cumbria LA8 8PA
TEL 01539 561 546 EMAIL nigel.libby@btinternet.com
WEB www.nigelandlibbyceramics.co.uk • Visitors welcome by appointment

JAMES HAKE

Plough Barn, Kirkby Lonsdale Road, Over Kellet, Lancashire LA6 IDA
TEL 07769 945 487 EMAIL jms_hake@yahoo.co.uk WEB www.jameshake.co.uk
Visitors welcome by appointment

JANET HALLIGAN

The Old School, Church Minshull, Nantwich, Cheshire CW5 6EA
TEL 01270 522 416 EMAIL info@janethalligan-ceramics.co.uk
WEB www.janethalligan-ceramics.co.uk • Visitors welcome by appointment

JOAN HOVERSTADT

37 Heaton Road, Withington, Manchester M20 4PU
TEL 0161 445 7578
Visitors welcome by appointment

JOHN KERSHAW

47 Oakthwaite Road, Windermere, Cumbria LA23 2BD
TEL 01539 443 888 **EMAIL** john@kershawpottery.com **WEB** www.kershawpottery.com
Visitors welcome by appointment

JIM MALONE Fellow

Dairylea Cottage, Lessonhall, Wigton, Cumbria CA7 0EA
TEL 01697 345 241
Visitors welcome by appointment

EMMA RODGERS Fellow

Ridgewood, Noctorum Road, Noctorum, Wirral, Cheshire CH43 9UQ
TEL 0151 652 8919 **EMAIL** emma@emmarodgers.co.uk **WEB** www.emmarodgers.co.uk
Visitors welcome by appointment

GARY STANDIGE

Yew Tree Barn, Windermere Road, Lindale, Cumbria LA11 6LB
TEL 01539 533 944 **EMAIL** garystandige@btinternet.com **WEB** www.garystandige.co.uk
Visitors welcome by appointment

YORKSHIRE AND HUMBERSIDE

BEN ARNUP

The Cottage, Love Lane, The Mount, York YO24 1FE
TEL 01904 633 433 **EMAIL** ben@benarnup.com **WEB** www.benarnup.com
Visitors welcome by appointment

LIZ BOWE

5 Chapel Court, 20 Briggate, Knaresborough, North Yorkshire HG5 8PF
TEL 01423 863 493 **EMAIL** lizbowe@gmail.com
Visitors welcome by appointment

LORETTA BRAGANZA Fellow

The Coach House, 198 Mount Vale, York YO24 1DL
TEL 01904 630 454 **EMAIL** loretta@braganzas.freeserve.co.uk
WEB www.braganzaceramics.com • Visitors welcome by appointment

PETER J CLOUGH Fellow

8 Southville Terrace, Harrogate, North Yorkshire HG1 3HH
TEL 01423 567 716 **EMAIL** potclough@hotmail.com
Visitors welcome by appointment

ISABEL K-J DENYER

Wighill House, Wighill, nr Tadcaster, North Yorkshire LS24 8BG
TEL 01937 835 632 **EMAIL** isapot@isabeldenyer.co.uk **WEB** www.studiopottery.co.uk
Visitors welcome by appointment

SUSAN DISLEY

Studio 3, Manor Oaks Studios, 389 Manor Lane, Sheffield S2 1UL
TEL 01142 700 374 **EMAIL** info@susandisley.co.uk **WEB** www.susandisley.co.uk
Visitors welcome by appointment

JANE HAMLYN

Millfield Pottery, Everton, nr Doncaster, South Yorkshire DN10 5DD
TEL 01777 817 723 **EMAIL** janehamlyn@saltglaze.fsnet.co.uk **WEB** www.saltglaze.fsnet.co.uk
Visitors welcome by appointment

KEIKO HARADA

Park Lea, 36 West Park Crescent, Roundhay, Leeds LS8 2EQ
TEL 01132 663 462 **EMAIL** keiko17@ntlworld.com
Visitors welcome by appointment

KARIN HESSENBERG Fellow

72 Broomgrove Road, Sheffield S10 2NA
TEL 0114 266 1610 **EMAIL** mail@karinhessenberg.co.uk **WEB** www.karinhessenberg.co.uk
Visitors welcome by appointment

CHRIS JENKINS Fellow

19 Towngate, Marsden, Huddersfield HD7 6DD
TEL 01484 844 444 **EMAIL** chris@towngatepottery.co.uk
Visitors welcome by appointment

RUTH KING Fellow

Rose Cottage, Main Street, Shipton-by-Beningbrough, York YO30 1AB
TEL 01904 470 196 **EMAIL** ruthkingceramics@tiscali.co.uk **WEB** www.ruthkingceramics.com
Visitors welcome by appointment

ANNA LAMBERT Fellow

Junction Workshop, 1 Skipton Road, Crosshills, nr Keighley, West Yorkshire BD20 7SB
TEL 01535 631 341 **EMAIL** anna@junctionworkshop.co.uk
WEB www. junctionworkshop.co.uk • Visitors welcome by appointment

ROGER LEWIS

TEL 07952 985 729 **EMAIL** rogerlewisceramics@gmail.com
Visitors welcome by appointment

JAMES OUGHTIBRIDGE

3 Field End Lane, Holmfirth, Huddersfield, West Yorkshire HD9 2NH
TEL 01484 680 312 **EMAIL** jamesoughtibridge@yahoo.co.uk
WEB www.jamesoughtibridge.co.uk • Visitors welcome by appointment

DAVID ROBERTS Fellow

Cressfield Barn, 60 Upperthong Lane, Holmfirth HD9 3BQ
TEL 01484 685 110 **EMAIL** david@davidroberts-ceramics.com
WEB www.davidroberts-ceramics.com • Visitors welcome by appointment

JIM ROBISON Fellow

Booth House Gallery, 3 Booth House Lane, Holmfirth HD9 2QT
TEL 01484 685 270 EMAIL jim.robison@boothhousegallery.co.uk
WEB www.jimrobison.co.uk • Visitors welcome by appointment

ANTONIA SALMON Fellow

20 Adelaide Road, Nether Edge, Sheffield S7 1SQ
TEL 01142 585 971 EMAIL antoniasalmon@blueyonder.co.uk
WEB www.antoniasalmon.co.uk • Visitors welcome by appointment

CAROL WAINWRIGHT

Contact through the CPA

EAST MIDLANDS

ROB BIBBY

Woodnewton Pottery, 43 Main Street, Woodnewton, Oundle PE8 5EB
TEL 01780 470 866 EMAIL robbibby@btinternet.com WEB www.robbibbyceramics.co.uk
Visitors welcome by appointment

BEN BRIERLEY

25 Turner Avenue, Loughborough, Leicestershire LE11 2DA
TEL 01509 828 349 EMAIL benedict@supanet.com
WEB www.ben-brierley-woodfired-ceramics.co.uk • Visitors welcome by appointment

CLARE CONRAD Fellow

44 Watkin Terrace, Northampton, Northamptonshire NN1 3ER
TEL 01604 628 125 EMAIL clareconrad@hotmail.com
WEB www.clareconradceramics.co.uk • Visitors welcome by appointment

WENDY HOARE

135 Billing Road, Northampton NN1 5RR
TEL 01604 622 880 EMAIL wendyhoareceramics@tiscali.co.uk
WEB www.studiopottery.co.uk • Visitors welcome by appointment

PETER ILSLEY

Whilton Locks Pottery, Whilton Locks, Daventry, Northamptonshire NN11 2NH
TEL 01327 842 886 WEB www.studiopottery.co.uk
Visitors welcome by appointment

WENDY JOHNSON Fellow

8 Cromford Road, Wirksworth, Derbyshire DE4 4FH
TEL 07963 629 366 EMAIL wendyjohnsonceramics@gmail.com
WEB wendyjohnsonblog.wordpress.com • Visitors welcome by appointment

JANE MADDISON

The Old School Cottages, Stragglethorpe, Lincoln LN5 0QZ
TEL 01400 272 971 EMAIL jkmaddison@aol.com
WEB www.winebreathers.com (under construction) • Visitors welcome by appointment

ANDREW MASON

3 Stiles Road, Alvaston, Derby DE24 0PG
TEL 01332 753 799 EMAIL andymasonceramics@btinternet.com
Visitors welcome by appointment

JOHN MATHIESON

50 Ridgeway, Weston Favell, Northampton NN3 3AN
TEL 01604 409 942 EMAIL jemathieson@talktalk.net WEB www.studiopottery.co.uk
Visitors welcome by appointment

PETER MOSS

19 St Giles Avenue, Lincoln LN2 4PE
TEL 01522 529 124 EMAIL petermossceramics@btinternet.com
WEB www.petermoss.me.uk • Visitors welcome by appointment

MARGARET ROLLASON

Contact through the CPA

FRAN TRISTRAM

Seymour Road Studios, 42 Seymour Road, West Bridgford, Nottingham NG2 5EF
TEL 01159 822 681 **EMAIL** fran.tristram@googlemail.com
WEB www.seymourroadstudios.co.uk • Visitors welcome by appointment

JOSIE WALTER Fellow

22 Nan Gells Hill, Bolehill, Matlock, Derbyshire DE4 4GN
TEL 01629 823 669 **EMAIL** josie@josiewalter.co.uk **WEB** www.josiewalter.co.uk
Visitors welcome by appointment

JOHN WHEELDON Fellow

4 West End, Wirksworth, Derbyshire DE4 4EG
TEL 01629 822 356 **EMAIL** ejw@johnwheeldonceramics.co.uk
WEB johnwheeldonceramics.co.uk • Visitors welcome by appointment

RACHEL WOOD

7 West Workshops, The Harley Foundation, Welbeck, Worksop S80 3LW
TEL 01623 642 425 **EMAIL** rachel.wood2@tiscali.co.uk
WEB www.rachelwoodceramics.co.uk

WEST MIDLANDS

JACQUI ATKIN

White Cottage, 3 Glyn Morlas, St Martins, Oswestry, Shropshire SY11 3EE
TEL 01691 773 670 **EMAIL** j.p.atkin@btopenworld.com **WEB** www.jacquiatkin.com
Visitors welcome by appointment; please call in advance for directions

PETER BEARD Fellow

Tanners Cottage, Welsh Road, Cubbington, Leamington Spa, Warwickshire CV32 7UB
TEL 01926 428 481 EMAIL peter@peterbeard.co.uk WEB www.peterbeard.co.uk
Visitors welcome by appointment

MARTIN BOOTH

49 Heaton Terrace, Porthill, Newcastle-under-Lyme, Staffordshire ST5 8PJ
TEL 01782 639 182

JOY BOSWORTH Fellow

Springbrook Lodge, Forge Lane, Blakedown, Worcestershire DY10 3JF
TEL 07779 221 678 EMAIL info@joybosworthceramics.com
WEB www.joybosworthceramics.com • Visitors welcome by appointment

SHEILA CASSON Honorary Fellow

Wobage Farm, Upton Bishop, Ross-on-Wye, Herefordshire HR9 7QP
TEL 01989 780 233
Showroom open Mar-Dec, Sat & Sun, 10am-5pm; at all other times please phone first

JENNIFER COLQUITT

Field Ceramics, c/o 14 Dibdale Road, Dudley, West Midlands DY1 2RU
TEL 01384 258 522 EMAIL jen@jen-and-petercolquitt.com
WEB www.jen-and-petercolquitt.co.uk • Visitors welcome by appointment

JO CONNELL

2 Harcourt Spinney, Market Bosworth, Nuneaton CV13 0LH
TEL 01455 292 678 EMAIL jo@jjconnell.co.uk WEB www.jjconnell.co.uk
Visitors welcome by appointment

LOUISE DARBY

Clay Barn, Redhill, Alcester, Warwickshire B49 6NQ
TEL 01789 765 214 EMAIL louisedarby@louisedarby.co.uk WEB www.louisedarby.co.uk
Visitors welcome by appointment

PATIA DAVIS

Wobage Farm Craft Workshops, Upton Bishop, Ross-on-Wye, Herefordshire HR9 7QP
TEL 01989 780 495 **WEB** www.workshops-at-wobage.co.uk
Open Thurs-Sun, 10am-5pm; at all other times please phone first. Closed Jan & Feb

BRIDGET DRAKEFORD

Upper Buckenhill Farmhouse, Fownhope, Herefordshire HR1 4PU
TEL 01432 860 411 **EMAIL** bdrakeford@bdporcelain.co.uk **WEB** www.bdporcelain.co.uk
Visitors welcome by appointment

MARK GRIFFITHS

The Pottery, Culmington, Ludlow, Shropshire SY8 2DF
TEL 01584 861 212 **EMAIL** mark@markgriffithspottery.co.uk
WEB www.markgriffithspottery.co.uk • Visitors welcome by appointment

DAVID JONES Fellow

21 Plymouth Place, Leamington Spa, Warwickshire CV31 1HN
TEL 01926 314 643 **EMAIL** davidjonesraku@lineone.net
WEB www.davidjonesceramics.co.uk • Visitors welcome by appointment

JIM AND DOMINIQUE KEELING

Whichford Pottery, Whichford, nr Shipston-on-Stour, Warwickshire CV36 5PG
TEL 01608 684 416 **EMAIL** theoctagon@whichfordpottery.com **WEB** www.theoctagon.co.uk
Open Mon-Fri, 9am-5pm; Sat & Bank holidays, 10am-4pm; Sun, 11am-4pm (Apr-Dec)

TONY LAVERICK

Ridgway House, Leek Road, Longsdon, Staffordshire ST9 9QF
TEL 01538 386 050 **EMAIL** tonylaverick@btinternet.com **WEB** www.tonylaverick.co.uk
Visitors welcome by appointment

SARAH MONK

Eastnor Pottery, Home Farm, Eastnor, Ledbury, Herefordshire HR8 1RD
TEL 01531 633 886 **EMAIL** admin@eastnorpottery.co.uk **WEB** www.eastnorpottery.co.uk
Visitors welcome by appointment

JONATHAN PHILLIPS

Contact through the CPA

PETRA REYNOLDS Fellow

Wobage Workshops, Upton Bishop, Ross-on-Wye, Herefordshire HR9 5SQ
TEL 01989 562 498 EMAIL petrareynolds@gmail.com WEB www.workshops-at-wobage.co.uk
Studio open 10am-5pm, Thurs-Sun, Mar-Dec; closed Jan & Feb

DAVID SCOTT Fellow

9 Fosse Way, Radford Semele, Leamington Spa, Warwickshire CV31 1XQ
TEL 01926 613 560 EMAIL d.scott1@lboro.ac.uk
Visitors welcome by appointment

CLAIRE SENEVIRATNE

15 Romeo Arbour, Warwick Gates, Warwick CV34 6FD
TEL 07972 634 455 EMAIL claire@seneviratne.co.uk WEB www.claireseneviratne.co.uk
Visitors welcome by appointment

SHELTON POTTERY

18 Heath End Road, Alsager, Stoke-on-Trent ST7 2SQ
TEL 01270 872 686 EMAIL sheltonpottery@aol.com WEB www.sheltonpottery.co.uk
Visitors welcome by appointment

ALAN SIDNEY Fellow

5 Bull Street, Bishop's Castle, Shropshire SY9 5DB
TEL 01588 638 844 EMAIL jenniferhepke@btinternet.com
Visitors welcome by appointment

MARK SMITH

61 High Street, Rocester, Staffordshire ST14 5JU
TEL 01889 591 311 EMAIL mark@marksmithceramics.com
WEB www.marksmithceramics.com • Visitors welcome by appointment

PETER STARKEY

Pine Cottage, The Doward, Whitchurch, Ross-on-Wye, Herefordshire HR9 6B9
TEL 01600 890 823 EMAIL peter.starkey@btinternet.com
Visitors welcome by appointment

JEREMY STEWARD Fellow

Wobage Farm Workshops, Upton Bishop, Ross-on-Wye, Herefordshire HR9 7QP
TEL 01989 562 498 EMAIL info@workshops-at-wobage.co.uk
WEB www. workshops-at-wobage.co.uk • Visitors welcome by appointment

CRAIG UNDERHILL

8 Prescot Road, Stourbridge, West Midlands DY9 7LD
TEL 01384 376 559 EMAIL craigunderhill@waitrose.com WEB www.craigunderhill.co.uk
Visitors welcome by appointment

JON WILLIAMS

Eastnor Pottery, Home Farm, Eastnor, Ledbury, Herefordshire HR8 1RD
TEL 01531 633 886 EMAIL admin@eastnorpottery.co.uk
WEB www.jonwilliamspottery.co.uk • Visitors welcome by appointment

PAUL YOUNG Fellow

Station Pottery, Shenton Lane, Shenton, nr Nuneaton, Warwickshire CV13 0AA
TEL 07711 628 337 EMAIL potterpaulyoung@hotmail.com
WEB www.paulyoungceramics.co.uk

WALES

BILLY ADAMS Fellow

4 Allensbank Road, Heath, Cardiff CF14 3RB
TEL 07876 451 887 EMAIL theadamsfamily.cardiff@btinternet.com
Visitors welcome by appointment

DUNCAN AYSCOUGH Fellow

Farmers, Bethlehem, Carmarthenshire SA19 9DW
TEL 01550 777 460 **EMAIL** duncan@ayscoughceramics.co.uk
WEB www.ayscoughceramics.co.uk • Visitors welcome by appointment

JAN BEENY

8 Grenville Road, Penylan, Cardiff CF23 5BP
TEL 02920 481 197 **EMAIL** janbeeny@hotmail.com **WEB** www.janbeeny.co.uk

BEV BELL-HUGHES Fellow

Fron Dirion, Conwy Road, Llandudno Junction, Conwy LL31 9AY
TEL 01492 572 575 **EMAIL** bevandterry@googlemail.com
Visitors welcome by appointment

TERRY BELL-HUGHES Fellow

Fron Dirion, Conwy Road, Llandudno Junction, Conwy LL31 9AY
TEL 01492 572 575 **EMAIL** bevandterry@googlemail.com
Visitors welcome by appointment

DAVID BINNS Fellow

34 Park Street, Denbigh, Denbighshire, North Wales LL16 3DB
TEL 07946 795 896 **EMAIL** dsbinns@hotmail.com **WEB** www.davidbinnsceramics.co.uk
Visitors welcome by appointment

CHARLES BOUND Fellow

Street Farm, Geuffordd, Welshpool, Powys SY21 9DR
TEL 01938 590 230 **EMAIL** joy@geuffordd.fsnet.co.uk **WEB** www.charlesbound.com
Visitors welcome by appointment

SHEILA BOYCE

Oak Villa, Lower Brynamman, Ammanford, Wales SA18 1SN
TEL 01269 826 942 **EMAIL** oncefired@aol.com **WEB** www.oncefired.co.uk
Visitors welcome by appointment

ADAM BUICK

The Studio, Llanferran, St Davids, Pembrokeshire SA62 6PN
TEL 07772 935 367 **EMAIL** adam@adambuick.com **WEB** www.adambuick.com
Visitors welcome by appointment

ROSEMARY COCHRANE

76 Mill Street, Usk, Monmouthshire NP15 1AW
TEL 01291 671 567 **EMAIL** rc@rosemarycochrane.co.uk **WEB** www.rosemarycochrane.co.uk
Visitors welcome by appointment

LOWRI DAVIES

Fireworks Clay Studios, 24 Tudor Lane, Riverside, Cardiff CF11 6AZ
TEL 07973 623 005 **EMAIL** lowri_davies@yahoo.com **WEB** www.lowridavies.com
Visitors welcome by appointment

DAVID FRITH Fellow

Brookhouse Pottery, Brookhouse Lane, Denbigh, Denbighshire, Wales LL16 4RE
TEL 01745 812 805 **EMAIL** frith@brookhousepottery.co.uk
WEB www.brookhousepottery.co.uk • Visitors welcome by appointment

MARGARET FRITH Fellow

Brookhouse Pottery, Brookhouse Lane, Denbigh, Denbighshire, Wales LL16 4RE
TEL 01745 812 805 **EMAIL** frith@brookhousepottery.co.uk
WEB www.brookhousepottery.co.uk • Visitors welcome by appointment

CHRISTINE GITTINS

Model House, Bull Ring, Llantrisant, Mid Glamorgan CF72 8EB
TEL 07768 736 166 **EMAIL** christinegittins@aol.com **WEB** www.christinegittins.com
Visitors welcome by appointment

JENNIFER HALL

Spring Gardens, Llanwrthwl, Llandrindod Wells, Powys, Wales
TEL 01597 810 119 **EMAIL** jennythepotter@hotmail.com
Visitors welcome by appointment

MORGEN HALL Fellow

Chapter Arts Centre, Market Road, Canton, Cardiff CF5 1QE
TEL 02920 238 716 EMAIL morgen@morgenhall.co.uk WEB www.morgenhall.com
Visitors welcome by appointment

FRANK HAMER Honorary Fellow

Llwyn-On, Croes-yn-y-Pant, Mamhilad, Pontypool, South Wales NP4 8RE
TEL 01495 785 700 WEB www.pottersdictionary.com
Visitors welcome by appointment

ASHRAF HANNA Fellow

Pen-y-Daith, Chapel Lane, Keeston, Haverfordwest, Pembrokeshire, Wales SA62 6EH
TEL 01437 710 774 EMAIL ashrafhanna.ceramics@btinternet.com
WEB www.ashrafhanna.net

JOANNA HOWELLS Fellow

2 Cwrt Isaf, Tythegston, Bridgend, Mid-Glamorgan CF32 0ND
TEL 01656 784 021 EMAIL studio@joannahowells.co.uk WEB www.joannahowells.co.uk
Visitors welcome by appointment

SIMON HULBERT Fellow

Brook Street Pottery and Gallery, Hay-on-Wye, Hereford HR3 5BQ
TEL 01497 821 070 EMAIL info@brookstreetpottery.co.uk
WEB www.brookstreetpottery.co.uk • Visitors welcome by appointment

LINDA JOHN

Contact through the CPA

CATRIN MOSTYN JONES

TEL 07787 507 228 EMAIL vividceramics@hotmail.com WEB www.vividceramics.co.uk
Visitors welcome by appointment

WALTER KEELER Fellow

Moorcroft Cottage, Penallt, Sir Fynwy, Wales NP25 4AH
TEL 01600 713 946
Visitors welcome by appointment

LIZ LAWRENCE

Contact through the CPA

WENDY LAWRENCE

27a Love Lane, Denbigh, Denbighshire LL16 3LT
TEL 01745 799 629 / 07748 715 596 **EMAIL** wlawrenceceramics@hotmail.com
WEB www.wendylawrenceceramics.com • Visitors welcome by appointment

CLAUDIA LIS

'The Central', Princes Street, Montgomery, Powys, Wales SY15 6PY
TEL 01686 668 244 **EMAIL** ceramics@claudialis.co.uk **WEB** www.claudialis.co.uk
Visitors welcome by appointment

CHRISTINE MCCOLE

Hafod Hill Pottery, Llanboidy, Whitland, Carmarthenshire SA34 0ER
TEL 01994 448 361 **EMAIL** potters@hafodhillpottery.com
WEB www.hafodhillpottery.com • Visitors welcome by appointment

NICK MEMBERY

Waun Hir Pottery, Gwynfe Road, Ffairfach, Llandeilo SA19 6YT
TEL 01558 823 099 **EMAIL** nick@kitchen-pottery.co.uk **WEB** www.kitchen-pottery.co.uk
Visitors welcome by appointment

AUDREY RICHARDSON

Morawel, Parrog Road, Newport, Pembrokeshire SA42 0RF
TEL 01239 820 449
Visitors welcome by appointment

PHIL ROGERS Fellow

Lower Cefnfaes, Rhayader, Powys, Wales LD6 5LT
TEL 01597 810 875 **EMAIL** marstonpottery@yahoo.co.uk **WEB** www.philrogerspottery.com
Studio open 9.30am-5pm; please phone first if coming a long distance

MICKI SCHLOESSINGK Fellow

Bridge Pottery, Cheriton, nr Llanmadoc, Gower, Swansea SA3 1BY
TEL 01792 386 499 **EMAIL** micki@mickisaltglaze.co.uk **WEB** www.mickisaltglaze.co.uk
Gallery open Easter to Christmas, Tues-Sat; please phone or check website for opening times

GEOFFREY SWINDELL Fellow

18 Laburnum Way, Dinas Powys, Cardiff CF64 4TH
TEL 02920 512 746 **EMAIL** geoffswindell@tiscali.co.uk
WEB www.geoffreyswindellceramics.co.uk • Visitors welcome by appointment

OWEN THORPE Fellow

Old Chapel, Priestweston, Chirbury, Montgomery, Powys, Wales SY15 6DE
TEL 01938 561 618 **EMAIL** owen.thorpe@yahoo.com
WEB www.owenthorpeceramics.co.uk • Visitors welcome by appointment

JOHN WARD Fellow

Fachongle Uchaf, Cilgwyn, Newport, Pembrokeshire SA42 0QR
TEL 01239 820 706 **EMAIL** john.ward50@yahoo.com
Visitors welcome by appointment

JAMES AND TILLA WATERS

Bryndyfan Farm, Llansadwrn, Llanwrda, Wales
TEL 01550 777 215 **EMAIL** info@jamesandtillawaters.co.uk
WEB www.jamesandtillawaters.co.uk • Visitors welcome by appointment

TONY WHITE

Upper Hafod Lodge, Cwmystwyth, Ceredigion SY25 6DX
TEL 01974 282 202 **EMAIL** tonyjohnwhite@btinternet.com
WEB www.tonywhiteceramics.co.uk • Visitors welcome by appointment

PETER WILLS

44 Newcastle Hill, Bridgend, Mid-Glamorgan CF31 4EY
TEL 01656 662 902 **EMAIL** peter@peterwills.co.uk **WEB** www.peterwills.co.uk
Visitors welcome by appointment

EAST

DEBORAH BAYNES

Nether Hall, Shotley, Ipswich, Suffolk IP9 1PW
TEL 01473 788 300 **EMAIL** deb@deborahbaynes.co.uk **WEB** www.potterycourses.net
Visitors welcome by appointment

MATTHEW BLAKELY Fellow

9 Abbey Lane, Lode, Cambridge CB25 9EP
TEL 01223 811 959 **EMAIL** smashingpots@uk2.net **WEB** www.matthewblakely.co.uk
Visitors welcome by appointment

SUSAN BRUCE

4 Pinewood, Woodbridge, Suffolk IP12 4DS
TEL 01394 384 865 **EMAIL** susie.bruce1@btinternet.com
Visitors welcome by appointment

VICTORIA BRYAN

57 Top End Renhold, Bedford, Bedfordshire MK41 0LS
TEL 01234 870 687

SYLVIA DALES

75/77 Melford Road, Sudbury, Suffolk CO10 1JT
TEL 01787 374 581 / 07773 182 138 **EMAIL** sylviadales@hotmail.co.uk
Visitors welcome by appointment

JOYCE DAVISON

Ranters, 75 Pales Green, Castle Acre, King's Lynn, Norfolk PE32 2AL
TEL 01760 755 405 EMAIL joycedavison.ranters@virgin.net
Visitors welcome by appointment

KAREN DOWNING

Richmond House, Gedgrave, Orford, Suffolk IP12 2BU
TEL 01394 450 313 EMAIL karen.downing@virgin.net

ANTJE ERNESTUS

Foundry Hill Cottage, Corpusty Road, Wood Dalling, nr Holt, Norfolk NR11 6SD
TEL 01263 587 672 EMAIL antje@gofast.co.uk WEB www.studiopottery.co.uk
Visitors welcome by appointment

ALAN FOXLEY

26 Shepherds Way, Saffron Walden, Essex CB10 2AH
TEL 01799 522 631 EMAIL foxleyalan1@waitrose.com WEB www.studiopottery.co.uk
Visitors welcome by appointment

TESSA FUCHS Fellow

Trinity Cottage, Chediston, Halesworth, Suffolk IP19 0AT
TEL 01986 875 724 EMAIL tessafuchs@tiscali.co.uk WEB www.tessafuchs.co.uk
Visitors welcome by appointment

MARGARET GARDINER

Glebe House, Church Road, Great Hallingbury, Bishop's Stortford, Herts CM22 7TY
TEL 01279 654 025 EMAIL info@maggygardiner.com WEB www.maggygardiner.com
Visitors welcome by appointment

ANDRE HESS Fellow

32 Seaman Close, St Albans, Hertfordshire AL2 2NX
TEL 01727 874 299 EMAIL andre_hess@btinternet.com
Visitors welcome by appointment

JOHN HIGGINS Fellow

32 Seaman Close, Park Street, St Albans, Hertfordshire AL2 2NX
TEL 01727 874 299 **EMAIL** johnceramics@aol.com **WEB** www.studiopottery.co.uk
Visitors welcome by appointment

MARIA LINTOTT

Contact through the CPA

MADE IN CLEY

Made in Cley, High Street, Cley-next-the-Sea, nr Holt, Norfolk NR25 7RF
TEL 01263 740 134 **EMAIL** madeincley@aol.com **WEB** www.madeincley.co.uk
Gallery open all year round; Mon-Fri, 10am-5pm; Sun, 11am-4pm

ANGELA MELLOR

38a St Mary's Street, Ely, Cambridgeshire CB7 4ES
TEL 01353 666 675 **EMAIL** angela@angelamellor.com **WEB** www.angelamellor.com
Visitors welcome by appointment

STEPHEN MURFITT

The Workshop, 18 Stretham Road, Wicken, Ely, Cambridgeshire CB7 5XH
TEL 01353 721 160 **EMAIL** t.murfitt@sky.com **WEB** www.stephenmurfitt.co.uk
Visitors welcome by appointment

JEREMY NICHOLS

Baas Farm Studios, Baas Hill, Broxbourne, Hertfordshire EN10 7PX
TEL 020 8961 0409 **EMAIL** info@jeremynichols.co.uk **WEB** www. jeremynichols.co.uk
Visitors welcome by appointment

STEPHEN PARRY

Ryburgh Pottery, May Green, Little Ryburgh, Fakenham, Norfolk NR21 0LP
TEL 01328 829 543 **EMAIL** sparry@gofast.co.uk **WEB** www.spwoodfiredceramics.co.uk
Large showroom at the pottery open all year; please phone first

JANE PERRYMAN Fellow

Wash Cottage, Clare Road, Hundon, Suffolk CO10 8DH
EMAIL jane.perryman@btinternet.com **WEB** www.janeperryman.co.uk
Visitors welcome by appointment

COLIN SAUNDERS

3 Chapel Cottages, Withersdale Street, nr Harleston, Norfolk IP20 0JG
TEL 01379 588 278
Visitors welcome by appointment

RUTHANNE TUDBALL Fellow

Temple Barn Pottery, Solomon's Temple, Welborne, Dereham, Norfolk NR20 3LD
TEL 01362 858 770 **EMAIL** ruthanne.tudball@btopenworld.com
WEB www.ruthannetudball.com • Visitors welcome by appointment

LONDON

HELEN BEARD

Studio 34, Craft Central, 33-35 St John's Square, London EC1M 4DS
TEL 020 7490 8520 **EMAIL** info@helenbeard.com **WEB** www.helenbeard.com
Visitors welcome by appointment

KOCHEVET BENDAVID Fellow

147 Overhill Road, East Dulwich, London SE22 0PT
TEL 020 8516 1241 **EMAIL** kookiebendavid@hotmail.co.uk **WEB** www.kochevetceramics.com
Visitors welcome by appointment

CHRIS BRAMBLE

Contact through the CPA

KAREN BUNTING Fellow

53 Beck Road, London E8 4RE
TEL 020 7249 3016 **EMAIL** bunting.all@btinternet.com **WEB** www.studiopottery.co.uk
Visitors welcome by appointment

DIERDRE BURNETT Fellow

48 Gipsy Hill, London SE19 1NL
TEL 020 8670 6565 **EMAIL** deirdreburnett@btinternet.com
Visitors welcome by appointment

IAN BYERS Fellow

16 Stroud Road, London SE25 5DR
TEL 020 8654 0225 **EMAIL** ian.byers3@btinternet.com
Visitors welcome by appointment

DAPHNE CARNEGY Fellow

Unit 30, Kingsgate Workshops, 110-116 Kingsgate Road, London NW6 2JG
TEL 020 8442 0337 **EMAIL** d.carnegy@tiscali.co.uk **WEB** www.daphnecarnegy.com
Visitors welcome by appointment

CARINA CISCATO Fellow

Unit 7c Vanguard Court, 36-38 Peckham Road, London SE5 8QT
TEL 020 7701 2940 **EMAIL** studio@carinaciscato.co.uk **WEB** www.carinaciscato.co.uk
Visitors welcome by appointment

SOPHIE COOK

4 Dunstans Road, East Dulwich, London SE22 0HQ
TEL 07880 524 514 **EMAIL** sophie@sophiecook.com **WEB** www.sophiecook.com
Visitors welcome by appointment

PRUE COOPER

Studio A208, Riverside Business Centre, Haldane Place, Wandsworth SW18 4UQ
TEL 020 8870 2680 **EMAIL** info@pruecooper.com **WEB** www.pruecooper.com
Visitors welcome by appointment

ROBERT COOPER

105 Kilearn Road, Catford, London SE6 1BS
TEL 020 8488 3986 **EMAIL** robert.cooper20@ntlworld.com **WEB** www.robertcooper.net
Visitors welcome by appointment

JANE COX Fellow

85 Wickham Road, Brockley, London SE4 1NH
TEL 020 8692 6742 **EMAIL** jane@janecoxceramics.com **WEB** www.janecoxceramics.com
Visitors welcome by appointment

BEN DAVIES

17 Cecilia Road, London E8 2EP
TEL 020 7249 6519 **EMAIL** ben@bendaviesceramics.co.uk
WEB www.bendaviesceramics.co.uk • Visitors welcome by appointment

JOHN DAWSON

47 Heathwood Gardens, Charlton, London SE7 8ES
TEL 020 8316 1919 **EMAIL** john16749@btinternet.com **WEB** www.btinternet.com/~john16749
Visitors welcome by appointment

PHYLLIS DUPUY

Contact through the CPA

ANNABEL FARADAY

6 Victoria Park Square, London E2 9PB
TEL 020 8980 4796 **EMAIL** annabel@bethnalgreen.biz **WEB** www.annabelfaraday.co.uk

SOTIS FILIPPIDES

Sotis Studio Ceramics, Studio 1.17, OXO Tower, Barge House Street, London SE1 9PH
TEL 07733 151 276 **EMAIL** sotis@sotis.co.uk **WEB** www.sotis.co.uk
Gallery open Tues-Sat, 11am-6pm; at all other times by appointment

PENNY FOWLER

84 Middleton Road, Hackney, London E8 4LN
TEL 020 7254 2707 **EMAIL** penny.fowler@blueyonder.co.uk
WEB www.pennyfowlerceramics.co.uk • Visitors welcome by appointment

TONY GANT Fellow

53 Southdean Gardens, Southfield, London SW19 6NT
TEL 020 8789 4518 **WEB** www.tonygantpottery.com
Studio open Mon-Sat, 10am-5pm; please phone first

FRED GATLEY

Sir John Cass Department of Art, London Metropolitan University, Central House,
Whitechapel High Street, London E1 7PF
TEL 020 7320 1912 **EMAIL** f.gatley@londonmet.ac.uk • Visitors welcome by appointment

DIMITRA GRIVELLIS

Unit 6, Broadway Market Mews, London E8 4TS
TEL 020 7272 8482 **EMAIL** dimitragrivellis@yahoo.co.uk
Visitors welcome by appointment

REGINA HEINZ Fellow

Studio A 208, Riverside Business Centre, Bendon Valley, London SW18 4UQ
TEL 07779 167 229 **EMAIL** regina_heinz@ceramart.net **WEB** www.ceramart.net
Visitors welcome by appointment

AKIKO HIRAI

Unit G3, The Chocolate Factory, Farleigh Place, London N16 7SX
TEL 07950 298 128 **EMAIL** akikohiraiceramics@hotmail.co.uk
WEB www.akikohiraiceramics.com • Visitors welcome by appointment

DUNCAN HOOSON

9 Birchington Road, Crouch End, London N8 8HR
TEL 020 8342 9032 **EMAIL** dhooson@btinternet.com **WEB** www.duncanhooson.com
Visitors welcome by appointment

IKUKO IWAMOTO

Unit 51 Craft Central, 33-35 St John's Square, London EC1M 4DS
TEL 07734 592 791 EMAIL ikuko.iwamoto@network.rca.ac.uk WEB www.ikukoi.co.uk
Visitors welcome by appointment

CHRIS KEENAN Fellow

Unit 7C Vanguard Court, r/o 36-38 Peckham Road, London SE5 8QT
TEL 020 7701 2940 EMAIL chriskeenan.potter@gmail.com WEB www.chriskeenan.co.uk
Visitors welcome by appointment

DAN KELLY

Contact through the CPA

SUN KIM

Studio 4a, Vanguard Court, 36-38 Peckham Road, London SE5 8QT
TEL 07976 039 552 EMAIL sunkim_77@yahoo.com WEB www.sunkim.co.uk
Visitors welcome by appointment

GABRIELE KOCH Fellow

Studio 147, 147 Archway Road, Highgate, London N6 5BL
TEL 020 8292 3169 EMAIL contact@gabrielekoch.co.uk WEB www.gabrielekoch.co.uk
Visitors welcome by appointment

DEANA LEE

60 Lydden Grove, London SW18 4LN
TEL 07717 727 118 EMAIL dl@deanaleeceramics.com WEB www.deanaleeceramics.com
Visitors welcome by appointment

ANJA LUBACH

Studio 110, Cockpit Arts, Deptford, London SE8 3DZ
TEL 07946 841 249 EMAIL info@anjalubach.com WEB www.anjalubach.com
Visitors welcome by appointment

SOPHIE MACCARTHY Fellow

The Chocolate Factory, Farleigh Place, London N16 7SX
TEL 07754 947 340 **EMAIL** sophie_macc@yahoo.co.uk
WEB www.sophiemaccarthy.co.uk • Visitors welcome by appointment

HANNE MANNHEIMER

Manifold / Arch 33, Ermine Mews, Laburnum Street, London E2 8BF
TEL 07763 111 664 **EMAIL** hanne@hannemannheimer.com
WEB www.hannemannheimer.com • Visitors welcome by appointment

MARCIO MATTOS Fellow

Unit 7, Broadway Market Mews, London E8 4TS
TEL 07910 499 156 **EMAIL** m-m-ceramics@hotmail.com **WEB** www.musiclay.co.uk
Visitors welcome by appointment

HITOMI MCKENZIE

Contact through the CPA

PETER MCNAMEE

Contact through the CPA

LESLEY MCSHEA

Church Street Workshops, Guttridges Yard, 172 Stoke Newington Church Street,
London N16 0JL **TEL** 020 7241 3676 **EMAIL** les_pot@yahoo.co.uk
WEB www.lesleymcshea.com • Visitors welcome by appointment

ANNE MERCEDES

Contact through the CPA

VALÉRIA NASCIMENTO

248b, Kingston Road, Teddington, London TW11 9JF
TEL 020 8977 1433 **EMAIL** info@valerianascimento.com
WEB www.valerianascimento.com • Visitors welcome by appointment

SUSAN NEMETH Fellow

97 Albion Road, London N16 9PL
TEL 07855 002 678 **EMAIL** susannemeth@talktalk.net
WEB www.chocolatefactoryn16.com/susannemeth • Visitors welcome by appointment

JACQUI RAMRAYKA

Archway Ceramics, 410 Haven Mews, 23 St Paul's Way, London E3 4AG
TEL 07973 771 687 **EMAIL** jacqui.ramrayka@virgin.net **WEB** www.jacquiramrayka.com
Visitors welcome by appointment

MERETE RASMUSSEN Fellow

4a Vanguard Court, 36-38 Peckham Road, London SE5 8QT
TEL 07908 866 241 **EMAIL** mr@mereterasmussen.com **WEB** www.mereterasmussen.com
Visitors welcome by appointment

ANETA REGEL DELEU

The Chocolate Factory, Unit G2, Farleigh Place, London N16 7SX
TEL 07726 910 182 **EMAIL** anetaregel@yahoo.co.uk **WEB** www.anetaregel.com
Visitors welcome by appointment

SULEYMAN SABA

64 Grosvenor Terrace, Camberwell, London SE5 0NP
TEL 020 7277 1812 **EMAIL** oilspot@tiscali.co.uk **WEB** www.suleymansaba.com
Visitors welcome by appointment

KATE SCOTT

21 Iliffe Yard, Kennington, London SE17 3QA
TEL 020 7622 0571 **EMAIL** katescott102@gmail.com **WEB** www.katescottceramics.co.uk
Visitors welcome by appointment

ANNA SILVERTON

41 Burghill Road, London SE26 4HJ
TEL 020 8659 0767 **EMAIL** annasilverton@hotmail.com
Visitors welcome by appointment

DANIEL SMITH

Archway Ceramics, 23 St Paul's Way, London E3 4AG
TEL 020 8983 1323 **EMAIL** danielsmith101@gmail.com
WEB www.danielsmith-ceramics.com • Visitors welcome by appointment

HELEN SWAIN Fellow

8 Fyfield Road, Walthamstow, London E17 3RG
TEL 020 8520 4043
Visitors welcome by appointment

NICOLA TASSIE

Standpoint Studios, 45 Coronet Street, London N1 6HD
TEL 020 7729 5292 **EMAIL** nicola.tassie@netclick.org.uk
Visitors welcome by appointment

KAORI TATEBAYASHI

401 1/2 Workshops, 401 Wandsworth Road, London SW8 2JP
TEL 07816 422 033 **EMAIL** info@kaoriceramics.com **WEB** www.kaoriceramics.com
Visitors welcome by appointment

LOUISA TAYLOR

Studio 200, Cockpit Arts, 18-22 Cockpit Arts, Creekside, London SE8 3DZ
TEL 07779 620 130 **EMAIL** louisa@louisataylorceramics.com
WEB www. louisataylorceramics.com • Visitors welcome by appointment

ANNIE TURNER

Studio 2ed, Vanguard Court, 36-38 Peckham Road, London SE5 8QT
TEL 07890 013 286 **EMAIL** annieturner@mac.com
Visitors welcome by appointment

TINA VLASSOPULOS Fellow

29 Canfield Gardens, London NW6 3JP
TEL 07817 396 016 EMAIL tina@tinavlassopulos.com WEB www.tinavlassopulos.com
Visitors welcome by appointment

ANNETTE WELCH

21 Colyton Road, East Dulwich, London SE22 0NE
TEL 020 8693 9400 EMAIL annettewelch@mac.com
Visitors welcome by appointment

GLEN WILD

4 Lownes Courtyard, Boone Street, London SE13 5TB
TEL 07837 656 766 EMAIL info@glenwild.co.uk WEB www.glenwild.co.uk
Visitors welcome by appointment

SOUTH EAST

SYLPH BAIER

3 Florence Road, Brighton, East Sussex BN1 6DL
TEL 01273 540 552 EMAIL ceramics@sylphbaier.co.uk WEB www.sylphbaier.co.uk
Visitors welcome by appointment

JOHN BERRY

45 Chancery Lane, Beckenham, Kent BR3 6NR
TEL 020 8658 0351

RICHARD BOSWELL

66 Wallington Shore Road, Fareham, Hampshire PO16 8SJ
TEL 01329 511 497 EMAIL richatwallington@yahoo.co.uk
Visitors welcome by appointment

DYLAN BOWEN

The Old Smithy, 12 The Green, Tackley, Oxfordshire OX5 3AF
TEL 01869 331 278 EMAIL jdbowen@talktalk.net WEB www.dylanbowen.co.uk
Visitors welcome by appointment

MATTHEW CHAMBERS

43 Downsview Gardens, Wootten Bridge, Ryde, Isle of Wight PO33 4LS
TEL 07715 181 269 EMAIL info@matthewchambers.co.uk WEB matthewchambers.co.uk
Visitors welcome by appointment

LINDA CHEW Fellow

42 Cheriton Road, Winchester, Hampshire SO22 5AY
TEL 01962 867 218 EMAIL chewceramics@yahoo.com
Visitors welcome by appointment

ELAINE COLES

73a High Street, Chobham, Surrey GU24 8AF
TEL 01276 856 769 EMAIL elaine@elainecoles.co.uk WEB www.elainecoles.co.uk
Visitors welcome by appointment

GILLES LE CORRE Fellow

19 Howard Street, Oxford OX4 3AY
TEL 01865 245 289 EMAIL elaine@lecorre5.wanadoo.co.uk WEB www.photostore.org.uk
Visitors welcome by appointment

ROSALIE DODDS

14 Rugby Road, Brighton BN1 6EB
TEL 01273 501 743 EMAIL rosaliedodds14@hotmail.com WEB www.firewaysartists.com
Visitors welcome by appointment

GEOFFREY EASTOP Fellow

The Old Post Office, Ecchinswell, Newbury, Berkshire RG20 4TT
TEL 01635 298 220 EMAIL geastop@talktalk.com
Visitors welcome by appointment

SANDRA EASTWOOD

The Bungalow, 34 Hampton Road, Teddington TW11 0JW
TEL 020 8286 4327 **EMAIL** seesaw@blueyonder.co.uk **WEB** www.studiopottery.co.uk
Visitors welcome by appointment

KATERINA EVANGELIDOU

Doras Green Cottage, Doras Green, Farnham, Surrey GU10 5DZ
TEL 01252 850 409 **EMAIL** katrina.ellerby@btinternet.com
Visitors welcome by appointment

STANLEY FIELD

4 Arlington Road, Richmond, Surrey TW10 7BY
TEL 020 8940 1069 **EMAIL** stanleyfield@talktalk.net **WEB** www.stanleyfield.co.uk
Visitors welcome by appointment

JUDITH FISHER

Huntswood House, St Helena Lane, Streat, nr Hassocks, Sussex BN6 8SD
TEL 01273 890 088
Visitors welcome by appointment

LIZ GALE Fellow

Taplands Farm Cottage, Webbs Green, Soberton, Southampton SO32 3PY
TEL 02392 632 686 **EMAIL** lizgale@interalpha.co.uk **WEB** www.lizgaleceramics.co.uk
Visitors welcome by appointment

GEORGINA GARDINER (NÉE DUNKLEY)

8 Hydestile Cottages, Hambledon Road, Hambledon, Surrey GU8 4DL
TEL 01483 869 907 **EMAIL** geogie@georginagardiner.com

CAROLYN GENDERS Fellow

Oak Farm, Lewes Road, Danehill, East Sussex RH17 7HD
TEL 01825 790 575 **EMAIL** cgenders@btinternet.com **WEB** www.carolyngenders.co.uk
Visitors welcome by appointment

TANYA GOMEZ

74 Winterbourne Close, Lewes, East Sussex BN7 1JZ
TEL 07903 818 093 **EMAIL** tgceramic@yahoo.co.uk **WEB** www.tgceramics.co.uk
Visitors welcome by appointment

PENNY GREEN

Swanworth Villa, 31 Horsham Road, Dorking RH4 2JA
TEL 01306 883 196 **EMAIL** penelopegreen@btinternet.com
WEB www.pennygreenceramics.co.uk • Visitors welcome by appointment

ELAINE HEWITT

Summerhill Cottage, Summerhill Lane, Frensham, Surrey GU10 3EW
TEL 01252 793 955
Visitors welcome by appointment

ASHLEY HOWARD Fellow

12 Pottery Lane, Wrecclesham, Farnham, Surrey GU10 4QJ
TEL 07970 424 762 **EMAIL** info@ashleyhoward.co.uk **WEB** www.ashleyhoward.co.uk
Visitors welcome by appointment

GRAHAM HUDSON

5 South View, Wallingford, Oxon OX10 0HJ
TEL 01491 837 756 **EMAIL** graham.hudson3@talktalk.net
WEB www.grahamhudson-ceramics.co.uk • Visitors welcome by appointment

CLAIRE IRELAND

Studio 5, Kew Bridge Steam Museum, Green Dragon Lane, Brentford,
Middlesex TW8 0EN **TEL** 07902 027 970 **EMAIL** claireirelanduk@yahoo.co.uk
WEB www.claireirelandceramics.com • Visitors welcome by appointment

EMMA JOHNSTONE

The Blue Door Studio, c/o 34 Hawks Road, Kingston upon Thames, Surrey KT1 3EG
TEL 07970 672 535 **EMAIL** embluedoor@aol.com
WEB www.emmajohnstoneceramics.com • Visitors welcome by appointment

PHILIP JOLLEY

Contact through the CPA

LISA KATZENSTEIN

24 Centurion Rise, Hastings, East Sussex TN34 2UL
EMAIL lisa@katzenstein.fslife.co.uk WEB www.lisakatzenstein.co.uk
Visitors welcome by appointment

DAVIA KOJELYTE-MARROW

27 Beechey Avenue, Marston, Oxford OX3 0JU
TEL 01865 420 634 EMAIL daivakojelyte@hotmail.com WEB daivakojelyte.co.uk
Visitors welcome by appointment

PETER LANE Honorary Fellow

Ivy House, Jacklyns Lane, New Alresford, Hampshire SO24 9LG
TEL 01962 735 041 EMAIL peter@studioporcelain.co.uk WEB www. studioporcelain.co.uk
Small selection of pieces in studio by prior appointment only

PHIL LYDDON

76 Richmond street, Brighton, East Sussex BN2 9PE
TEL 01273 691 770 EMAIL phillyddon@hotmail.com WEB www.phillyddon.co.uk
Visitors welcome by appointment

WEST MARSHALL Fellow

Contact through the CPA

GARETH MASON Fellow

7 Old Acre Road, Alton, Hampshire GU34 1NR
TEL 01420 543 573 EMAIL gareth@garethmason.net WEB www.garethmason.net

ERIC JAMES MELLON Honorary Fellow

5 Parkfield Avenue, Bognor Regis, West Sussex PO21 3BW
TEL 01243 268 949
Visitors welcome by appointment

EMILY MYERS Fellow

2 Chalkpit Cottages, Tangley, Andover, Hampshire SP11 0RX
TEL 01264 730 243 EMAIL emily@emilymyers.com WEB www.emilymyers.com
Visitors welcome by appointment

MARGARET O'RORKE

Corpus Christi Farm House, Sandford Road, Littlemore, Oxford OX4 4PX
TEL 01865 771 653 EMAIL margaret.ororke@btinternet.com WEB www.castlight.co.uk
Visitors welcome by appointment

SUE PARASKEVA

22a Green Street, Ryde, Isle of Wight PO33 2QT
TEL 07968 336 485 EMAIL sue@paraskevapots.com WEB sueparaskeva.co.uk
Visitors welcome by appointment

RICHARD PHETHEAN Fellow

2 Hillfield, Sibford Ferris, Banbury, Oxfordshire OX15 5QS
TEL 01295 780 041 EMAIL richard@richardphethean.co.uk
WEB www. richardphethean.co.uk • Visitors welcome by appointment

MARIE PRETT

Singing Soul Gallery, 19 Stone Street, Cranbrook, Kent TN17 3HF
TEL 01580 714 551 EMAIL marieprett@yahoo.co.uk WEB www.singingsoulgallery.co.uk
Visitors welcome by appointment

PAUL PRIEST

Contact through the CPA

LESLEY RISBY

113 Draycott Avenue, Harrow, Middlesex HA3 0DA
TEL 020 8907 5600 **EMAIL** mail@lesleyrisby.co.uk **WEB** www.lesleyrisby.co.uk
Visitors welcome by appointment

DUNCAN ROSS Fellow

Daneshay House, 69A Alma Lane, Upper Hale, Farnham, Surrey GU9 0LT
TEL 01252 710 704 **EMAIL** duncanross.ceramics@virgin.net
WEB www.duncanrossceramics.co.uk • Visitors welcome by appointment

INGRID SAAG

57 Cobham Road, Kingston Upon Thames, Surrey KT1 3AE
TEL 020 8974 5465 / 07917 608 218 **EMAIL** info@ingridsaag.com **WEB** www.ingridsaag.com
Visitors welcome by appointment

KATE SCHURICHT

The Old Farmhouse, Frogs Hill, Newenden, Kent TN18 5PX
TEL 07786 576 039 **EMAIL** kate@kateschuricht.com **WEB** www.kateschuricht.com
Visitors welcome by appointment; specialist short courses offered

KATHY SHADWELL

24 Priory Avenue, North Cheam, Surrey SM3 8LX
TEL 020 8644 7471 **EMAIL** jrwhiting@tiscali.co.uk
Visitors welcome by appointment

DAN STAFFORD

3 Westfield Cottage, Breach Lane, Lower Halstow, Sittingbourne, Kent ME9 7DD
TEL 07974 770 939 **EMAIL** contact@danstafford.co.uk **WEB** www.danstafford.co.uk
Visitors welcome by appointment

BARRY STEDMAN

113 Station Road, Flitwick, Bedfordshire MK45 1LA
TEL 07932 367 515 **EMAIL** bstedman@btinternet.com **WEB** www.barrystedman.co.uk

DEBORAH TIMPERLEY

59 Smithbarn, Horsham, West Sussex RH13 6DT
TEL 01403 265 835 **EMAIL** deborah.timperley@btinternet.com
WEB www.studiopottery.co.uk • Visitors welcome by appointment

SUE VARLEY

54 Elthorne Road, Uxbridge UB8 2PS
EMAIL davidvarley@btconnect.com
Visitors welcome by appointment

CLARE WAKEFIELD

10 Station Road, Walmer, Deal, Kent CT14 7QR
TEL 01304 239 771 **EMAIL** clarewakefield@sky.com **WEB** www.clarewakefield.co.uk
Visitors welcome by appointment

ROSE WALLACE

Magdalen Road Studios, Oxford OX4 1RE
TEL 01865 728 756 **EMAIL** enquiries@rosewallaceceramics.co.uk
WEB www.rosewallaceceramics.co.uk • Visitors welcome by appointment

SARAH WALTON Fellow

Keepers, Bo-peep lane, Alciston, nr Polegate, East Sussex BN26 6UH
TEL 01323 811 517 **EMAIL** smwalton@btconnect.com **WEB** www.sarahwalton.co.uk
Visitors welcome by appointment

MAGGIE WILLIAMS

Poulders, 65 Ospringe Street, Faversham, Kent ME13 8TW
TEL 01795 531 768 **EMAIL** maggie.williams@canterbury.ac.uk
Visitors welcome by appointment

TESSA WOLFE MURRAY

38 Lorna Road, Hove, East Sussex BN3 3EN
TEL 01273 777 574 **EMAIL** tessa@wolfemurrayceramics.co.uk
WEB www.wolfemurrayceramics.co.uk

MARY WONDRAUSCH OBE Honorary Fellow

The Pottery, Brickfields, Compton, nr Guildford, Surrey GU3 1HZ
TEL 01483 414 097
Visitors welcome by appointment

GILL WRIGHT

52 South Street, Epsom KT18 7PQ
TEL 01372 723 908 **EMAIL** gill.wright18@gmail.com
Workshop in Headley; visitors welcome by appointment

SOUTH WEST

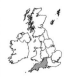

DAVID ALLNATT

Mayfield, Edenwall, Coalway, Coleford, Gloucestershire GL16 7HP
TEL 01594 833 041 **EMAIL** davidallnatt@btinternet.com **WEB** www.allnattceramics.com
Visitors welcome by appointment

TIM ANDREWS Fellow

Woodbury Studio/Gallery, Greenway, Woodbury, Exeter EX5 1LW
TEL 01395 233 475 **EMAIL** timandrews@eclipse.co.uk **WEB** www.timandrewsceramics.co.uk
Visitors welcome by appointment

FELICITY AYLIEFF Fellow

1&2 Dafford Street, Larkhall, Bath BA1 6SW
TEL 01225 334 136 / 07714 212 124 **EMAIL** aylieff@btinternet.com / felicity.aylieff@rca.ac.uk
Visitors welcome by appointment

SUZANNE BERGNE Fellow

Cambrays Barn, Upper Slaughter, Gloucestershire GL54 2JB
TEL 01451 821 328
Visitors welcome by appointment

GILLIAN BLISS

Contact through the CPA

CLIVE BOWEN Fellow

Shebbear Pottery, Shebbear, Devon EX21 5QZ
TEL 01409 281 271 EMAIL rosiebowen@talktalk.net
Visitors welcome by appointment

DAVID BROWN

DB Pottery, Church Street, Merriott, Somerset TA16 5PR
TEL 01460 75655 EMAIL dbpottery@hotmail.co.uk WEB www.dbpottery.co.uk
Visitors welcome by appointment

SANDY BROWN Fellow

3 Marine Parade, Appledore, Bideford, Devon EX39 1PJ
TEL 01237 478 219 EMAIL sandy@sandybrownarts.com WEB www.sandybrownarts.com
Visitors welcome by appointment

JAN BYRNE

19 Rosslyn Rd, Bath BA1 3LQ
TEL 07789 200 735 EMAIL jan.byrne1@btinternet.com WEB www.janbyrne.net
Visitors welcome by appointment

TREVOR CHAPLIN

Marridge Hill Cottage, Ramsbury, Marlborough, Wiltshire SN8 2HG
TEL 01672 520 486 EMAIL sodapot@yahoo.co.uk
Visitors welcome by appointment

BRUCE CHIVERS

The School House, Dunsford, Exeter, Devon EX6 7DD
TEL 01647 252 099 EMAIL bruce.chivers@southdevon.ac.uk
WEB www.studiopotteryandsculpture.co.uk • Visitors welcome by appointment

KEVIN DE CHOISY Fellow

50 Bove Town, Glastonbury, Somerset BA6 8JE
TEL 01458 835 055 EMAIL glazed&confused@talktalk.net
Visitors welcome by appointment

RUSSELL COATES Fellow

The Haven, Gare Hill Road, nr Witham Friary, Frome, Somerset BA11 5EX
TEL 07745 477 135 EMAIL russell.coates@yahoo.co.uk WEB www.russellcoates.co.uk
Visitors are welcome at the showroom; please phone first

ROGER COCKRAM Fellow

Chittlehampton Pottery and Gallery, Chittlehampton, North Devon EX37 9PX
TEL 01769 540 420 EMAIL roger@rogercockram-ceramics.co.uk
WEB www.rogercockram-ceramics.co.uk • Visitors welcome by appointment

NIC COLLINS Fellow

The Barn Pottery, North Bovey Road, Moretonhampstead, Devon TQ13 8PQ
TEL 01647 441 198 EMAIL nic.collins4@btopenworld.com WEB www.nic-collins.co.uk
Visitors welcome by appointment

DELAN COOKSON Fellow

3 King George Memorial Walk, Phillack, Hayle, Cornwall TR27 5AA
TEL 01736 755 254 EMAIL delancookson@hotmail.com
Visitors welcome by appointment

MIKE DODD Fellow

The Pottery, Dove Workshops, Barton Road, Butleigh, Glastonbury, Somerset BA6 8TL
TEL 01458 850 385 EMAIL mike@mikedoddpottery.com
Visitors welcome by appointment

JACK DOHERTY Fellow

Leach Pottery, Higher Stennack, St Ives, Cornwall TR26 2HE
TEL 01736 799 703 EMAIL jack.doherty@virgin.net WEB www.dohertyporcelain.com
Visitors welcome by appointment

SARAH DUNSTAN

Gaolyard Studios, Dove Street, St Ives, Cornwall TR26 2LZ
TEL 07877 610 149 **EMAIL** sarahdunstanceramics@gmail.com
WEB www.sarahdunstan.co.uk • Visitors welcome by appointment

FENELLA ELMS

Alma Cottage, Lottage Road, Aldbourne, Marlborough, Wiltshire SN8 2EB
TEL 0790 009 0790 **EMAIL** fenella@fenellaelms.com **WEB** www.fenellaelms.com
Visitors welcome by appointment

ROSS EMERSON

Old Trickey's Farm House, Blacksborough, Devon EX15 2HZ
TEL 01823 681 012 **EMAIL** ross@rossemerson.co.uk **WEB** www.rossemerson.co.uk
Visitors welcome by appointment

DAVID GARLAND

1 The Forge, Chedworth, Gloucestershire GL54 4AF
TEL 01285 720 307 **EMAIL** sdgarland@btinternet.com

RICHARD GODFREY Fellow

1 Battisborough Cross, Devon PL8 1JT
TEL 01752 830 457 **EMAIL** rg@richardgodfreyceramics.co.uk
WEB www.richardgodfreyceramics.co.uk • Visitors welcome by appointment

CHRISTOPHER GREEN Fellow

PO Box 115, Bristol BS9 3ND
TEL 0117 950 0852 **EMAIL** cguk@seegreen.com **WEB** www.glazecalc.com
Visitors welcome by appointment

PAUL GREEN

Contact through the CPA

IAN GREGORY Honorary Fellow

Crumble Cottage, Ansty, Dorchester, Dorset DT2 7PN
TEL 01258 880 891 **EMAIL** ian@ian-gregory.co.uk **WEB** www.ian-gregory.co.uk
Visitors welcome by appointment

LISA HAMMOND Fellow

Kigbeare Studio Pottery, Kigbeare Manor, Southcott, Okehampton, Devon EX20 4NL
TEL 01837 53027 **EMAIL** lisa@lisahammond-pottery.co.uk
WEB www.lisahammond-pottery.co.uk • Visitors welcome by appointment

BILL AND BARBARA HAWKINS Fellow

Port Isaac Pottery, Roscarrock Hill, Port Isaac, Cornwall PL29 3RG
TEL 01208 880 625 **EMAIL** portisaacpottery@btconnect.com
Open throughout the year; Summer, 10am-5pm; Winter, Thurs-Sun only, 10am-4pm

PETER HAYES Fellow

2 Cleveland Bridge, Bath BA1 5DH
TEL 01225 466 215 **EMAIL** peter@peterhayes-ceramics.uk.com
WEB www.peterhayes-ceramics.uk.com • Visitors welcome by appointment

RICK HENHAM

Gaolyard Studios, Dove Street, St Ives, Cornwall TR26 2LZ
TEL 07880 794 544 **EMAIL** info@rickhenham.com **WEB** www.rickhenham.com
Visitors welcome by appointment

TERRI HOLMAN

Northcombe, Moretonhampstead Road, Bovey Tracey, Devon TQ13 9NH
TEL 01626 835 578 **EMAIL** terriholman@hotmail.co.uk
Visitors welcome by appointment

HARRY HORLOCK-STRINGER Honorary Fellow

King William House, Lopen, South Petherton, Somerset TA13 5JU
TEL 01460 242 135
Visitors welcome by appointment

JOHN HUGGINS Fellow

Ruardean Garden Pottery, Ruardean Forest of Dean, Gloucestershire GL17 9TP
TEL 01594 543 577 **EMAIL** ruardeanpottery@hotmail.com **WEB** www.ruardeanpottery.com
Studio open Tues-Sat, 11am-4pm; please phone to confirm

TIM HURN

Home Farm House, Bettiscombe, Bridport, Dorset DT6 5NU
TEL 01308 868 171 **EMAIL** tj.hurn@tiscali.co.uk **WEB** www.timhurn.co.uk
Visitors welcome by appointment

BERNARD IRWIN

Contact through the CPA

PAUL JACKSON Fellow

Helland Bridge Pottery, Hellandbridge, Bodmin PL30 4QR
TEL 01208 75240 **EMAIL** paul@paul-jackson.co.uk **WEB** www.paul-jackson.co.uk
Studio open week days 10am-5pm; visitors welcome by appointment

ANNE JAMES Fellow

7 Gloucester Road, Painswick, Gloucester GL6 6RA
TEL 01452 813 846 **EMAIL** annejames37@waitrose.com
Visitors welcome by appointment

VICTORIA JARDINE

Glenwood Studio, Glenwood House, Longburton, Sherborne, Dorset DT9 5PG
TEL 01963 210 211 **EMAIL** victoriajardine@hotmail.co.uk **WEB** www.victoriajardine.com
Visitors welcome by appointment

JOHN JELFS Fellow

Cotswold Pottery, Clapton Row, Bourton-on-the-Water, Gloucestershire GL54 2DN
TEL 01451 820 173 **EMAIL** john.jelfs@homecall.co.uk **WEB** www.cotswoldpottery.co.uk
Studio open most days 10am-5pm; please phone first

JUDE JELFS

Cotswold Pottery, Clapton Row, Bourton-on-the-Water, Gloucestershire GL54 2DN
TEL 01451 820 173 EMAIL jude.jelfs@homecall.co.uk WEB www.cotswoldpottery.co.uk
Studio open most days 10am-5pm; please phone first

NIGEL LAMBERT

Contact through the CPA

JOHN LEACH Fellow

Muchelney Pottery, Muchelney, nr Langport, Somerset TA10 0DW
TEL 01458 250 324 EMAIL john@johnleachpottery.co.uk WEB www.johnleachpottery.co.uk
Muchelney Pottery Shop and John Leach Gallery are open Mon-Sat, 9am-1pm, 2-5pm

CLAIRE LODER

11 Frankley Terrace, Camden, Bath BA1 6DP
TEL 01225 335 521 EMAIL info@claireloder.co.uk WEB claireloder.co.uk
Visitors welcome by appointment

ALASDAIR NEIL MACDONELL

2 Kennington Road, Bath BA1 3EA
TEL 01225 465996 EMAIL neil@macdonell-ceramics.co.uk
WEB www.macdonell-ceramics.co.uk • Visitors welcome by appointment

SALLY MACDONELL

2 Kennington Road, Bath BA1 3EA
TEL 01225 465996 EMAIL sally@macdonell-ceramics.co.uk
WEB www.macdonell-ceramics.co.uk • Visitors welcome by appointment

JOHN MALTBY Honorary Fellow

The Orchard House, Stoneshill, Crediton, Devon EX17 4EF
TEL 01363 772 753

LAURENCE MCGOWAN Fellow

6 Aughton, Collingbourne Kingston, Marlborough, Wiltshire SN8 3SA
TEL 01264 850 749 **EMAIL** potteringabout2000@yahoo.co.uk
WEB www.laurencemcgowan.co.uk • Visitors welcome by appointment

KATE MELLORS

Contact through the CPA

TOFF MILWAY Fellow

Conderton Pottery, Conderton, nr Tewkesbury, Gloucestershire GL20 7PP
TEL 01386 725 387 **EMAIL** toffmilway@toffmilway.co.uk **WEB** www.toffmilway.co.uk
Workshop and showroom open Mon-Sat, 10am-5pm; phone at other times.

ROGER MULLEY

Heron House, Pond Lane, Clanfield, Waterlooville, Hampshire PO8 0RG
TEL 02392 595 144 **EMAIL** roger.mulley@btinternet.com

CLAIRE MURRAY

The Old Coach House, Ashreigney, nr Chulmleigh, Devon EX18 7NB
TEL 01769 520 775 **EMAIL** clairemurray@btinternet.com
WEB www.clairemurray-ceramics.co.uk • Visitors welcome by appointment

JITKA PALMER

3 Florence Park, Westbury Park, Bristol BS6 7LS
TEL 01179 243 473 **EMAIL** jitkapalmer@gmail.com **WEB** www.jitkapalmer.co.uk
Visitors welcome by appointment

LEA PHILLIPS

Unit 2, Coombe Park, Ashprington, Totnes, Devon TQ9 7DY
TEL 07736 371 427 **EMAIL** lea.phillips@virgin.net **WEB** www.leaphillips-pottery.co.uk
Studio open Mon-Sat, 11am-6pm; please phone first

JOHN POLLEX Fellow

Stowford House, 43, Seymour Ave, St Judes, Plymouth, Devon PL4 8RB
TEL 01752 224 902 EMAIL john@johnpollex.co.uk WEB www.johnpollex.co.uk
Visitors welcome by appointment

NICK REES Fellow

Muchelney Pottery, Muchelney, nr Langport, Somerset TA10 0DW
TEL 01458 250 324 EMAIL nick@nickreespotter.co.uk WEB www.nickreespotter.co.uk
Visitors welcome by appointment

MARY RICH Fellow

The Pottery, Cowlands Creek, Kea, Truro TR3 6AT
TEL 01872 276 926 EMAIL mary@maryrich.co.uk WEB www.maryrich.co.uk
Visitors welcome by appointment

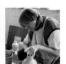

CHRISTINE-ANN RICHARDS Fellow

Chapel House, High Street, Wanstrow, Somerset BA4 4TE
TEL 01749 850 208 EMAIL mail@christineannrichards.co.uk
WEB www.christineannrichards.co.uk • Visitors welcome by appointment

GEORGIA SHEARMAN

27 Stevens Crescent, Totterdown, Bristol BS3 4UH
TEL 01179 710 071 EMAIL injoygeorgia@hotmail.co.uk WEB www.studiopottery.co.uk
Visitors welcome by appointment

ELIZABETH SMITH

Millhead House, Millhead, Bampton, nr Tiverton, Devon EX16 9LP
TEL 01398 331 442 EMAIL smithmillhead@aol.com WEB www.crafts.org.uk
Visitors welcome by appointment

PENNY SIMPSON

The Studio, 44a Court Street, Moretonhampstead, Devon TQ13 8LG
TEL 01647 440 708 EMAIL psimpson@thestudiopots.fsnet.co.uk
WEB www.pennysimpsonceramics.co.uk • Open Mon-Fri, 9.30am-5pm; Sat, 10am-12 noon

PETER SMITH Fellow

Higher Bojewyan, Pendeen, Penzance, Cornwall TR19 7TR
TEL 01736 788 820 EMAIL petersmith1@lineone.net WEB petersmithceramics.com
Visitors welcome by appointment

JENNY SOUTHAM

11 Prospect Park, St James, Exeter, Devon EX4 6NA
TEL 01392 437 555 EMAIL jennysoutham@fsmail.net WEB www.jennysoutham.co.uk
Visitors welcome by appointment

CHRIS SPEYER Fellow

TEL 07770 936 678 EMAIL chris.speyer@btinternet.com

JOANNA STILL

4 Beckford Cottages, Hindon, Salisbury, Wiltshire SP3 6ED
TEL 01747 820 478 EMAIL joanna.still@talk21.com
Visitors welcome by appointment

TAJA

38 Cross Street, Moretonhampstead, Devon TQ13 8NL
TEL 01647 440 782 EMAIL hitaja@hotmail.com WEB www.tajaporcelain.com
Visitors welcome by appointment

HIRO TAKAHASHI

The Haven, Gare Hill Road, nr Witham Friary, Frome, Somerset BA11 5EX
TEL 01373 836 171 / 07767 279 420 EMAIL hirotakahashi_coates@yahoo.com
Visitors welcome at the showroom; please phone first

YO THOM

The Old Cricket House, North Street, Fontmell Magna, Shaftesbury, Dorset SP7 0NS
TEL 01747 854 671 EMAIL yo@yothom.com WEB www.yothom.com
Visitors welcome by appointment

MARIANNE DE TREY Honorary Fellow

Contact through the CPA

PATRICIA VOLK

The Workshops, Stowford Manor Farm, Wingfield, Wiltshire BA14 9LH
TEL 07894 451 542 EMAIL info@patriciavolk.co.uk WEB www.patriciavolk.co.uk
Visitors welcome by appointment

SASHA WARDELL Fellow

36 Tory, Bradford-on-Avon, Wiltshire BA15 1NN
TEL 07855 110 603 EMAIL sasha@sashawardell.wanadoo.co.uk
WEB www.sashawardell.com • Visitors welcome by appointment

NICOLA WERNER

Burcombe Farm, Bolham Water, Clayhidon, Cullompton, Devon EX15 3QB
TEL 01823 680 957 WEB www.nicolawerner.com
Visitors welcome by appointment

ANDREW WICKS

Cowshed 2, Wick Yard, 15a Bath Road, Farleigh Wick, Wiltshire BA15 2PU
TEL 01225 469 159 EMAIL andrew@andrewwicks.co.uk WEB www.andrewwicks.co.uk
Visitors welcome by appointment

RICHARD WILSON

The Old Timber Yard, West Bay, Bridport, Dorset DT6 4EL
EMAIL rwilsonpots@surfree.co.uk WEB www.chapelyard.co.uk
Studio open Tues-Sat, 10am-5pm

DAVID WINKLEY Fellow

Vellow Pottery, Lower Vellow, Williton, Taunton, Somerset TA4 4LS
TEL 01984 656 458 EMAIL david@vellowpottery.co.uk WEB www.vellowpottery.co.uk
Gallery shop and workshop open Mon-Sat, 9am-6pm

MARIA WOJDAT

EMAIL mariawojdat@hotmail.com WEB www.mariawojdat.co.uk
Visitors welcome by appointment

GARY WOOD Fellow

One Two Five, Box Road, Bathford, Bath BA1 7LR
EMAIL info@garywoodceramics.co.uk WEB www.garywoodceramics.co.uk
Visitors welcome by appointment

PHILIP WOOD Fellow

Linden Mead Studio, Linden Mead, Whatley, Somerset BA11 3JX
TEL 01373 836 425 EMAIL philipwood1@gmail.com
Visitors welcome by appointment

TAKESHI YASUDA Honorary Fellow

1&2 Dafford Street, Larkhall, Bath BA1 6SW / Red House Design Studio @
The Sculpture Factory, 139 East Xinchang Road, Jingdezhen 333001 PRC
TEL 01225 334 136 (UK) EMAIL takeshi@takeshiyasuda.com WEB www.takeshiyasuda.com

ALISTAIR YOUNG

Guy Hall Cottage, Awre, Newnham-on-Severn, Gloucestershire GL14 1EL
TEL 01594 510 343 EMAIL alistair@alistairyoung.co.uk WEB www.alistairyoung.co.uk
Visitors welcome by appointment

SCOTLAND

DAVID BODY

John O'Groats Pottery, 3 The Craft Centre, John O'Groats, Wick, Caithness KW1 4YR
TEL 01955 611 284 EMAIL info@jogpot.co.uk
Visitors welcome by appointment

VANESSA BULLICK

The Barn, Torr Forret, Cupar, Fife KY15 4PY
EMAIL vanessabullick@yahoo.co.uk **WEB** www.vanessabullick.co.uk
Visitors welcome by appointment

LORNA FRASER

WASPS Studios, Patriothall, Stockbridge, Edinburgh EH3 5AY
TEL 07884 352 711 **EMAIL** lornafraser@hotmail.co.uk **WEB** www.lornafraser.co.uk
Visitors welcome by appointment

WILL LEVI MARSHALL Fellow

Holm Studio, Auchencairn, Castle Douglas, Dumfries, Scotland DG7 1QL
TEL 01556 640 399 **EMAIL** will.levi.marshall@btinternet.com **WEB** www.holmstudio.com
Visitors welcome by appointment

HANNAH MCANDREW

Studio 3, Lochdougan House, Kelton, Castle Douglas, Galloway, Scotland DG7 1SX
TEL 01556 680 220 **EMAIL** info@hannahmcandrew.co.uk
WEB www.hannahmcandrew.co.uk • Visitors welcome by appointment

SUSAN O'BYRNE

Glasgow Ceramics Studio, WASPS, 77 Hanson Street, Glasgow G31 2HF
TEL 01415 508 030 **EMAIL** susanobyrne@hotmail.co.uk **WEB** www. susanobyrne.com
Visitors welcome by appointment

IAN PIRIE Fellow

Contact through the CPA

PHILOMENA PRETSELL

Rose Cottage, 10 Fountain Place, Loanhead, Midlothian EH20 9EA
TEL 0131 440 0751 **EMAIL** philomenapretsell@hotmail.co.uk
Visitors welcome by appointment

LORRAINE ROBSON

Linlithgow, West Lothian, Scotland
TEL 07939 301 721 **EMAIL** info@lorrainerobson.co.uk **WEB** www.lorrainerobson.co.uk
Visitors welcome by appointment

LARA SCOBIE

1 Claremont Bank, Edinburgh EH7 4DR
TEL 01315 566 673 **EMAIL** lmscobie@dundee.ac.uk **WEB** larascobieceramics.co.uk
Visitors welcome by appointment

FIONA THOMPSON

TEL 07901 930 654 **EMAIL** fi_ceramics@hotmail.com
WEB www.fionathompsonceramics.co.uk
Visitors welcome by appointment

ROSEMARY WREN Honorary Fellow

The Oxshott Pottery, Nutwood Steading, Strathpeffer, Ross-shire IV14 9DT
TEL 01997 421 478 • Although The Oxshott Pottery is no longer in production there
are still many pieces of historical interest for sale; visitors welcome by appointment

NORTHERN IRELAND

PETER MEANLEY Fellow

6 Downshire Road, Bangor, County Down, Northern Ireland BT20 3TW
TEL 02891 466 831 **EMAIL** pjmeanley@yahoo.co.uk
Visitors welcome by appointment

DEREK WILSON

25-51 York Street, Belfast, County Antrim BT15 1ED
TEL 07860 533 681 **EMAIL** studio@derekwilsonceramics.com
WEB www.derekwilsonceramics.com • Visitors welcome by appointment

OUTSIDE THE UK

ELIZABETH AYLMER

Buzón 911, 11690 Olvera, Cádiz, Spain
TEL 0034 956 234 060 EMAIL lizyjen@terra.es WEB www.artesaniadelprado.es
Visitors welcome by appointment

CHRISTY KEENEY

Doon Glebe, Newmills, Letterkenny, Co Donegal, Ireland
TEL 00353 7491 67258 EMAIL christykeeny2@gmail.com WEB www.christykeeney.co.uk
Visitors welcome by appointment

HYEJEONG KIM

149-17 Gugi-Dong, Jongno-Gu, Seoul, 110-804, Republic of Korea
TEL/FAX 0082 (0)2379 5766 EMAIL hk@potspots.com WEB www.potspots.com

MARTIN MCWILLIAM Fellow

Martin McWilliam, Auf dem Koetjen 1, 26209 Sandhatten, Germany
TEL 0049 4482 8372 EMAIL ceramics@martin-mcwilliam.de
WEB www.martin-mcwilliam.de • Visitors welcome by appointment

SEAN MILLER

5 Rue Marcel Callo, 56220 Peillac, France
TEL 0033 0299 93 48 13 EMAIL seanpots@btinternet.com WEB www.seanpots.com
Studio open Wed-Sun

URSULA MORLEY PRICE

Chez Gaty, Vaux Lavalette 16320, France
TEL 0033 0545 259 167 EMAIL ursula.morley-price@orange.fr
Visitors welcome by appointment

CHRISTINE NIBLETT

Carrer Xesc Forteza 6, Valldemossa, 07170 Mallorca, Spain
TEL 0034 971 616 172 / 020 7824 8625
Visitors welcome by appointment

MARCUS O'MAHONY

Glencairn Pottery, Lismore, Co Waterford, Ireland
TEL 0035 3585 6694 EMAIL moceramics@eircom.net WEB www.marcusomahoney.com
Visitors welcome by appointment

ROBERT SANDERSON Fellow

PO Box 612, Scariff, Co Clare, Ireland
TEL 00353 6192 2918 EMAIL robert@thelogbook.net WEB www.thelogbook.net

MOTOKO WAKANA

713-30 Shimotakano, Sugito, Kitakatsushika, Saitama 345-0043 Japan
TEL +81 (0)480 33 3646 EMAIL wakanamoto@hotmail.com

MARY WHITE Honorary Fellow

Contact through the CPA